Silvia Malaguzzi

The Pearl

RIZZOLI
NEW YORK

Graphic design
RovaiWeber design

First published in the United States
of America in 2001 by
Rizzoli International Publications, Inc.
300 Park Avenue South
New York, NY 10010

Copyright © 2000 OCTAVO
Produzioni Editoriali Associate SpA
Borgo Santa Croce 8, Firenze

ISBN 0-8478-2364-4
LC 00-107630

Printed and bound in Italy

Table of Contents

Foreword

The bivalve of genus *Meleagrina margaritifera* is a mussel with characteristics seemingly of any other mussel, but it has one very particular capability: it can produce those small and precious gems, pearls.

The beauty of pearls, the risk involved in their collection—which requires skin-divers to descend to great depths—and the limited number of stones available gave them great value in the eyes of ancient Oriental civilizations, which made large use of them in female and male costume decoration.

But what was it that made pearls so highly prized in the West? To the Greeks and Romans, the fact that pearls originated in the Middle and Far East imbued them with an exotic mystique over and above their natural beauty. Their source is actually celebrated in one of the determining characteristics of a pearl, its suffused translucence, referred to as "orient."

Pearls must have seemed an astonishing product of nature to the people who first discovered them. Their roundness and immaculate pale color were attributes so unusual in the natural world as to suggest the concept of ineffable perfection; this characteristic of the divine was, by extension, also considered royal among those civilizations that attributed semi-divine powers and faculties to the person of the king. Necklaces of large pearls were frequent elements in ancient Indian sculptures,[1] while reliefs from Assyria and Persia portrayed rulers with clothes and even their beards adorned with pearls. The Persian tradition, whereby the tiara of the king had to contain three rows of pearls,[2] was equally significant, if less eccentric. During the late Roman era, when the empire had been divided into two parts, the empires of the East (Byzantium) and the West, the tendency of western emperors to emulate oriental modes of pomp and display resulted in the Persian tiara decorated with pearls being introduced into imperial costume. Following his military triumph over the Parthians, Caracalla began this trend, which was later embraced by Aurelian and Diocletian and definitively adopted by Constantine.[3]

Thus pearls, today considered de rigueur elements in women's ornamentation, were originally worn by both women and men, but their use was not restricted to royal costume. We know from the work of the Roman writer Ammianus Marcellinus (330 ca.–400 ca. A.D.), that at the time of the emperor Julian the Apostate (361–363 A.D.), men also wore pearls in the form of *colliers* and earrings, today considered purely feminine styles.[4]

In the western world the dates and events surrounding the appearance of pearls are not altogether clear. Many hypotheses have been advanced, but the most credible suggests that pearls were introduced during the reign of Alexander the Great, whose extraordinary imperial ambitions took him and his army to the mouth of the river Indus, on the far borders of the Persian empire, between 334–330 B.C.[5] On his return, the general brought with him precious stones of all types, including pearls, which were accompanied by tales of their creation, how they were fished and their magical properties.

Archaeological excavations seem to confirm the absence of pearls among the precious materials found in the civilizations of Mediterranean peoples like the Etruscans, the Lydians and the Phoenicians[6] during the archaic and classical eras, whereas great use was made of them in Greek jewelry. Plutarch (46–120 A.D.) recorded that pearls were unknown in pharaonic Egypt but were highly prized during the Ptolemaic dynasty that ruled the country during the Hellenistic epoch.[7] Even the Holy Scriptures seem to confirm this. There seems to be no term in the Old Testament that could incontestably and unequivocally be translated as pearl,

Byzantine art (6th c.), *Mosaic of Theodora,* Ravenna, San Vitale.

Page 10: Roman-Egyptian art (170–190 A.D.), *Encaustic portrait of a woman on wood,* Vienna, Kunsthistorisches Museum.

whereas the word is explicitly mentioned on several occasions in the New Testament.[8] The first Greek text in which pearls are not just mentioned but also described is *De lapidibus* by Theophrastus (372/369–288/285 B.C.), which was written around 315 B.C., i.e. a few years after the conquest of Alexander the Great. The scientist, a pupil of Aristotle, describes the appearance of the gem imprecisely, which suggests that he was not familiar with the object, and from that fact, one can infer that pearls were probably not very widespread in the Greek world yet and were objects of curiosity.[9]

Finally, the hypothesis, that with the advent of the Hellenistic world, the pearl was introduced to the West together with other marvels of the eastern world, would appear to be supported by the etymology of the Greek word *margarites* (from which the Latin word *margarita* is also derived), which seems to have its roots in the Orient.[10]

If it is true that the pearl came to the West with Alexander, or even if pearls arrived earlier, the exploits of the Greek general certainly opened a trade route by which contacts between East and West were considerably strengthened. With the increase of trade, pearls were imported into the Hellenistic world in such quantities that the fashions of personal ornamentation were changed. The beginning of the use of pearls in the West, therefore, coincided with the discovery of the exotic Orient and its immense riches. The natural beauty of pearls, accompanied by the stories regarding their exotic genesis, was adopted as an element of women's *parure*. Their appearance, origin, methods of collection, and curative and talismanic qualities fascinated Hellenistic and, later, Roman writers, who dedicated paragraphs of their work to the pearl. During the Middle Ages, these tracts were given complex interpretations by mystical Christians, who were interested in discovering the alchemical properties of pearls, and by the doctors-astrologers of the Renaissance, who were interested in pearls' curative qualities. Pearls have a twofold essence: on the one hand, they are valued as a beautiful material in the production of jewelry; on the other hand, their attractiveness has sparked a multifaceted body of literature that celebrates their spiritual value and considers them as emblems rather than gems.

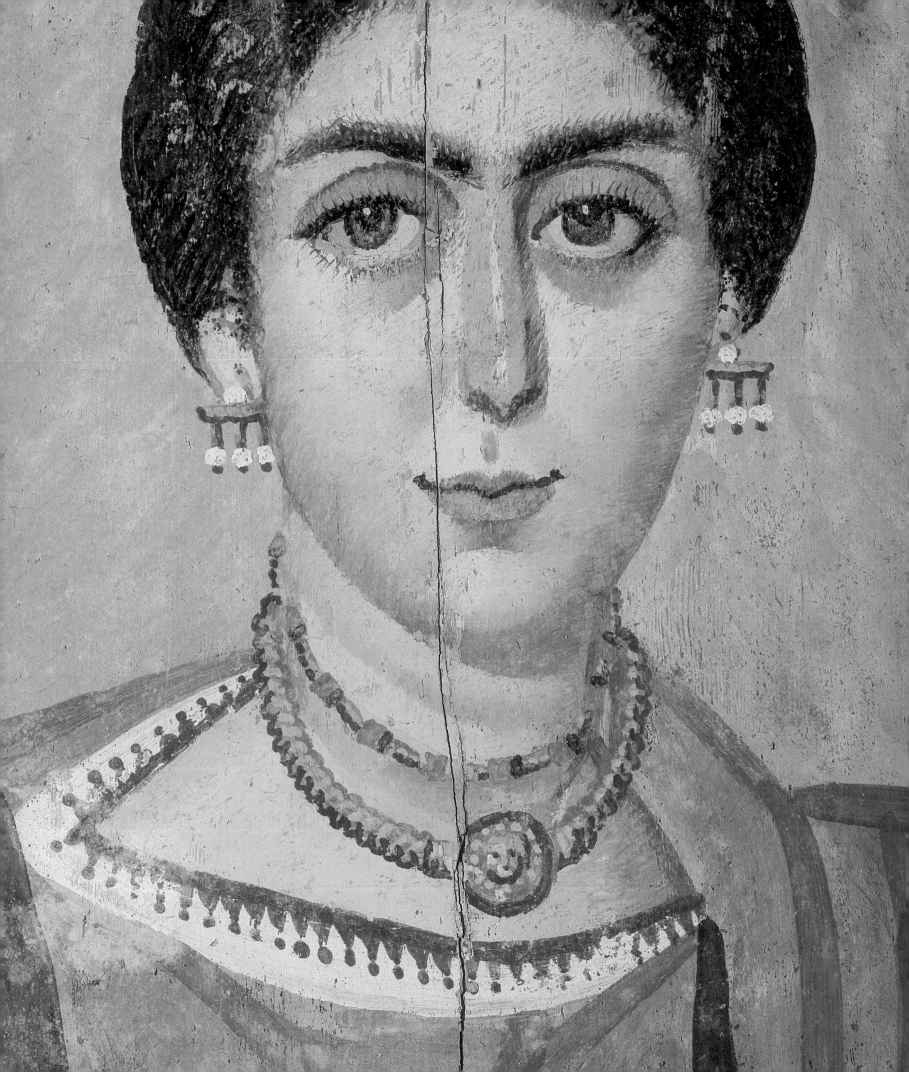

The Pearl

The Perception of Pearls from the Hellenistic Era to the Baroque

Writers, Poets and Philosophers: The Pearl in Pagan Antiquity (4th c. B.C.—4th c. A.D.)

The Myth of the Origin of the Pearl The intuitive link that would seem to exist between the pearl, that precious organic gemstone, and Aphrodite, the Greek goddess, does not appear to receive any mention in the writings of the scientists and literary writers of the Hellenistic epoch. Their origins are curiously alike. Pearls are generated by shellfish, and Aphrodite is also a product of the sea, as interpreted pictorially by Sandro Botticelli in his representation of the goddess hovering above the waves, on a precarious boat-like shell. However, a subtle but fundamental difference is to be found between the genesis of the pearl and that of the goddess: the first is produced inside a shell, whereas the myth of the goddess says she was born from sea-spray, and the shell was only the means by which she was transported over the sea to Cyprus. Furthermore, during the Hellenistic epoch, at the time of the first contacts between the Greek and eastern cultures, the codification of Olympic mythology had been defined for some time, and with it the myth of the birth of Aphrodite. So, if pearls were introduced to the West during the Hellenistic era, the myth of its origins could not have contributed to that of the birth of the goddess, which came from much more ancient times.[1]

Arrian (ca. 95–ca. 175 A.D.), however, recounts the discovery of pearls in a mythological vein, when he refers to a work on India written by Megasthenes, a member of the retinue of Alexander the Great. Hercules, the Roman version of the Greek Heracles, the hero and traveler, had many wives and sons in India but only one daughter, Pandea, to whom he gave a kingdom, the city of Taxila, and many elephants and soldiers. But after discovering an unknown and precious gem in the sea, the pearl, he collected great numbers of them, and he gave them to his daughter to ornament herself.[2] Despite the reference to Hercules/Heracles, a hero of Olympus, examination of the legend reveals that its origin was not entirely Greek and was, indeed, present in the more ancient Indian mythological tradition that centered on Krishna, a god in the Hindu pantheon. The tale told by Megasthenes and recounted by Arrian is therefore an example of contamination and cultural synthesis between myths of different origin. This phenomenon emerged with the meeting of the western and eastern worlds and profoundly, and increasingly frequently, characterized the syncretistic Hellenistic culture.[3]

Arrian attributed the origin of the flourishing pearl trade between the Orient and the West to the influence of the mythological exploits and travels of Heracles. All merchants who traveled to India at that time, even for other goods, bought pearls. He also pointed out that the Indian name for pearls was similar to the Greek word *margarites*.[4] And thus, in addition to referring to the first significant example of contact between East and West, he gives an etymology of *margarites*.

In the writings of Hellenistic philosopher-scientists and more general Roman authors, the pearl takes on form and color as an object of acute observation and equally fanciful deductions. To the Greek scientist Theophrastus (371/70–288/87 B.C.), pearls in nature were transparent,[5] while Athenaeus of Naucratis (2nd–3rd c. A.D.) stated that at times they were so golden that it was difficult to tell the difference between the two substances, however that they could also be silvery in appearance or perfectly white.[6]

To Pliny the Elder (23/24–79 A.D.), who dedicated a long section to pearls in his *Naturalis Historia*, the "healthy parts" of the oyster's shell looked like layered skin, almost a "callous of the body."[7] In water, pearls were soft, but once removed, they hardened,[8] yet despite this rather rapid change, the writer believed that their physical nature was substantially solid, as when they were dropped, they often broke irreparably.[9] Athenaeus stated that the pearl was found in the "fleshy part" of the oyster,[10] and Pliny was convinced that maybe four or five might be found within the same creature,[11] while others believed it was possible that up to twenty might be present.[12]

Ammianus Marcellinus thought that a sort of law of compensation might exist in cases such as these in which, if the oyster produced more than one pearl, they would inevitably be smaller than if there had been one.[13] According to Pliny, the shell of the pearl-oyster was formed like that of the ordinary oyster, but when the right season arrived, the shell rose to the surface of the sea, opened and was filled with a fertilizing element that could be assimilated to dew. Once "pregnant," the oyster gave birth to pearls, depending on the quantity and quality of the dew: if the dew was pure, the pearl would be white, if impure, it would take on a brownish tinge.[14]

The Roman writer Solinus (mid-3rd c. A.D.) placed an even more anthropomorphic slant on this account, saying that to the oyster, the dew was "like a husband for desire of which it opens," but it was necessary that the dew have a lunar quality, i.e. that it fall during the night, as it therefore would conserve its generating powers.[15]

Many authors agreed in the belief that this miraculous fertilization depended more on the heavens than the sea—where it took place—as it is from the heavens that dew falls, and the coloring of pearls depended on the clearness or cloudiness of the dew.[16] For Solinus, the size of the pearl depended on the width of the aperture of the shell,[17] while for Ammianus Marcellinus, it was proportional to the quantity of fertilizing dew that penetrated, and he added that while morning dew produced pearls of great beauty, evening dew made them irregular and reddish in color.[18] The heavens, in combination with the climatic conditions in which fertilization took place, was also seminal for the birth and growth of the pearl. According to Pliny, lightning frightened oysters to the point that they would close to protect themselves, so preventing the dew from nourishing the pearl, and the size of the pearl, as a result of its enforced fast, would be much smaller. Thunder, on the other hand, was even more extreme in its effect, in that the oyster would close and, in its fright, generate air bubbles in a sort of induced abortion.[19]

Athenaeus held the opposite view. He believed that when thunderstorms were frequent, pearls were also large and beautiful, as they received a larger quantity of liquid nourishment in the form of rain.[20] In winter, the shells closed at the bottom of the sea, while in summer they would float on the surface, opening by night and closing by day to prevent the pearl's color being damaged by strong sunlight. It goes without saying that those shells that attached themselves like crabs to the rocks at high tide were the most beautiful as they were the best defended against the sun.[21]

With age, pearls tend to yellow and form lines; they become more dense and adhere more securely to their shells. When this occurs, it is necessary to use a file to remove them.[22]

Jan and Hubert van
Eyck, *The Ghent
Altarpiece* (1425–30c.),
*The Virgin
Reading* and *Christ
Blessing*, Ghent,
St. Bavo.

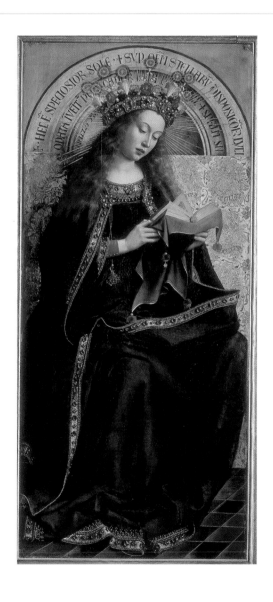

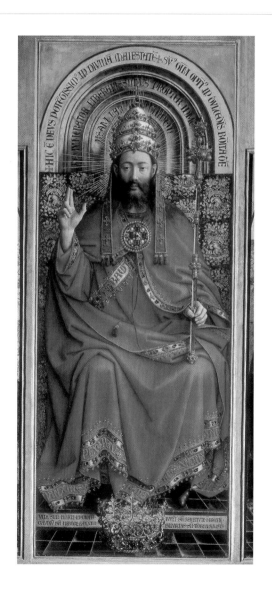

Jan and Hubert van Eyck, *The Ghent Altarpiece* (1425–30 c.), details *of The Virgin Reading* and *Christ Blessing,* Ghent, St. Bavo.

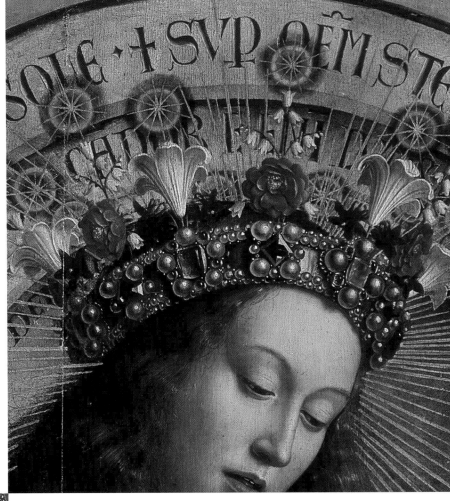

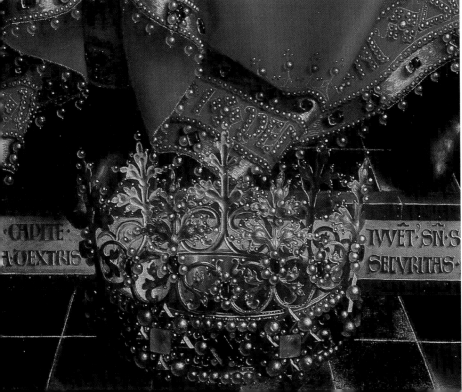

Oysters live together in a sort of society similar to that of bees; a queen and a king head the colony and lead them to safety when danger threatens, but if they are captured by a pearl-diver, it makes it easier to collect the rest of the colony.[23] Pliny added that the colony could have more than two leaders and that, in general, this role was held by the oldest and largest oysters.[24] According to Aelian (170–235 A.D.), the leader of the colony had a different color and would only lead to safety those oysters that obeyed it.[25]

Theophrastus contrasted the anomalous character of the pearl with precious stones of mineral origin,[26] and Pliny implicitly confirmed this aspect when he grouped pearls among marine animals rather than other gems in the thirty-seventh book of his work *Naturalis Historia*. Aelian was of the same opinion and dedicated a significant passage to the question in his treatise on the nature of animals. In his work, *Verrine*, Cicero (106–43 B.C.) used the expression "gems and pearls," distinguishing between organic gems and mineral stones and implicitly emphasizing the different nature of the two species.[27] The same classification, seen in the writings of Quintus Curtius Rufus[28] (alive during the reigns of emperors Claudius and Vespasian) and Pomponius Mela[29] (who wrote during the reign of Caligula, 37–41 A.D.), is explained by the comment in the *Aeneid* by Servius (4th c. A.D.): the pearl had a different character from other gems in that it could only be white while the others could assume different colors. However, Servius himself seems unconvinced by this same explanation and offered a second hypothesis, according to which the pearl, unlike other gemstones, must have a hole bored through it to be used.[30]

Clearly, there was a great deal of confusion about the nature of pearls, but this notwithstanding, the stones were not totally ignored by Hellenistic and Hellenistic-Roman literature, even though references to them were vague rather than based on fact. The absence of pearls in Hellenistic lapidary treatises dealing with medical-magical subjects is striking. They are not mentioned in treatises specifically dealing with stones and their properties, either, which were rather widely circulated in the Hellenistic culture of Alexandria in Egypt, a natural meeting place of East and West. To counter this singular absence, the pearl is a frequent presence in works by geographers and writers of the pagan world, who referred to it as an oddity or a prodigy of nature. This was the approach of Solinus, who inserted a paragraph dedicated to pearls in his *Collectanea rerum memorabilium*.

Pliny and Aelian stated that the most important attributes of a pearl were its whiteness, roundness, smoothness and weight.[31] The specimens that possessed all these characteristics were so rare that it was almost impossible to find two that were identical. And it was for this very reason that Pliny believed that it was from the Latin *unicus* (unique) that the word *unio* was derived, which was used in Latin instead of *margarita* to define a pearl of such uncommon qualities.[32]

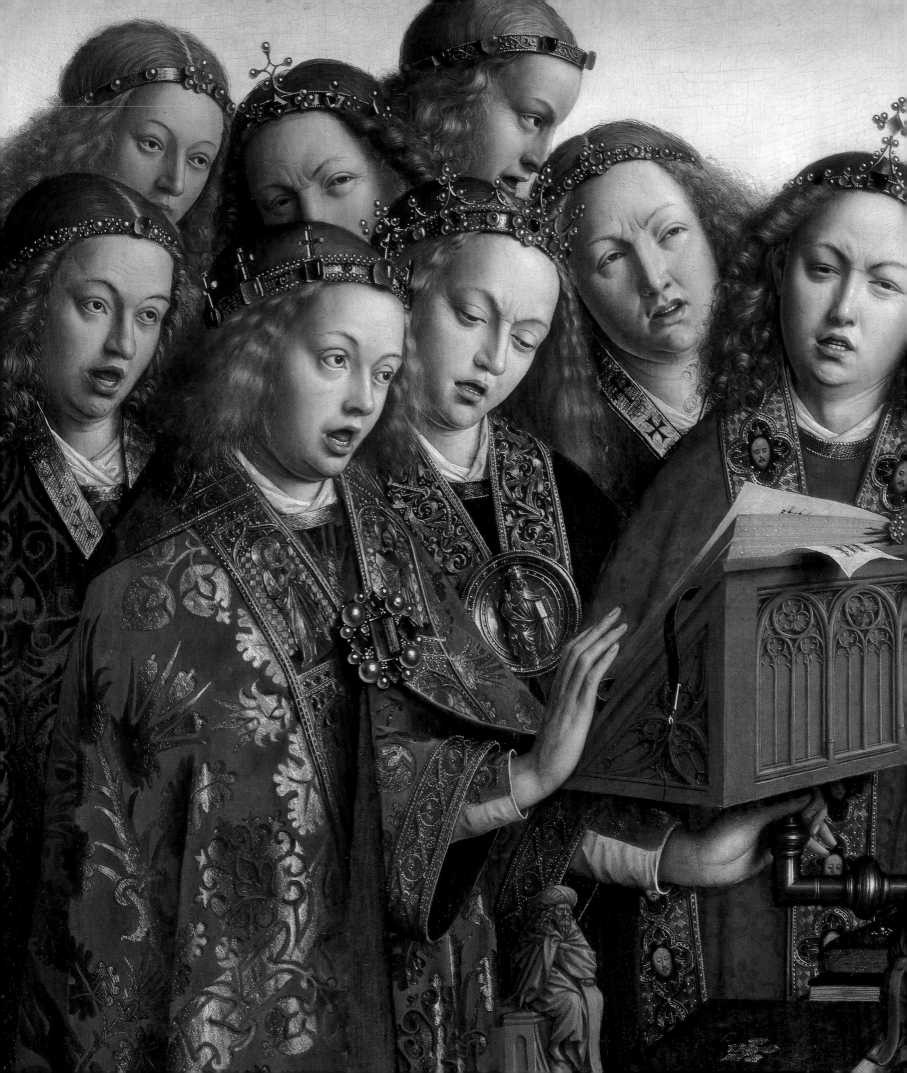

Pearl Fishing There seems little doubt that the majority of pearls seen during the Hellenistic epoch came from India.[33] It was thought that pearls larger than elephants were fished in the waters of the island of Taprobane (Sri Lanka),[34] but that many sites in India also provided excellent examples.[35] Parts of the Red Sea, particularly the islands, were home to pearls of almost the same renown as those from India.[36] The same was true of the Persian Gulf where the pearl divers were particularly able and specialized.[37] Pearls were also found in the Mediterranean Sea but they were small and reddish in color and therefore not of exceptional beauty.[38] Similarly, pearls from Britannia, according to Tacitus (b. 55 A.D.), were small and discolored. He conjectured that the inferior quality of British pearls was not a result of the works of nature, but due to the incapacity of the local pearl fishermen who, rather than open the oysters at the right time to remove the pearls, waited until the creatures expelled them naturally when the pearls were fully grown; they were therefore received when they were old and in poor physical condition.[39]

Pearl diving was considered equally dangerous for all types of pearl-bearing oysters and often the lives of fishermen were lost to dangerous dogfish when the oysters sought refuge from the divers among the rocks.[40] But dogfish were certainly not the only danger. Oysters defended their precious product strenuously, and when the diver slipped his fingers inside a shell, the oyster would close the shell suddenly cutting off the fingers cleanly and bringing about the death of the luckless man.[41] Pliny was persuaded that this was a legitimate defense,[42] while Aelian believed that such behavior was not common to all pearl-bearing oysters, just the most ferocious.[43]

It seems there were different methods of pearl fishing, depending on the writer, the epoch and the customs of the countries from which the pearls came. Oysters were collected in nets in India, including the promontory of Perimula, where the people of the Ictiophagi had devised a sophisticated technique whereby large nets were arranged in a ring around the beach to capture the local cone-shaped mollusks.[44] In the Persian Gulf, bamboo canes were used, but in those waters there was a species of oyster that resembled a crab more than a shell, so that the canes were ineffective. This oyster attached itself to the rocks just like a crab, making it impossible to free it, except by hand, but this was a dangerous business and meant risking serious wounds.[45] Aelian thought that if the oyster were thrown back into the sea once the pearl had been extracted, it would soon be ready to produce new pearls, but he added that if the mollusk in the shell died, the pearl would die too.[46]

An Object of Desire and a Symbol of Value The description by Curtius Rufus of the king of India is certainly important for an understanding of the use of pearls in contemporary Indian civilization. The king used to appear in public lying on a litter decorated with strings of pearls that hung down like small bells; he himself was adorned with pearls on his arms, above and below his elbows, and on his ankles.[47] Philostratus (170–249 A.D.) told how a statue entirely decorated with pearls "arranged in the symbolic manner of the barbarians" existed in the temple in Taxila, the Indian city that Pandea, daughter of Heracles, ruled.[48] It is interesting to note that for Indians, in addition to their ornamental function in regal etiquette, pearls had a spiritual significance linked to the celebration of a deity in a sacred area. Certainly, the admiration and incredulity of the Greeks seem to have followed from knowledge of this custom, they being the first westerners to learn of the pomp and splendor of these "barbarians" of the East. The conquest of India must have convinced Alexander the Great and his fleet that the quantity of riches taken from the Persians could only have represented a tiny percentage of the immense treasure of precious stones, pearls, gold and ivory that the latter had seen in person.[49]

But when did pearls first reach Rome? Pliny was convinced that pearls were introduced to Rome by Pompey after his victory over Mithridates, king of the Parthians (63 B.C.). His account says that Mithridates had an immense *dattiloteca*, i.e. a collection of rings set with precious stones, which, after being captured as the spoils of war, was placed in the Campidoglio by Pompey, giving rise to a new fashion among the élite of Rome.[50] Whether true or not, it is certain that during Pliny's life, pearls were established as an ornament of Roman dress; they were also objects of great interest, to judge by the space the Roman writer dedicated to them in several points of his *Naturalis Historia*. Pearls were costly and second only to diamonds in Pliny's scale of values,[51] and they were used by Indians as the principal goods of exchange in trade with the West. Western merchants were unable to stem the rise in price of pearls, such was their greed for those fascinating and exotic "rejects of the sea."[52] Some writers defined their value as equal to their quantity in gold,[53] while others felt they were more valuable,[54] up to three times more.[55]

Once pearls were extracted from oysters, they were left in clay jars and covered in salt so that the fleshy parts would rot and drop to the bottom of the jar.[56] Once this occurred, the gem from the sea was ready to become part of a prized piece of women's jewelry.[57] Theophrastus spoke of "costly necklaces" that were becoming popular in Hellenistic Greece, made more attractive by their exotic origin.[58] In the Roman world, the use of the *monile bacatum*[59] (pearl necklace) was accompanied by the custom of hanging one or more pearls from the earlobes.[60] Pliny reported the reprehensible desire of rich married women for display that induced them to wear earrings consisting of several dangling pearls so that they could hear them clicking against one another

Sandro Botticelli (1445–1510), *Allegory of Spring*, detail of one of the Graces, Florence, Uffizi.

with a sound like a rattlesnake.[61] But in Rome pearls were also set in rings and used to adorn the hands, and joined on threads and woven into the hair, as used by Lollia Paulina, wife of the emperor Caligula.[62]

Roman emperors well knew the pomp required by royal oriental etiquette on official occasions, and it fascinated them as much as it had Alexander the Great at the time of his conquest of the Persian empire. Consequently, drawing inspiration from the semi-divine character of royal investiture and from the absolute power that they wielded, the emperors of the late Roman period adopted pearls as gems that symbolized the costume of the imperial court, echoing the magnificence of the courts of the Orient. The most extravagant emperors were Caligula and Nero, of whose imperial excess Seneca (5/4 B.C.–65 A.D.), Pliny and Suetonius (69–140 A.D.) all left ample descriptions.

Seneca recounts with bitter irony the episode when, having granted pardon to Pompey Poenus, Caligula offered Poenus his foot adorned with pearls so that it could be kissed in gratitude. The acidic conclusion of the philosopher was that the emperor's foot offered to the lips of poor Pompey would have been the cleanest part of the emperor's body.[63] Pliny also wrote of Caligula's pearl-lined boots and categorized the young emperor with Nero, who had the costly habit of decorating stage masks, scepters and travel litters with pearls.[64] Suetonius tells how pearls and precious stones were included among the gifts liberally handed out by Nero during the circus games. Pearls also ornamented the casket in which the emperor placed his shaved beard when it was consecrated in the Campidoglio.[65] But it was Caligula whose excesses went furthest, when he offered his guests food sprinkled with gold and drank pearls dissolved in vinegar, confirming that being emperor meant indulging in the most extreme excesses.[66]

Numerous anecdotes from Roman authors of different periods mention the vulgar custom of dissolving pearls in vinegar as a gesture of ostentation. Horace (65–8 B.C.) wrote that the son of the actor Aesop was the first person in Rome to do so when, during a banquet, he drank a pearl dissolved in vinegar after removing it from the ear of his table companion Metella.[67] Another pearl that suffered the same fate was the one used by Cleopatra to complete her theatrical seduction of Mark Antony. She had made a wager with the Roman general that she could spend a particular and very large sum of sesterces on a single banquet. After having the most succulent and costly delicacies brought to the table, she called for a cup of vinegar, removed one of the two magnificent pearls she was wearing, threw it ostentatiously into the cup and drank. The person adjudicating the bet was afraid she would do the same with the other, and kept it as a souvenir of the event. When the Romans conquered Alexandria, the pearl was divided in two and was used to adorn the ears of the colossal statue of Venus in the Pantheon in Rome.[68] Emperor Alexander Severus also donated his pearls to the statue of Venus explaining that he did not consider it manly

Jan and Hubert van Eyck, *The Ghent Alterpiece*
(1425–30 c.), detail of *Christ Blessing*, Ghent, St. Bavo.

to own jewels.[69] For Pausanias (160–180 A.D.), the power of vinegar to dissolve pearls contained a moral message: often the basest things seem to have the upper hand over precious objects and succeed in destroying them forever.[70]

In addition to the collection of rings brought to Rome by Pompey after his victory over Mithridates, there were many pearl crowns, a mosaic set with pearls with a sundial at the top, and a portrait of Pompey's head set with pearls. It is with pungent irony that the historian writes that the aim of the general in having his portrait made was certainly not that of creating a likeness, but of exhibiting the magnificence of his war booty. Considering the tragic death of Pompey by decapitation, one might consider the portrait an evil omen.[71]

Julius Caesar also loved pearls, so much so that Suetonius insinuated with his customary malice that the purpose of the campaign to conquer Britannia was dictated by greed, as the general was convinced that the islands were home to many pearls.[72] And in fact on his return, Caesar dedicated to Venus a crown entirely set with pearls from Britannia, as he wrote in the dedicatory inscription.[73] Caesar also gave an enormously expensive pearl to his favorite mistress, Servilia, the mother of Brutus.

In Rome, Caligula's wife, Lollia Paulina, also displayed very beautiful pearls and, at a simple engagement luncheon party, she appeared literally bedecked in emeralds and pearls. These were not imperial gifts, Pliny emphasizes, but the result of the corruption of her father, Marcus Lollius. In a despicable gesture, Lollius had sold the Roman army to the king of the Parthians in exchange for gems to appease the inexhaustible greed of his daughter.[74] It is said that Lollia Paulina had a treasure of precious stones and that she owned a tunic of incalculable value made entirely from pearls.[75] Pliny's criticism of this "foolish woman" was stinging and, to show up how unfairly small were the spoils of war heroically won by the two Roman victors over the Picenti, he compares their rewards to the unrestrained extravagance of the emperor's wife.[76]

Alongside the curiosity about the pearl as an object of scientific observation and admiration of its exotic beauty, the Latin writers seemed to be unable to avoid bitter commentary on the unseemly and excessive use of pearls in Roman ornamentation, making them the *casus belli* of social condemnation. Consequently, the essence of beauty and material value, the pearl, was shifted to the moral plane and burdened with all the faults the gem was accused of by the Stoic philosophers. The thinking of the Stoics was based on the antithesis between matter and spirit, associating all value with the latter and none with the former. This was taken to the extent that anything material became an object of contempt, in particular pearls, which seemed to symbolize the quintessence of matter. That exquisitely Latin literary device, satire, frequently made use of the concept of pearls to give a negative connotation to persons or things and to underline their ephemeral nature.[77] Seneca stated that while a wise man holds all that is important to him in his head, i.e. spiritual nourishment, fools are only able to desire material objects, and so women, to him the paradigms of foolishness, are incapable of wanting anything but useless and

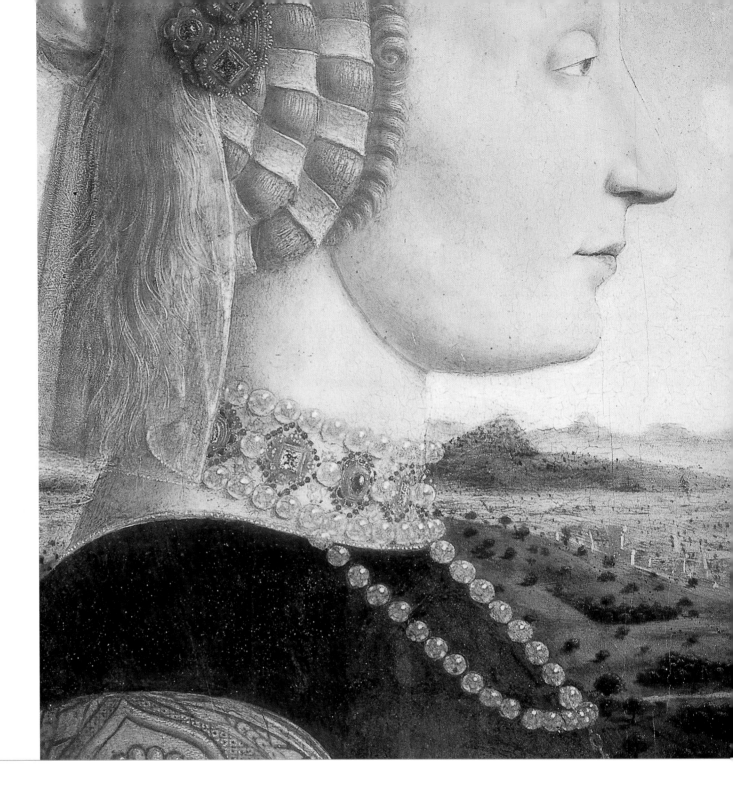

Piero della Francesca (1415/20–1492), *Portrait of Battista Sforza*, Florence, Uffizi.

uninspiring pearls.[78] According to Persius (34–62 A.D.), it is human nature that induces us to perform stupid acts such as dyeing wool purple or removing pearls from shells with the sole purpose of providing ourselves with superfluous ornaments.[79]

To the Stoic censure of pearls, symbols of culpable luxury, further scorn was heaped on the greed and stupidity of those women for whom the pearl represented the most costly pleasure.[80] Juvenal (45/65–127 A.D.) confirms that nothing was more intolerable than a rich married woman whose neck was adorned with emeralds and her ears lengthened by the weight of large pearls.[81] For Seneca too, women were the incarnation of foolishness, of which the most obvious symptom was their love of material things; this was best demonstrated by the dangling of not one, but two or three "family inheritances" from their ears. The fragile nature of these parts of the body clearly made them unsuitable to support such great weights.[82] Pliny defined pearls as "lictors of womanliness"[83] to underscore how they were preferred above all to other jewels, while Quintilianus (35/40–93 ca A.D.) described as absolutely ridiculous the custom of decking out a triumphant general with pearls and clothes with a long train as they made him appear as spineless, foolish and affected as a woman.[84] Cicero assumed a less severe tone and limited his observations to considering pearls to be as useless as rhetorical flourishes whose function is purely decorative.[85]

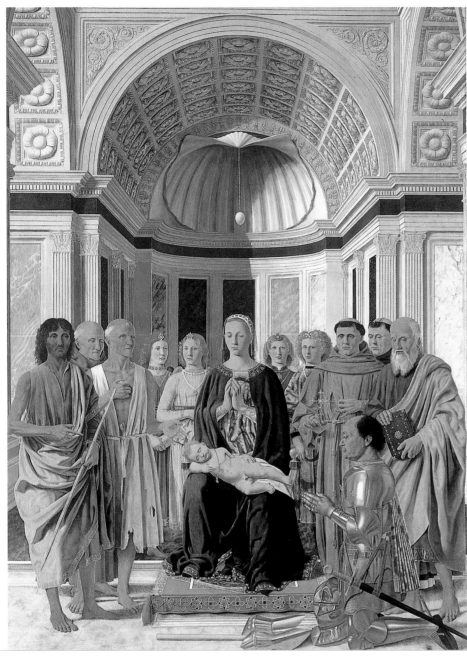

Piero della
Francesca
(1415/20–1492),
Brera Altarpiece,
Milan, Brera.

The Holy Scriptures and Their Christian Interpreters If the birth of Christ was an event of profound revolutionary consequences from a religious, historical and social point of view, in reality its effects on a philosophical and cultural level were not immediate. Instead, the new mystical outlook was accompanied by the uncertainties that are usual in the early stages of a new era, and Christianity revealed itself to have both eschatological and doctrinal ambiguities. Although enthusiastic in their desire to worship God, the first apologists did not want to accept the drastic requirement to reject centuries of the art, poetry, thought, philosophy, or even the idolatry of pagan religion. Attitudes toward the subject matter of Plinian mineralogical science, for example, were more or less equivocal: on the one hand, they did not want to accept the authority of a pagan author, but on the other, the denial of a culture that by then had become fully established created serious difficulties for those with more open minds. The teaching of poverty, moreover, caused the exegetes (the interpreters of the scriptures) to condemn precious stones as instruments of the devil used to tempt foolish women away from spiritual values with their splendor. Yet it was impossible not to perceive the creational power of God in gems or to fail to recognize a sublime manifestation of the supreme Being in such beauty. In many passages in the Old and New Testaments, gems imposed those same subtle questions of interpretation on the exegetes that all passages of the Scriptures required. Hermeneutics had to overcome these obstacles and to pose the question whether, for reasons of interpretation, it was legitimate to embrace the writings and thoughts of pagan authors or if they, and the gems they referred to, were to be excluded forever as bearing the stamp of sin. Traces of this interpretative uncertainty, or rather interpretative dualism, are found in the Holy Scriptures and are particularly clear in the passages in which pearls appear.

In his *First Letter to Timothy*, St. Paul tells his disciple that Christian women should not ornament themselves with pearls, gold or fine clothes during rites or services, but with the "spiritual ornaments" of good deeds (2–9). Pearls here remain symbols of luxury and are therefore imbued with the ephemeral and empty values linked to material riches, as were previously attributed to them by moralizing and Stoic pagan literature. St. Paul compares the precious materials that pearls represent with the good deeds he calls spiritual ornaments, and outlines the possibility that an ornament might have a dual nature: the evident one of a precious material, and the more concealed nature that alludes to moral wealth.

In the two parables told by St. Matthew that refer to pearls, the interpretation of material wealth is disregarded in favor of purely symbolic and spiritual values. In Chapter 13, verse 45, Matthew writes, "Again, the kingdom of heaven is like unto

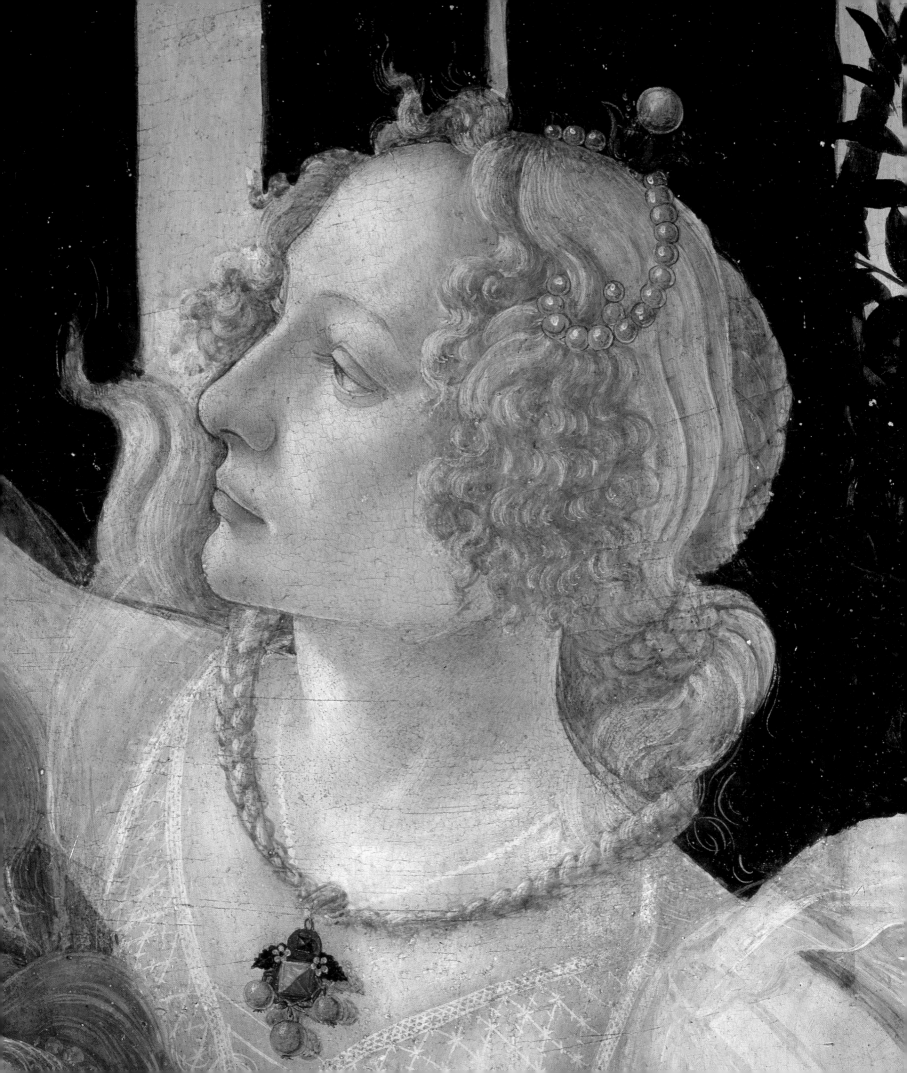

a merchant man, seeking goodly pearls: who, when he had found one pearl of great price, went and sold all that he had, and bought it." In Chapter 7, verse 6 of the same gospel, we read, "Give not that which is holy unto the dogs, neither cast ye your pearls before swine, lest they trample them under their feet." Given the spiritual nature of these messages, the pearls are given a symbolic value. But which? That was the question that the exegetes asked. Are pearls baubles to be despised or sublime symbols of a divine message? The answer seemed to be: both.

The question of female demeanor during the liturgy appears to be a merely formal problem,[1] but it is closely linked to a more profound moral question of the substitution of spiritual with material values. Clement of Alexandria (150–216 A.D.) loudly denounced those women who, in their obtuseness, give greater importance to the small product of the pearl-bearing oyster than to the wonderful beauty of the "holy stone," the word of God. He uses the words that Theophrastus had used not many centuries before, with the scientific objectivity of the naturalist, to underline the banality of the origin of the pearl and its insignificant size that do not justify such base greed.[2] Tertullian (160–245 A.D.) also referred to pearls with disapproval. According to him, the hard and round excrescence found in the oyster is similar to what can be found in the brains of certain fish and is more a defect of the creature than a quality.[3]

But the iniquity of the female instinct does not lack arguments to justify itself; thus women, incapable of going beyond the material plane, claim to themselves that there is no harm in enjoying a thing that nature and, consequently, God has generously offered. Clement of Alexandria answered these specious arguments, contending that God had freely bestowed upon Man what He considered necessary for a good and useful life and hidden what He considered superfluous. Hence, to search at the bottom of the ocean for a pearl enclosed in an oyster shell not only signified being desirous of the superfluous, but represented a subversion of God's natural order, in that man was setting himself against God's far-sighted and superior will and was therefore committing a sin.[4]

Clement of Alexandria, however, did not ignore Matthew's two parables in which pearls were instilled with an exquisitely spiritual symbolism. In the passage in his work *Pedagogo* in which he condemned pearls as being the essence of ephemeral material wealth, he was prepared to allow that they also possessed a spiritual meaning. His reasoning was that in the Holy

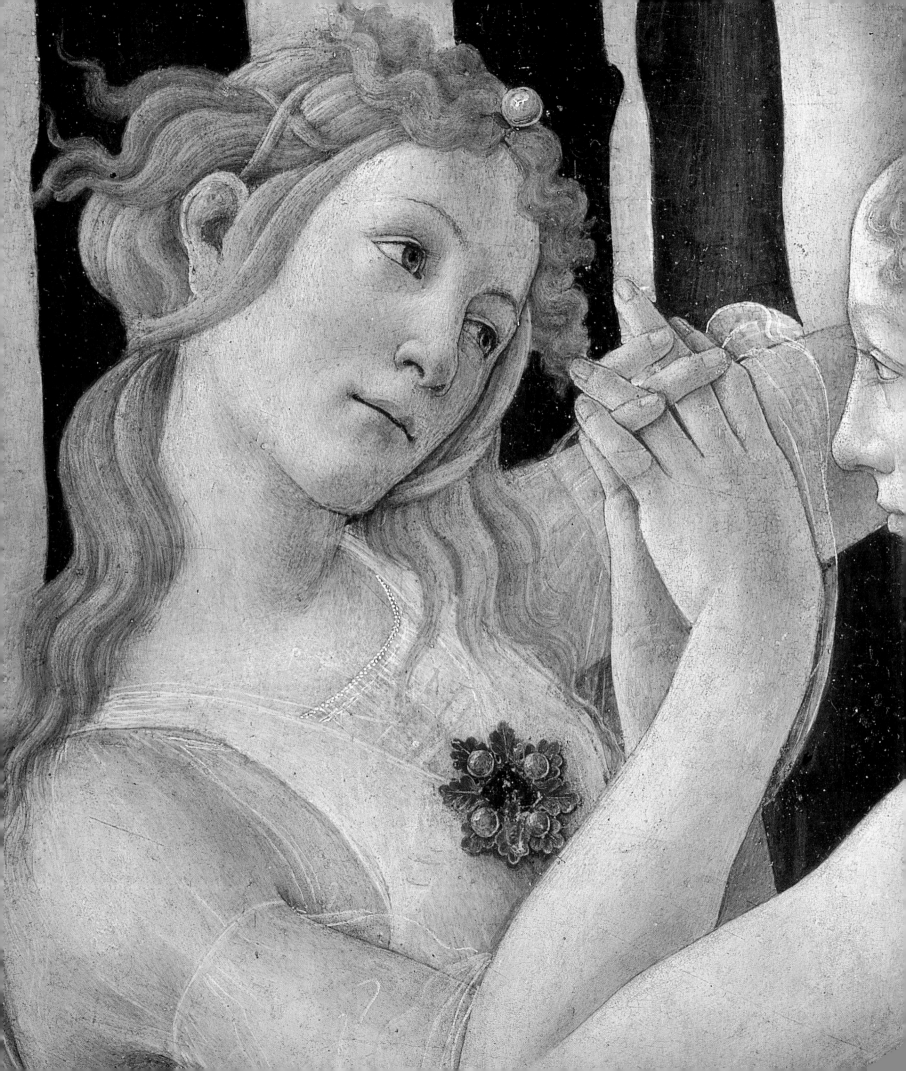

Scriptures pearls were endowed with the value of the Word of God or of Christ, and, just as Christ was reborn in the waters of his Baptism, so pearls were born inside the shell in the waters of the sea.[5]

Origen (185–255 A.D.), a pupil of Clement of Alexandria, was the author of one of the longest and most detailed commentaries on the parable of the pearl in the whole of exegetical literature in Matthew (13,45). Before beginning his commentary, Origen made a long digression on the nature of the pearl, which he compiled from a great deal of pagan literature. Though not revealing anything new, Origen's analysis created the premise for an allegorical reading that seems to encompass all aspects. The author pointed out that there are two principal species of pearls, saltwater and freshwater. The first type came primarily from India and the Red Sea and the second from India alone. Pearls existed elsewhere, however - the Bosphorus and Britannia, for example, though the pearls were of poorer quality. Created in a different species of mollusk, pearls live in colonies under the command of a leader that first had to be caught, if divers wished to capture the entire colony. Origen even reported the legend of the fertilization of the oysters by heavenly dew, without substantial modification from the pagan sources, but he engaged in a detailed interpretation of all later information from the angle of Christian mysticism.

According to Origen, Jesus knew the difference between the different species of pearl and so, in the parable in Matthew (13,45) when He used the words "goodly pearls," Jesus was alluding to the teachings of those who had been able to understand the word of God and was contrasting them with "dark and stained pearls," the symbols of the clouded and confused arguments of heretics. For Origen, the "goodly pearls" in Matthew's parable had a second meaning: they represented the prophets, or the Old Testament, while the "beautiful pearl" for which the merchant sold all the others was none other than Christ, or the New Testament. And thus Origen created a sort of contrast between the Old and New

Testaments in which the "fragmentary" doctrine of the Old Testament (plural: goodly pearls) was a necessary passage for comprehension of the Christian message, but at the same time would pale before the power and the depth of the "unitary" teachings of the Gospels (singular: beautiful pearl). To the Greek exegete, the message of the parable was that the Old Testament should not be ignored; on the contrary, it should be studied and absorbed for its precognitive value and in order to provide greater understanding of the New Testament.[6] The pearls, therefore, were a metaphor for the Holy Scriptures.

The *Physiologus*, a Christian bestiary written between the second and fourth centuries in the same Alexandrian milieu as the works by Clement and Origen, dedicated an entire paragraph to the interpretation of the nature of pearls. In this work it is the technique with which pearls are fished that constitutes the basis for interpretation of the allegory. The work relates that pearl fishermen used an agate tied to a cord to extract pearls from the sea; when the agate was lowered, it spontaneously headed toward the places where oysters hid. According to the *Physiologus*, fertilization of pearl-bearing oysters took place at the same time by means of the dew and light, whether from the sun, moon or stars. This assumption was the hinge around which the interpretation revolved: the agate represented St. John the Baptist, as it shows us the pearl just as the Saint had showed us Christ; the sea was the world; the fishermen the prophets and the two valves of the oyster shell symbolized the Old and New Testaments. Similarly, the dew, the sun, the moon and the stars represent the different mystical faces of the Holy Spirit that permeate the two Testaments and fertilize them with divinity. Finally, the pearl is Christ the Savior for whom "the good merchant is prepared to sell all his goods."[7] Medieval exegetic literature, therefore, imbued pearls with a new spiritual dimension that elevated them from their diabolical role as symbols of material wealth to symbolize Christ Himself, a value that they maintained throughout the Middle Ages.

Without changing this reading very much, Ugo da San Vittore (d. 1141) made a subtle and careful interpretation of Matthew's parable (13, 45) particularly in regard to the origin of pearls. Analogous to the rise of the oyster shell from the bottom of the sea to be permeated with the heavenly dew, so Mary arose from the house of her father to go to the Temple, where she received the word from the archangel Gabriel; and as the shell was made pregnant by the morning dew,

Mary conceived Christ through the Holy Spirit during morning prayers. But the analogies between the oyster shell and Mary do not stop there, for in the same way that the shell opens to receive the dew, so Mary opened her mouth to pronounce the words "Ecce ancilla Domini" (Here is the Lord's maid) and receive the Holy Spirit. Similarly, the mollusk in the open shell is touched by the rays of the sun and fertilized.[8] But, as often occurred in medieval allegorical parlance, the "pearl of great price" in Matthew's parable slowly took on different meanings in addition to its Christological value, according to the use to which it was being put. For example, in the homilies of Macarius of Egypt (ca. 300–390), pearls are referred to as ornaments to be worn by the nobility only when the right to do so is granted by the king, in the same way that the pearl of the kingdom of Heaven can only be granted by the Son of God.[9] In this case, the pearl represents the kingdom of Heaven which only Christ can dispense. Yet such a clear distinction between the goal and the means for achieving it is not delineated, since the only way to obtain eternal life according to the doctrine of the gospels is to follow the teachings of Christ.

In his commentary on Matthew's parable, Albertus Magnus (1206–1280) dwells at length on the meaning of "goodly pearls." He said that only those pearls that are beautiful by color, nature and effect can be defined as such. The color must be silvery like the moon that symbolizes knowledge. Unique among the animal world, the oyster conceives the pearl chastely, using the light of the moon and the dew of heaven, which confer upon it celestial virtues since, like the saints, the oyster receives divine truth from heaven. The result is the pearl, a gem capable of rendering the body chaste and sober, of comforting the heart and the spirit, and of opening the mind to the understanding of the Holy Scriptures.[10]

Returning to the New Testament, the pearls in Matthew's parable in chapter 7, verse 6 also seem to conceal spiritual concepts of intense doctrinal and theological importance, and they too offered much food for thought to the exegetes. In the interpretation of Tertullian, the pearls become symbols of the Sacraments,[11] while Gregory of Nyssa (321–396) stated in *De virginitate* that if virginity was considered correctly, it was a precious condition worthy of God but when the rest of the individual's behavior did not accord with this excellent state, its value was lost and virginity was like a "pearl thrown to the pigs."[12] In his *Sermo in Monte Domini*, St. Augustine (354–430) considered pearls representative of everything that contains great spiritual value, though this

value, perhaps hidden within some allegory, may not be recognized by everyone.

The pearl lies enclosed on the seabed, and it is only possible to see it when it has been retrieved and extracted from its oyster.[13] Other medieval exegetes have identified the teachings of Christ with the pearls in the parable,[14] while to Albertus Magnus, they were worthy symbols of the precious contents of the Holy Scriptures.[15]

In a passage from the Book of Revelations, St. John depicts Babylon, the infernal city guilty of all vices, as a prostitute richly adorned with pearls (17, 4). On the other hand he describes Jerusalem as a heavenly city whose foundation stones are studded with a multitude of different types of precious stones, while the "twelve gates were twelve pearls" (21, 21). The literary model for John's description seems to have been that of celestial Babylon in Mesopotamia, in which precious stones were also used in an analogous symbolic meaning.

Another site in the Mesopotamian civilization may have influenced John's apocalyptic vision: the image of Paradise as a splendid hanging garden of the type that adorned the ziggurats, in which the trees were entirely composed of sparkling gems.[16] The revelations made using these two images—one celestial and the other infernal—appear to propose the dualism that was seen in the Christian symbolism of the pearl as both a precious material and therefore a symbol of worthlessness, and an emblem of the highest spiritual and theological concepts, as well as of Christ himself. They were shown by John as being both an ornament of Babylon, the mother of all whores, and of Jerusalem, the heavenly bride. The gates of heavenly Jerusalem were also the object of exegetical analysis and interpretation. Clement of Alexander considered the twelve pearls to refer to the apostles because of their number and because the apostles, like the pearls, shone with divine grace.[17]

Many exegetes emphasized the correlation of the numbers in this interpretation and added that each face of the city walls represents a virtue: Prudence, Fortitude, Justice and Temperance. Shining with virtue, the apostles would welcome the saints into the heavenly city from the four corners of the world, symbolized by the four sides of the city walls.[18] Other exegetes believed that the biblical description lent itself to two possible interpretations: if each gate were made from a single pearl, the pearl-apostle association would be valid, but if there were only one pearl, whereas there were twelve apostles, then the pearl would once more be a metaphor for Christ. If the description meant that the twelve pearls were used to decorate each of the gates, then the resultant total would symbolize the multitude of saints.[19]

St. Peter Damian (1007–1072) pointed out the unusual coincidence of the number of pearls with the number of gems on Moses' breast plate described in the Book of Exodus (28, 15–20) as a square ornament on which were set four rows of three gems, making twelve different stones in total. In a cabalistic analysis of the distribution of the gems, he believed that the gems might be arranged in the same manner on the gates of heavenly Jerusalem. If this were the case, he could with greater reason attribute the pearls with the symbolic value of the apostles, by which he meant those that had preached the Trinity in the four parts of the world.[20] Exegetic analysis of the Book of Revelations, however, often ascribes to pearls the more general symbolism of holy men who have been enlightened by faith in the ineffable pearl that is Christ himself.[21]

The apocryphal Acts of Thomas tells a disquieting parable that centers on the search for a pearl. A young man of royal descent set out for India one day from Egypt, carrying with him a stock of precious stones. His goal was to find a pearl that lay on the bottom of the sea, protected by a dragon that spat flames. The prince knew that he could only return to his

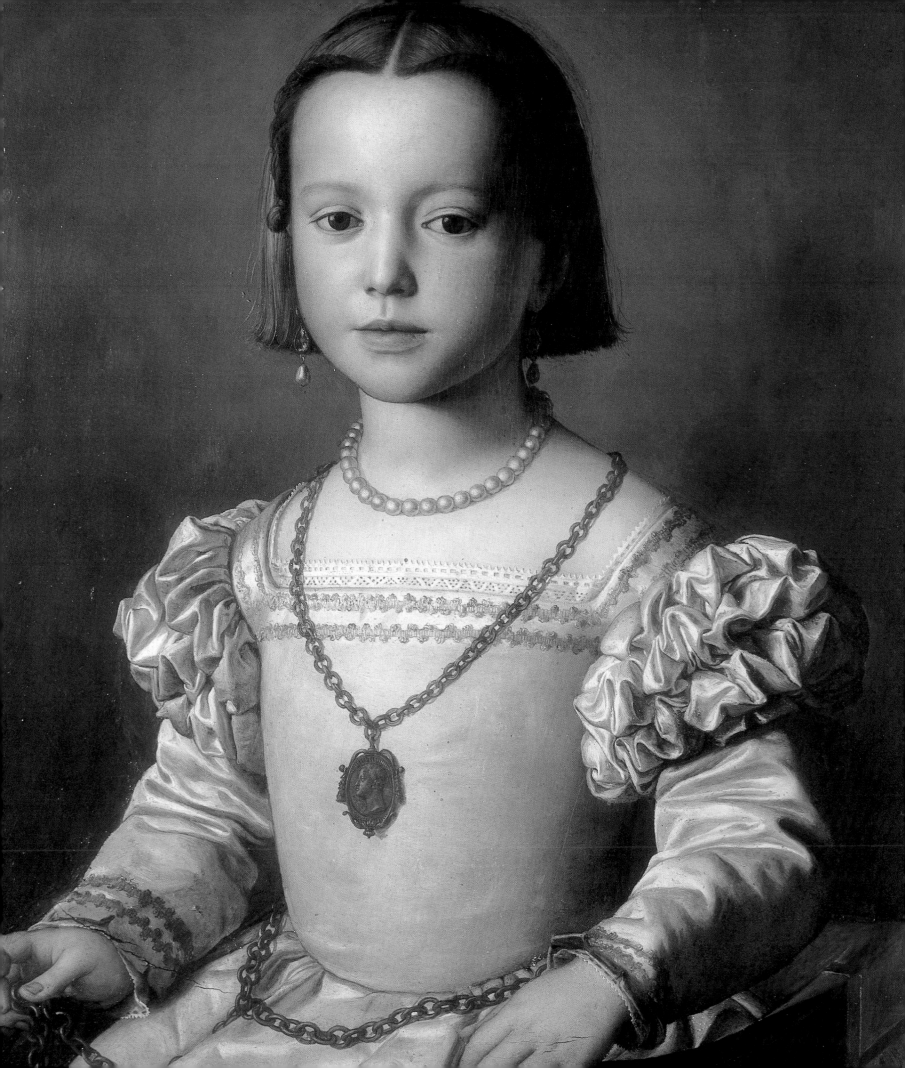

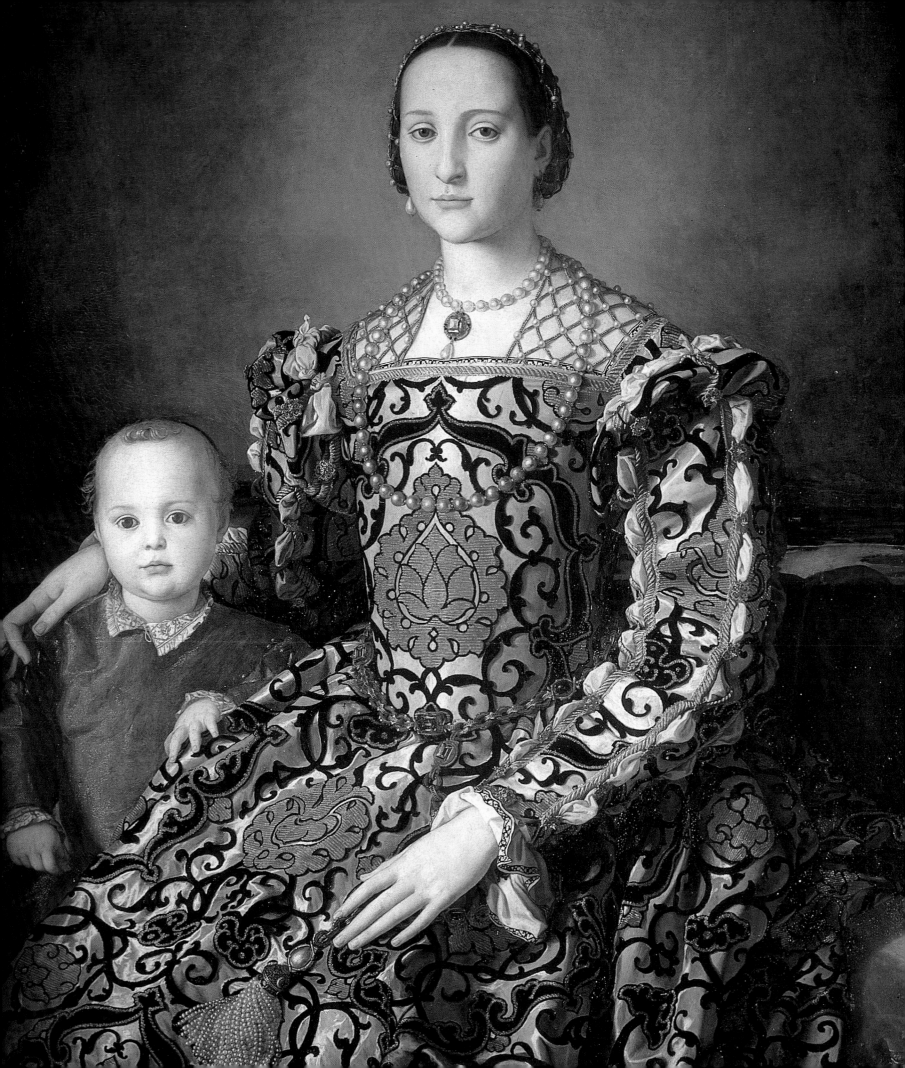

homeland and divide his kingdom with his brother if he were successful in his quest, but the prince had astute enemies. They succeeded in lulling him into a sleep so deep that he forgot the purpose of his expedition. The parents of the prince came to hear of the trap he had fallen into and decided to send him a letter by means of an eagle. In the letter, they begged him to abandon his mission and return home. Woken rudely from his sleep by the eagle with the letter, the young man realized how he had been duped and tried to pass his sleep to the dragon that guarded the pearl by reciting the names of his father, his brother and his mother in what was almost a magical chant. He was successful and the dragon fell asleep, offering no opposition to the prince's seizure of the splendid pearl. The prince was then able to return to Egypt, ready to assume the reins of power and rule his kingdom.[22]

In this interesting story, the pearl assumes two meanings, just as the figure of the prince is also charged with a double symbolism. He can be interpreted either as representing any human being engaged in the search for the Christ-pearl, or as Christ himself who, with the help of his father, saves the human soul-pearl redeemed from original sin through his word.

St. Ephraem Syrus (306–378) dedicated a great deal of space to discussion of pearls in his homilies, of which nine were entitled *On Pearls*. In all of these, he endowed pearls with the symbol of Christ. There are various analogies in the characteristics of the small gem and the Savior, starting with the fact that, being spherical, it has only a single face and, like the Truth, it is indivisible. The pearl represents light and purity just as these are attributes of God, but Ephraem also saw the Church, the immaculate daughter of Christ, in purity. Christ was God's only son, just as only one pearl is found in an oyster. Being symbolic of Christ, pearls were a favorite argument used by Ephraem to oppose the Nestorians with whom he carried on an unresolved theological debate. The Nestorian heresy stated that Christ had in fact been two different persons

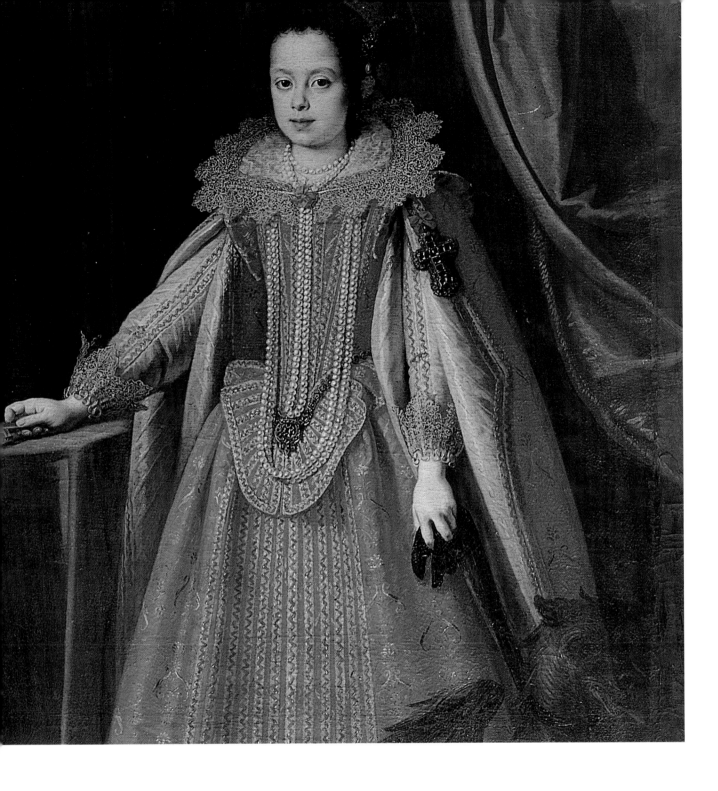

Justus
Sustermans
(1597–1681),
*Vittoria della
Rovere*,
Florence,
Palazzo
Martelli.

rather than a single figure with both a human and a divine nature. To counter this thesis, Ephraem held that two different natures existed in Christ, one derived from his human mother, Mary, and the other from his divine father, God, just as a pearl is a "daughter" of the earthly oyster and the divine dew.[23] Ephraem recognized that pearls were precious, material stones that were tangible evidence of the existence of a spiritual "heavenly pearl,"[24] and that in their function as ornaments for diadems, they were capable of attracting pagans who were ignorant of this double nature. Pearls also presented an analogy with the word of God, as they adorned the ears exactly as the word of God was perceived through our sense of hearing.[25] As such, pearls should never be given to poor women, since their material worth would eclipse their symbolic value, while if given to a rich woman, they would better retain their spiritual significance.[26]

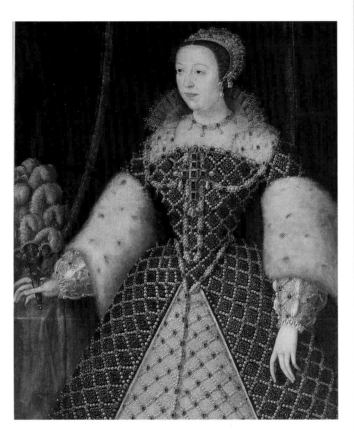

François
Clouet
(1510 c.–1572),
Portrait of
Catherine de
Medici,
Florence,
Galleria
Palatina.

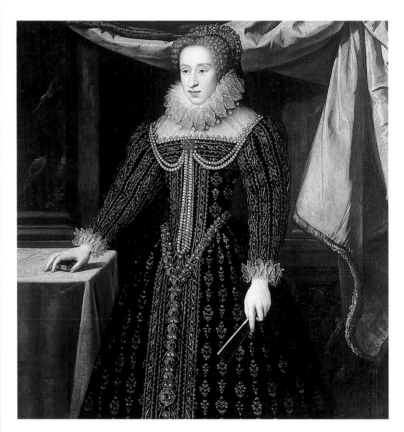

Unknown
Florentine
(17th c.),
Portrait of
Claudia di
Lorena,
Florence,
Uffizi.

Medieval Encyclopedias Whereas commentaries on the Holy Scriptures made use of many topics from classical mineralogy, tinting them with the colors of mysticism and translating them onto the spiritual level by means of metaphors, symbols and allegories of the sacred, another literary genre existed that seems to have absorbed pagan gemology unmodified: the encyclopedia.

Encyclopedism was the most characteristic product of pagan culture; it was, in fact, the most refined fruit of the eclectic curiosity of the Hellenistic world and posed the first Christians with an embarrassing dilemma: if it was necessary to do away with every form of idolatry to express their faith in absolute purity, what should they do with pagan culture? Was it a dangerous instrument of the devil or a valuable body of knowledge that, once amended, could also be used in theology?

At the start of the Christian era, debate arose on the legitimacy of applying a Christian interpretation to classical writings, on which the theologians of the early Christian church had been educated. Judaism influenced by Hellenism was favorable. Its arguments in favor of encyclopedic knowledge were based on the commendation in Solomon's apocryphal *Book of Wisdom* (7, 17–21), while early Christianity's suspicions of the allurements of knowledge were based on *Ecclesiastes* (3, 21).[27] The question was whether to take advantage of pagan culture as a valuable body of knowledge, or to outlaw it completely for the support it offered the digressive forces of *vana curiositas*, i.e. useless and profane curiosity.

In the fourth century, St. Augustine resolved the question in his second book of *De doctrina christiana* by inviting Christians to make use of all texts from profane culture in the exploration of the Word of God.[28] Augustine's thinking profoundly influenced Christian culture and in particular those curious literary products, encyclopedias.

So the principle of *reducere ad unum*, i.e. tracing everything back to its Creator, underlying biblical exegesis was extended to the production of encyclopedias. The structure of classification of the perceived world used in medieval encyclopedias reveals the same desire to achieve a

spiritual redemption of material beauty, otherwise considered an ephemeral illusion of the senses that would lead one astray from the true path to divine knowledge. And what could better represent material beauty than gems? In many cases, gems received substantial treatment in medieval encyclopedias and pearls were given special attention.

A reply to the thinking of Augustine was given in the *Etymologiae* of Isidore of Seville (560/570–650 ca), the first medieval encyclopedia that was prompted by the pastoral need to elevate the cultural level of monks and clerics. Isidore started from the conviction that by knowing the etymology of a word, one would be able to understand its meaning more fully; thus, the Latin word *margarita* (pearl) was derived from *maris* (sea), its origin.[29] Information regarding pearls in Isidore's work was taken from the pagan works of Pliny and Solinus, without the inclusion of any religious symbolism. On the other hand, Rabanus Maurus (780–856), abbot of the monastic school of Fulda, dedicated a great deal of space in *De Universo* to the symbolic reading of gems and pearls in particular. He too, considered the pearl a symbol of Christ, as did commentators in works on the Holy Scriptures.

Marbodo of Rennes (who worked between 1067 and 1101), the author of a descriptive work on precious stones, limited himself to repeating standard ideas about pearls, but it is worth emphasizing that so much diligent compilation had the merit of enormously diffusing the culture of lapidaries (descriptions and discussions of gems), even if they did not add anything new on the subject of pearls. Marbodo's work *De gemmis* was translated into nearly all European languages within a few years of its composition.[30] In the French and Latin prose versions a few lines were added below the section, common to all versions, on the pharmacological use of pearls for curing problems with the eyes.[31]

Interest in the pharmacological use of pearls was a novelty for late-medieval treatises, and the space dedicated to the gem's mystical nature was reduced to include material on its possible beneficial effects on certain physical afflictions. Belief in the therapeutic and magical properties of gems was as old as humanity itself and is known to have been extant in Mesopotamia and Egypt, but the treatises written in cosmopolitan and Eastern-influenced Alexandria had already moved toward the more scientific Greek approach to classical mineralogy. The first systematic considerations of the pharmacological use of pearls, however, appear to have occurred in the encyclopedias of the Middle Ages. What, then, had happened?

During the period between the end of the twelfth and the fifteenth centuries, many forgotten literary treasures of ancient Greek culture, which had reached the Byzantine and Arab cultures but had not progressed further, were translated into the Latin of the medieval West. Thus the works of ancient Greece, which had been rediscovered as the original source of all wisdom and knowledge, were brought back into western culture.[32] It was customary during the Middle Ages to refer all knowledge to an authoritative source and to create false references if they did not really exist. This was particularly the case with scientific literature: though it did not necessarily have to contain anything new, a book on medicine or one that was generically scientific had to be a distillation of wisdom based on proven remedies.

Giuseppe Arcimboldo (1527–1593), *Water,* **Vienna, Kunsthistorisches Museum.**

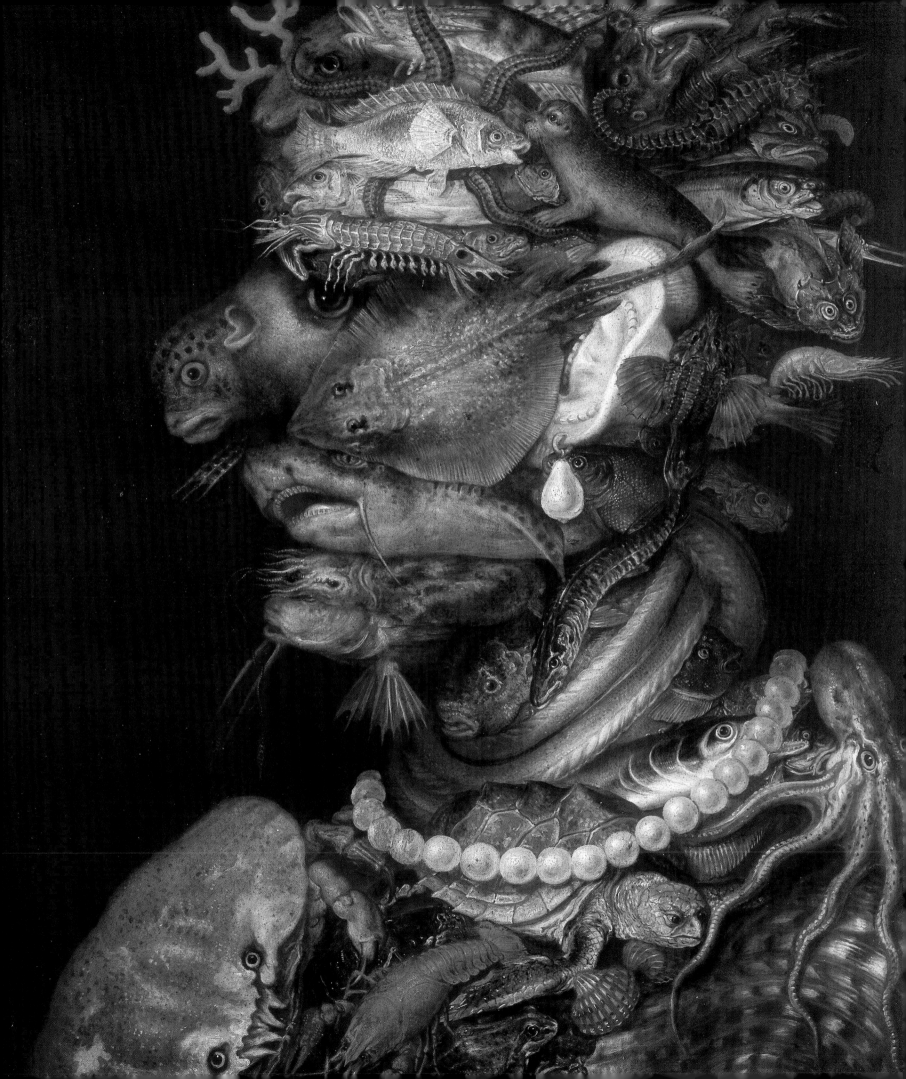

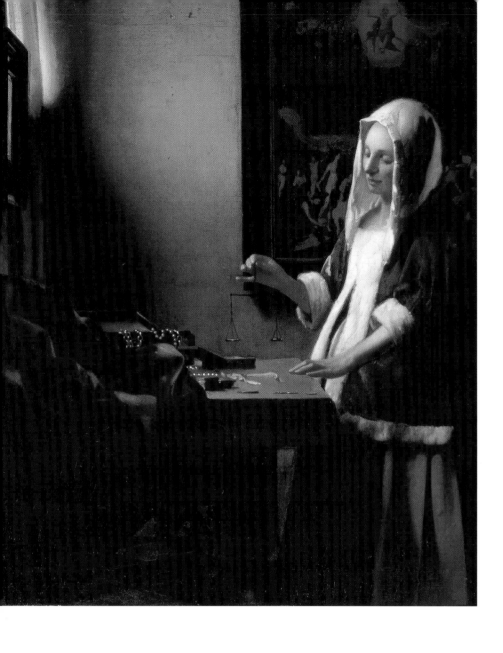

Jan Vermeer
(1632–1675),
*A Woman
Weighing
Pearls*,
Washington,
National Gallery
of Art.

44

Consequently, the encyclopedias written during this period contain many references to authentic or non-existent sources, often searched for in vain by philologists, like the famous text on mineralogy by Aristotle cited by Albertus Magnus and Vincent de Beauvais (d. 1264), the existence of which has never been certified. Thomas of Canterbury (1201–1270), who was the pupil of Albertus Magnus, Bartholomaeus Anglicus (1190–1250) and Alexander Neckam (1157–1217), the adopted brother of Richard Lionheart, and Vincent de Beauvais, the preceptor at the court of Louis IX of France, were all authors of encyclopedias that appear to be no more than compendiums of previous works,[33] but which include some interesting novelties when compared to the works of Pliny, Solinus, Isidore, Dioscorides and Aristotle. For example, Bartholomaeus Anglicus states that pearls were the most beautiful of all gems and expresses the conviction, originally presented in *De simplici medicina* by Platearius, that some were perforated in nature while others were bored by man. Bartholomaeus describes some of the therapeutic uses of pearls, for instance, that they had the virtue of providing comfort, or of removing excessive humidity in a limb due to their astringent properties, for which they could also be used in cases of unexpected hemorrhage or diarrhea. They also were thought to be effective in cases of weakness and to counter cardiac arrest.[34] Thomas of Canterbury held that one of the virtues of pearls was their ability to restore harmony and, when broken up and compressed into a pill, to combat weakness of the stomach though, if worn whole, could confer good health to both mind and body and make the wearer chaste. Take note, however! Only white pearls worked in pharmacology, while darker versions had no pharmacological properties.[35] For Vincent de Beauvais, one of the many powers of pearls was their capacity to heal insidious epilepsy.[36]

Albertus Magnus, theologian, scientist and pupil of Thomas Aquinas (1225/27–1274), was the author of numerous scientific treatises in which the contents often got separated from the Aristotelian treatises on which they were written to provide commentaries. His work *De mineralibus* arose from the need to complement Aristotle's treatise on the subject which was considered incomplete. Indeed, the Greek only wrote thirty or so lines on gems in his work *De meteorologia*, although a separate treatise on the subject has been lost. The *De mineralibus* by Albertus contains many ideas and personal observations. He states that in addition to the traditional countries from which pearls came, it was his opinion that both Germany and Flanders could be added, since he himself had found pearls in his mouth when eating oysters from those regions! He also described the morphology of oysters and pearls and dwelt on their pharmacological properties, some of which were their abilities to alleviate breathing difficulties, to cure heart attacks and, once again, epileptic crises, hemorrhages and diarrhea.[37]

A single chapter that has been handed down to us under the name of Alfonso X (1223–1284), the king of Castile, merited an unusual treatise in the thirteenth century. At the time, the court of Castile was culturally influenced by the Arab renaissance in the south of the

country and this curious treatise seems to confirm that fact, as the authors of the twelve parts that composed the work were Arabs. Of the two schools of treatises in the Arab culture in the thirteenth century—the Hellenistic school of magical-astrological treatises and the scientific-Aristotelian school comprising Greek medical works—the treatise of Alfonso X was unquestionably one of the first sort, even if certain influences of the second are evident. The work dedicates a sizeable space to pearls, which it refers to as *Aliofar*, and which astrologically is assigned the eleventh degree in the sign of Aries. The author of the section on Aliofar, Abolyas, defines pearls as "hot and dry" and by so doing confirms a dependence of mineral classification on Aristotelian science. The dew that fertilizes the oyster is carried by the north wind and the sun illuminates the stone in the oyster when it opens to receive nourishment. For Abolyas, pearls are not born round, but become so as they are dragged by the waves for long distances before reaching their destination. To the Arab author, the pearl was also the most beautiful and precious gem and, as such, was only appropriate for use by the nobility. Its beauty is completely natural, and it would not be possible to make it more perfectly round even using a lathe.[38] It also had extraordinary healing powers for problems of cardiac arrest, tachycardia, melanchony and cowardice, as it purified the blood of the heart which was the prime seat of these conditions. Physicians put it in potions used to cure infirmities in general, as its therapeutic properties were so varied, but it was also ground to a powder to cure eyes of excessive lachrymation. Sniffed in powder form, it cured headaches by causing a particular movement of the nerves in the eyes. To dissolve a pearl to liquid form, it should be closed in a jar with vinegar and buried for fourteen days in damp dung. Its healing powers were at their greatest when the stars were in a certain conjunction.[39]

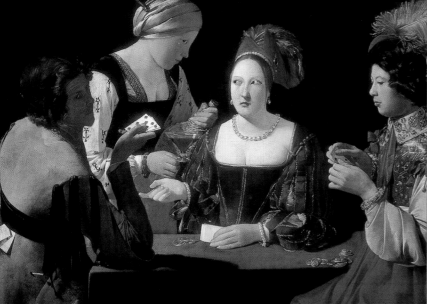

Georges
de La Tour
(1593–1652),
*Cheater with
the Ace of
Clubs*, Fort
Worth, Kimbell
Art Museum.

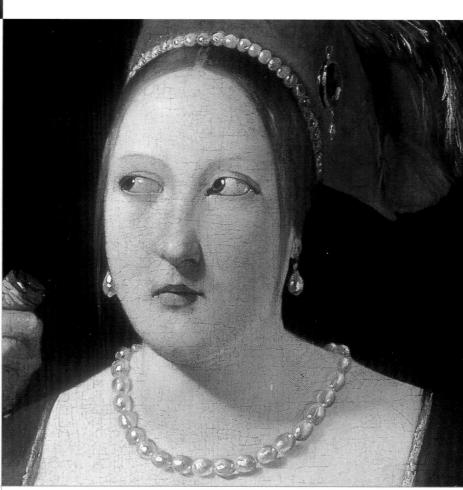

Georges
de La Tour
(1593–1652),
*Cheater with
the Ace of
Diamonds*,
Paris, Louvre.

47

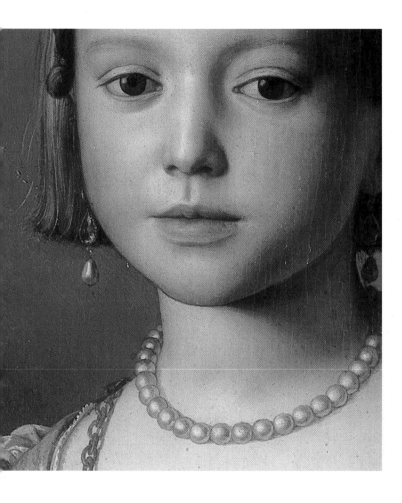

Alchemical Treatises Exegetic and encyclopedic literature were not the only genres to discuss gems and pearls. A deep-rooted network of somewhat exotic interests flourished during the Middle Ages; these were rarely documented, as they were often difficult to reconcile with orthodox religion, but this did not mean they were any the less taken to heart. Alchemy was one of these interests. When it first came into being in Alexandria in the first century A.D., it was presented as a scientific-empirical discipline with the aim of falsifying metals and precious stones. Soon, however, it gave its practitioners the illusion of being able to transform base metals into gold, using the philosopher's stone, and of finding the elixir that would be a remedy for all ailments and so grant eternal youth.[40]

In the ninth century, a letter between two figures of massive historical and cultural importance was "refound" that was destined to influence medieval science: it was written by Alexander the Great to Aristotle on the marvels of India and requested the philosopher to send two thousand scientists around the world to discover new topics of study.[41] Whether the find was true or simply a pretext to give the letter a degree of authority, it is certain that a pseudo-Aristotelian *corpus* of treatises was created around the letter, including the *Secretum Secretorum*. This was a book of alchemy,[42] translated into many languages,[43] which dedicated a large section to philosopher's gems.[44]

A version of the *Secretum Secretorum* printed at the end of the fifteenth century contained a brief entry on precious stones. Here pearls are separated into three qualities, red, yellow and sandy, which can be used without distinction to heal leg tumors either set in stones or hanging around the neck. Red pearls, however, especially when set in a ring, had the power to strengthen the heart of the wearer. If a lion were to be engraved, the wearer would then be granted the strength of the animal, greater wisdom, greater respect from his fellowmen and would be aided in achieving his goals.[45]

Agnolo Bronzino (1503–1572), *Portrait of Bia de Medici,* **detail, Florence, Uffizi.**

The alchemical subject matter of *Secretum Secretorum* provided the foundation for Thomas Aquinas' treatise on the philosopher's stone, in which he declared his conviction that precious stones had hidden properties that were typical of the heavenly bodies. That did not mean that they were made of the same substance as the stars, but that they possessed the same heavenly properties of the four elements (fire, earth, air and water), as well as sharing a little of the quintessence (fifth essence). Pearls too were endowed with these properties: on one hand, they had some of the characteristics of the heavenly bodies, on the other, they shared some of the quintessence, i.e. a property found in all matter that had qualities of eternity and healing powers, provided that the quintessence was extracted from the material using the correct alchemical process.[46] John of Rupescissa (14th c.) went so far as to claim that the quintessence of gold and pearls was able to free man from the devil and so allow him to enjoy all the pleasures of paradise.[47] Paracelsus (1493–1541) also dedicated notable space to the quintessence of pearls and said that it was normally represented by the color of the pearls; on this theme, he introduced another alchemical concept, the so-called "magisterius" which was the capacity of each inanimate substance to be transformed into another with the addition of a part of the latter. Paracelsus dedicated an entire chapter to the manner in which magisterius should be extracted from precious stones, corals and pearls which, from the latter, would be effective in strengthening the body.[48]

Pearls were also involved in the alchemical research of Raimondo Lullo (1233/35–1315) whose main occupation seemed to be the production of false ones. With Arnaldo de Villanova (1235–1313) and Roger Bacon (1214–1294), he was the instigator of a real renaissance in alchemy in the thirteenth century. The Catalan's writings included numerous prescriptions for the fabrication of precious stones in general and pearls in particular.[49] The author of one manuscript, Pietro Boni, asserts his conviction that whoever followed his advice would produce pearls more beautiful than nature could.[50]

Another manuscript, written by Agnolo Della Casa in the early seventeenth century, provides valuable evidence of the developments in Lullian alchemy during the Renaissance. In the chapter dedicated by Della Casa to the creation of small and large pearls that seem Oriental, he details the procedures required to achieve a good result, provided the alchemist has the shrewdness to complete the experiment by forcing a pigeon that has been denied food to eat the resulting compound. It will later have to be extracted from the bird and placed in the bladder of a fish, then heated, but not over a high flame, which will make it turn yellow.[51] That the passage of pearls through the digestive tract of a pigeon beautified them was a common belief, and Gerolamo Cardano (1501–1576)[52] and Andrea Baccio (16th c.),[53] physician to Pope Sixtus V, offer similar suggestions. In the second half of the seventeenth century, Francesco Redi (1626–1698), chief physician to the Grand Dukes of Tuscany and a member of the Accademia del Cimento, debunked this theory definitively when he said, "Four baroque pearls weighing twelve grains in total in the gizzard of a large pigeon were reduced to four grains in twenty hours; And eight other pearls, that weighed thirty grains in the gizzard of a similar pigeon, in two days were reduced to twenty grains; We therefore see the fine reward indicated by those who instruct that pearls swallowed by pigeons return to their ancient splendor and increase in price."[54]

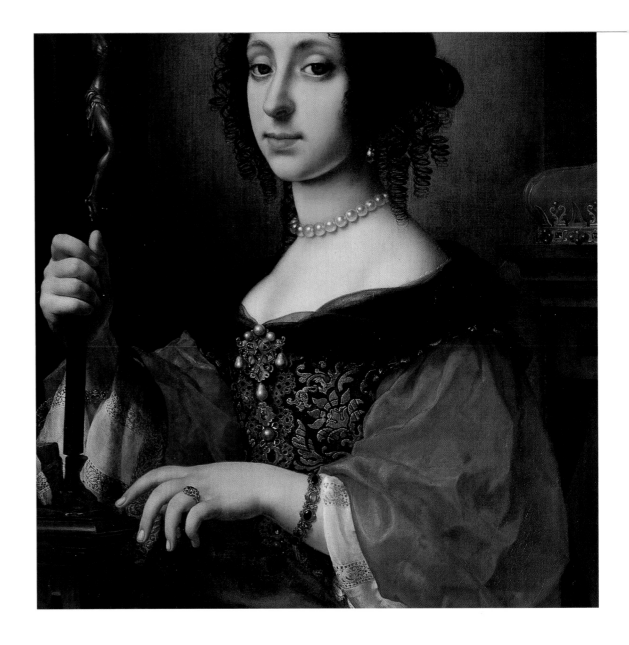

Carlo Dolci
(1616–1686),
Portrait of
Claudia Felicita
Dressed as Galla
Placidia,
Florence,
Galleria
Palatina.

Renaissance Occultists, Doctors of the Body and Soul Alchemy and pharmacology had been very closely related during the Middle Ages, and the plague of 1348 gave a strong boost to medical treatises written during the previous century. For example, the astrologer John of Eschenden (d. ca. 1379) and the Parisian theologian and astrologer Henri of Assia (1325–1397) were convinced that gems were valid antidotes to the plague.[1] The concept that gems, like herbs, were a part of pharmacology was not new, and they were regularly used to cure illnesses. But what were the principles that gave rise to the belief that gems and pearls could benefit health? Pietro da Abano (1253–1316) thought that their powers lay in their capacity to attract the influences of the planets onto those people who wore or ingested them.[2] Arnaldus Villanova, the founder of the Schola Medica Salernitana, stated his belief in the powers of stones[3] and asserted that gems existed to which nature granted extra powers if images of the constellations were engraved upon them.[4] In his work *Antidotarium*, one of the prescriptions he included was *Diamargariton* which, consisting of drilled and undrilled pearls, had the power to strengthen the heart if administered to patients suffering from heart complaints and, when given to patients suffering from depression, was able to raise their spirits.[5] Antonio Guainerio (15th c.) was the author of a tract on the plague and one on poisons, another frequent cause of death; he was convinced that gems and pearls had a strong influence that was derived from their relationship with the planets,[6] and he recounted a curious anecdote on this subject. A king learned that one day a certain child of royal descent would be able to wage war on him. In an attempt to avert such a possibility, the king sent the boy a saddle studded with precious stones in patterns that reflected the position of the planets on the boy's birth chart so that their powers would exert a state of peacefulness in the rider.[7]

The idea that pearls and stones bore the talismanic and curative powers of the planets was present in the medical writings of the thirteenth and fourteenth centuries, and during the Renaissance, figures of importance offered confirmation. What had occurred for such beliefs to exist? During the fifteenth century, the custom of referring to ancient literature that had begun a hundred years earlier took increasingly stronger hold. The idea that the past had been superior to the present lay at the base of Renaissance thought, and it was therefore necessary to refer to ancient wisdom to regain their lost "golden age."[8] Whereas physicians and alchemists had busied themselves during the previous century with re-establishing the concepts of Alexandrian science (which the medieval West had set aside), in the hope of finding the miraculous panacea for all ills, their efforts were redoubled in the fifteenth century and further supported by the new enthusiasm for philology.

In Florence a cultural elite flourished that enthusiastically welcomed Neoplatonic philosophy, with which it had come into contact on two separate occasions: in 1439 on the occasion of the ecumenical council that took place in Florence between the Church in the West and the Church of the East, and in 1454 when, following the fall of Constantinople, many Byzantine philosophers came to the city, bringing with them the "sacred texts" of their culture. In 1460, in this climate of ancient wisdom, a manuscript was brought from Macedonia to Florence that contained fourteen of the fifteen books of the work *Corpus Hermeticum* and the treatise entitled *Asclepius*. Produced in the Hellenistic-Alexandrian philosophical environment, the Corpus Hermeticum consisted of a series of dialogues between various speak-

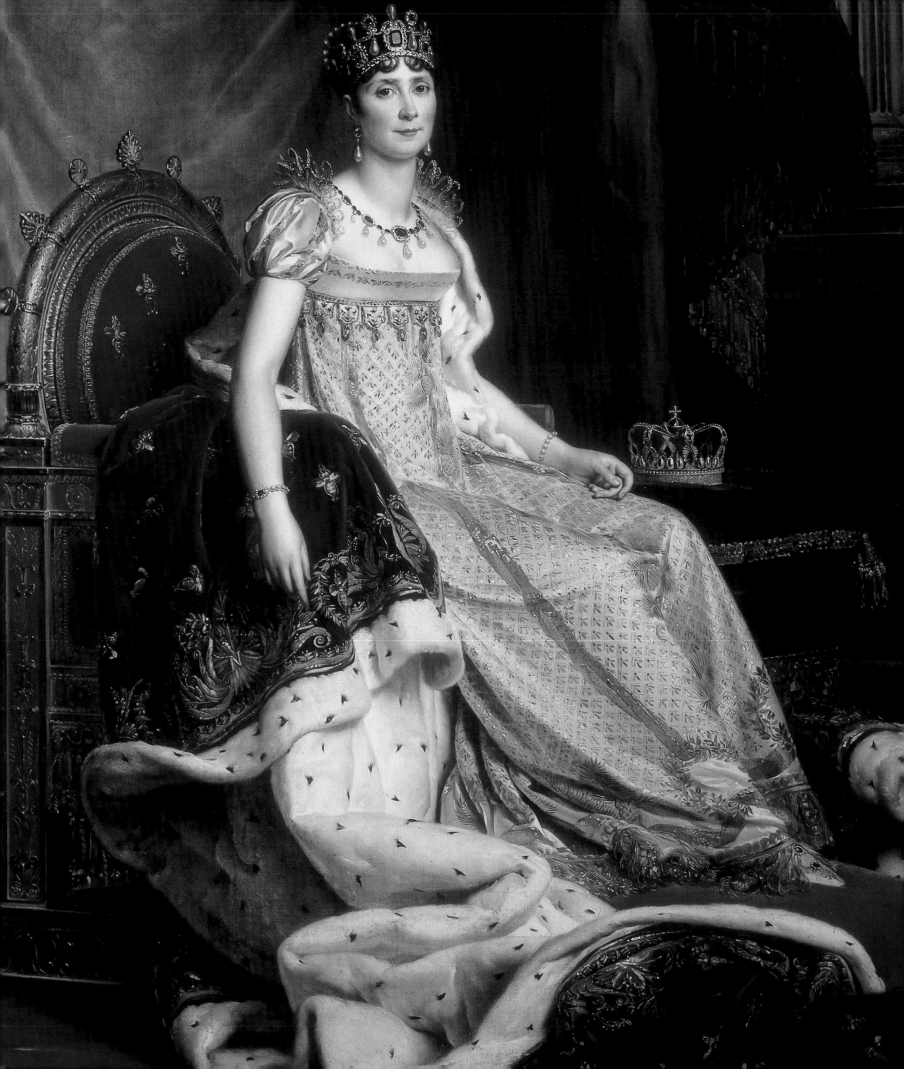

ers and the legendary figure of Hermes Trismegistos (Hermes the Thrice Greatest), bred from a hypothetical fusion of the Egyptian god Thoth with the Greek god Hermes. After the vicissitudes suffered by these works during previous centuries, they received their definitive redemption when Marsilio Ficino (1433–1499) was given responsibility for their translation for the benefit of the members of the Accademia Neoplatonica.

So much curiosity revolved around the manuscript that Cosimo the Elder charged Ficino with the translation of the *Corpus Hermeticum* before starting on the works of Plato, which also awaited his attention.[9] The contents must have been fascinating, because this previously almost unknown source provided support for the belief of the therapeutic and apothropaic powers of gems and, above all, support for the relationship between gems and the planets. Ficino, however, did not just translate it but used it as material to develop his own work, *De triplici vita*.[10] The passage in the *Corpus* in which the words of Hermes seem to resemble the contents of the Book of Genesis were used by Ficino to support the idea that occult practitioners were themselves prophets and, therefore, to use their writings as a source was not a culpable offense in the eyes of the Church.[11] In this manner, Ficino sidestepped any possible accusation of impiety that might have followed his use of the ancient and authoritative text. Ficino stated his conviction that the ancient sages did not use talismans and gems to evoke devils, but to gain a greater understanding of the nature of existence and of the degrees of the perception our world has of ideas.[12] The third book of *De triplici vita*, written in 1489, was dedicated to the king of Hungary, Matthias Corvinus, and was essentially a medical text based on the astrological supposition that everything received powers from the stars, precious stones included.[13]

In conformity with Neoplatonic theories, Ficino divided the world into three parts: the intellect, the spirit and the body. The intellect of the world was the seat of ideas, the body represented matter and the spirit was the magical and evocative power that linked the heavens to the earth. Within this context, the magical, curative and talismanic power of stones (part of the spirit of the world) was derived from the planets, and the stones themselves (part of the body of the world) were able to transmit the effects of the planets to human beings.[14] In the work *Theologia platonica*, Ficino had already declared how the powers of precious stones were determined not just by their shape, but also by their composition and by a particular influence transmitted from the spirits of the stars themselves. Nonetheless, the stones were still very close to

the level of matter, as the powers they possessed were of a physical nature and were transmitted to entities in the living world despite being drawn from heavenly bodies (10, 5).

In Ficino's tract, pearls, along with silver, crystal and marcasite, were one of the substances able to transmit the astral influences of the moon to the terrestrial world.[15] The association of pearls with the moon was based on color, luminosity, shape and general appearance and this dependence was also to be seen in another treatise, the *De occulta philosophia* by Cornelius Agrippa Von Nettesheim (d. 1535), though his opus centered on magic. Professor of Hermetic philosophy at Pavia and a commentator on Ficino's writings, Agrippa was responsible for a wide diffusion of Neoplatonism in Germany, where he was also investigated as a practitioner of the occult.[16] There were many similarities between his treatise and the work of Ficino; for example, the division of the world into elemental, celestial and intellectual parts was maintained, each of which received the effects from the level directly above, so that the powers of the Creator descended from Heaven via the angels to the intellectual world, then to the stars in the celestial world, and from there to the components of the elemental world.

It was Agrippa's belief that occultists might be able to reverse this process by attracting onto themselves the powers of the world above, so that they could then manipulate the world on the level below them. The means by which one could discover the powers of the elemental world were medicine and natural philosophy, while for the celestial world they were astrology and mathematics and, for the intellectual world, the study of religious ceremonies and their liturgy.[17] In the first of the three treatises, the gem-planet association represented a strengthening of the powers of the stones by means of a process of sympathy-antipathy in which the planets were the *quid medium* that transmitted the influences of the world of ideas to the material world.[18] This process of sympathy-antipathy was based on the association of each element with the four categories of stones, metals, plants and animals (which corresponded to earth, water, air and fire).[19] Some of the stones, however, were particularly linked to earth for reasons of morphology and genesis, while others had a strong link with water, air or fire, and the principle was also true for the categories of metals, plants and animals. These four elements were never found on the Earth in a pure form,[20] but they did exist on the planets[21] and even in God himself. Each planet was linked to an element.[22] One part of the natural properties of gems was determined by their being composed of certain elements, but other properties, the hidden ones, depended on the associations with the planets which, in turn, were the quid medium between the world of ideas and the world of matter.[23] The "sympathetic chain" of associations was sometimes determined by form or species, and at others by being a member of a group that shared a common element.[24] The sympathies and antipathies between celestial bodies and elements were reflected directly onto bodies at a lower level and they, in turn, tended to establish identical and reciprocal relationships.[25]

Pearls, like other gems, were part of these principles of natural Hermetic magic. Aggripa Von Nettesheim restated the concept that pearls, formed in shells following fertilization by dew, depended on the moon along with other white, green or transparent stones.[26] The therapeutic capacities offered by this association were traced back to the chain of sympathies and antipathies that existed between stars and their earthly projections. Like other substances and living creatures, man, his physical organs and his physiological functions were also subject to astral influences under an identical universal law. For example, the moon affected the overall well-being of the body, its limbs, brain, lungs, spinal marrow, stomach, menstruation, excrement, left eye and the ability to grow in association with the phases of the moon.[27] Consequently, as small extracts of the moon, pearls were recommended to patients suffering from ailments linked to these organs and functions. Andrea Baccio affirmed that pearls offered some benefit to all,[28] while their influence on the brain was certain, according to Anselm Boezio De Boot (mid-16th c.–1632),[29] gemologist to Rudolf II of Hapsburg, who also proposed a certain criticism of traditional Plinian concepts that had not previously been aired.[30] The effectiveness of pearls in curing lung problems had already been expressed by Arnaldus Villanova, who prescribed his *Diamargariton* in the cure of asthma.[31] Baccio and De Boot also claimed the effectiveness of this preparation in the treatment of consumption and alleged that pearls were efficacious against hemorrhages.[32] In light of these astrological considerations, the reasons why pearls were included in medieval and Renaissance pharmacology are far less mysterious than might have been thought.

Giovan Battista della Porta (1535–1615) suggested that the lunar stones should be mounted in silver, so that they could more easily capture the moonlight and its related powers, as silver was a lunar metal.[33] Andrea Baccio had no doubts that stars had a direct influence on stones and that they were able to confer supernatural forces on them. If, he

claimed, sunlight was represented by gold, then pearls represented the purest concentrate of moonlight, and this was confirmed by the fact that their growth corresponded to the phases of the moon. Consequently, pearls formed during the waning of the moon were small while a waxing moon would favor their development and they would become both large and beautiful. Even the conditions of the sky, according to Baccio, would affect the quality of pearls: if the sky were cloudy or stormy, they would grow to be dusky and stained.[34] Baccio's lapidary was explicitly connected to the medieval symbolic tradition and in it he stated his belief that pearls, being created by the heavens, were endowed with celestial properties and powers and were therefore able to bestow the gift of serenity upon their wearer.[35]

Camillo Leonardi (end 15th–beginning 16th c.) was the author of a lapidary dedicated to Cesare Borgia. In it he described those strange pearls formed by various mixtures of elements so compact that only by holding them up against the light could they be identified, in what was the first explicit mention of a baroque pearl.[36] He, too, took up the distinction first used by Albertus Magnus between pearls "perforated by nature" and those drilled by man and considered the question of which of the two species was made of the better material. He resolved it by saying that in his opinion the substance of which a pearl was made could not be based on a hole. He felt certain that pearls could cure quartan fever and, when dissolved in milk, that they were able to heal wounds. In Renaissance lapidaries, one frequently comes across claims, taken from medieval sources, that pearls were beneficial in treating cardiac ailments and that they could cure epilepsy and render their wearer chaste.[37]

In his work from the early seventeenth century, *Gemmarum et lapidum historia*, Anselmo Boezio De Boot considered the true formation and nature of pearls for the first time. On the one hand, he showed he believed in the pharmacological effectiveness of pearls, but on the other, he refused categorically many concepts of classical mineralogy. For example, he denied that pearls could be born inside a shell as a result of a celestial power and argued that the mollusk was the only cause of its generation.

De Boot did not believe that a pearl in water could have a different consistency than one out of water and considered Baccio's theory of the growth of the pearl in relation to the phases of the moon to be without foundation.[38] But his interest in precious stones must have been mainly technical, since he dedicated a large section of his chapter on pearls to the manner of evaluating them and to goldsmiths' techniques

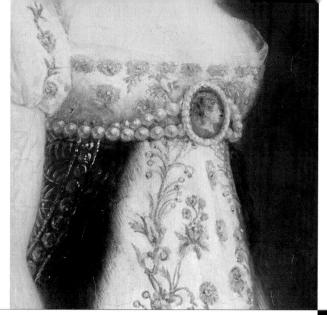

Elisabeth
Vigée Le Brun
(1755–1842),
Portrait of
Maria Carolina,
Queen of
Naples, details,
Versailles,
Musée National
du Château.

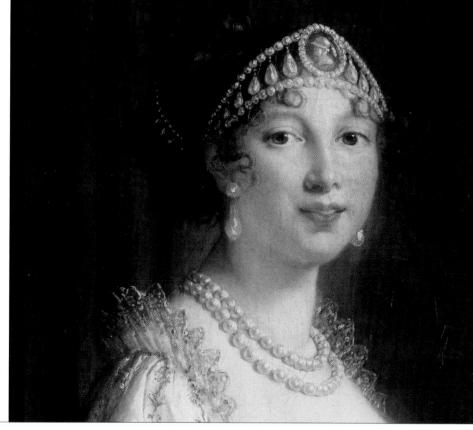

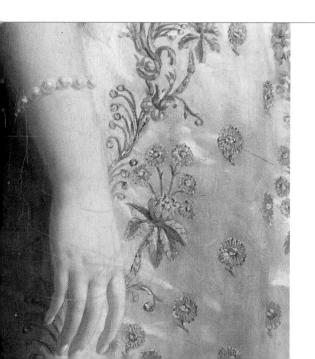

Eugène Delacroix (1798–1863),
Women of Algiers in Their Apartments, detail, Paris, Louvre

for their use in jewelry.[39] De Boot's distrust of the legends that had arisen around the nature and origin of pearls was the first inkling of a change in approach. In 1717, de Reaumur, a member of the *Academie de Science*, discovered the scientific truth of pearls by observing pearl-bearing oysters on the coasts of Provence. He established definitively that pearls were formed inside the animal in the exact manner in which kidneys produce gallstones and that oysters, solidly attached to the rocks, "ne peuvent pas s'élever jusqu'à la surface de l'eau pour recevoir la rosée" (cannot reach the surface of the sea to get the dew).[40]

With the formation of experimental science, symbolic and fantastic interpretations of natural phenomena died out, slowly but inexorably, and literature on gems took a technical and scientific turn that relegated all the legends, beliefs and symbolism associated with precious stones to literary and poetical works.

Pearls in the Diaries and Letters of Travelers The sixteenth century was the age of great geographical discoveries and journeys. These were the result of developments in shipbuilding techniques and the natural outlet for the commercial ventures that were replacing the exhausted feudal economies of Europe. One of the fundamental reasons that prompted the Spanish crown to finance geographic ventures of this nature was the search for new mineral resources, both of precious metals and precious stones, but the journeys also triggered an interest in the new flora, fauna, foods, spices and gems in countries that had never been explored, or which had remained completely unknown. The extensive literature composed of travel logs and letters written by the pioneers of these geographical discoveries around the end of the fifteenth and the start of the sixteenth centuries also provides interesting information on pearls.

Pearls are referred to even in the earliest written descriptions of the most adventurous voyages. Christopher Columbus's travel log (1446/1451–1506), written during the trip on which he discovered Cuba and Hispaniola, is one such example. Columbus wrote that it was the *Indios* that he had picked up on an earlier layover that claimed that Cuba was rich with gold mines and pearls, and he was able to confirm the existence of pearls when he found a large number of empty shells on a beach.[41] From Hispaniola, he wrote to the Catholic monarchs that he had been welcomed by the indigenous people who wore pearls on their arms and that, on being asked, they had informed him that the pearls were fished on the northern side of the island.[42]

Amerigo Vespucci (1454–1512) was received in the same manner. In his letter of July 18, 1500, to Lorenzo di Pierfrancesco dei Medici, he wrote how the natives had given him and his crew a number of small pearls and eleven large ones, and that they had indicated with signs that would procure others in the days to come.[43] A year later, Vespucci wrote to say he had met a certain Guasparre, who had spoken to him of the kingdom of Perlicat (now called Palikot to the north of Madras) in India that was rich with gold, pearls and other precious stones, and that Zilan (Ceylon, now Sri Lanka) was also similarly blessed. Vespucci was so impressed that he believed the country referred to must be the mythical Taprobana mentioned in ancient sources. However, another island, Scamatara (Sumatra), was rich with the same materials and Vespucci later felt that it was more probably the true Taprobana.[44] Whether Taprobana was Sri Lanka or Sumatra, it is certain that in the sixteenth century, pearls and other precious objects from both places were destined for Persian and Arabian markets.

Another navigator, Giovanni da Empoli (1483–1517) wrote to his father during the first decade of the sixteenth century, referring to many parts of India in which it was possible to find pearls, including Cape Comorin and Sri Lanka.[45] During the same epoch, an Italian jeweler from Brescia, Cesare Federici (1530 ca.–1600 ca.) who traveled for purely commercial reasons, confirmed da Empoli's claims. He described the manner of pearl-fishing, which each year began in March or April and lasted seven weeks, as the divers moved from site to site. The best swimmers went ahead to reconnoiter where the oysters were most heavily concentrated, then basic necessities were provided to the rest of the divers. Anyone was allowed to dive for the oysters, provided they pay a certain sum to the king of Portugal and to the church of the fathers of St. Paul, as all the divers in the area had been converted to Christianity. A cord tied with a stone was thrown into the sea and a man swam down it with a basket attached to his left arm. He filled it as quickly as possible with all the oysters he could collect, then swam back up the cord to the boat, where his companions pulled him on board. It was then the turn of the next man. In the evening, each diver piled his oysters in a heap and left them until the oyster inside died, before opening the shell. Many oysters, of course, contained no pearl. When the fishing season was over, the merchant caste divided the pearls into four groups according to their quality and established the price of the pearls. Sale of the pearls was based on negotiation. Federici concluded his report with practical advice on navigation in this zone of the Indian Ocean.[46]

In his work *Giro del mondo* (1699–1700), Francesco Gemelli Careri (1651–1725) referred to the islands of Minar and Tetucorin off Zeilan (Ceylon) as being rich in pearls. Divers there were obliged to pay a certain levy to the Dutch, who had by then dispossessed the

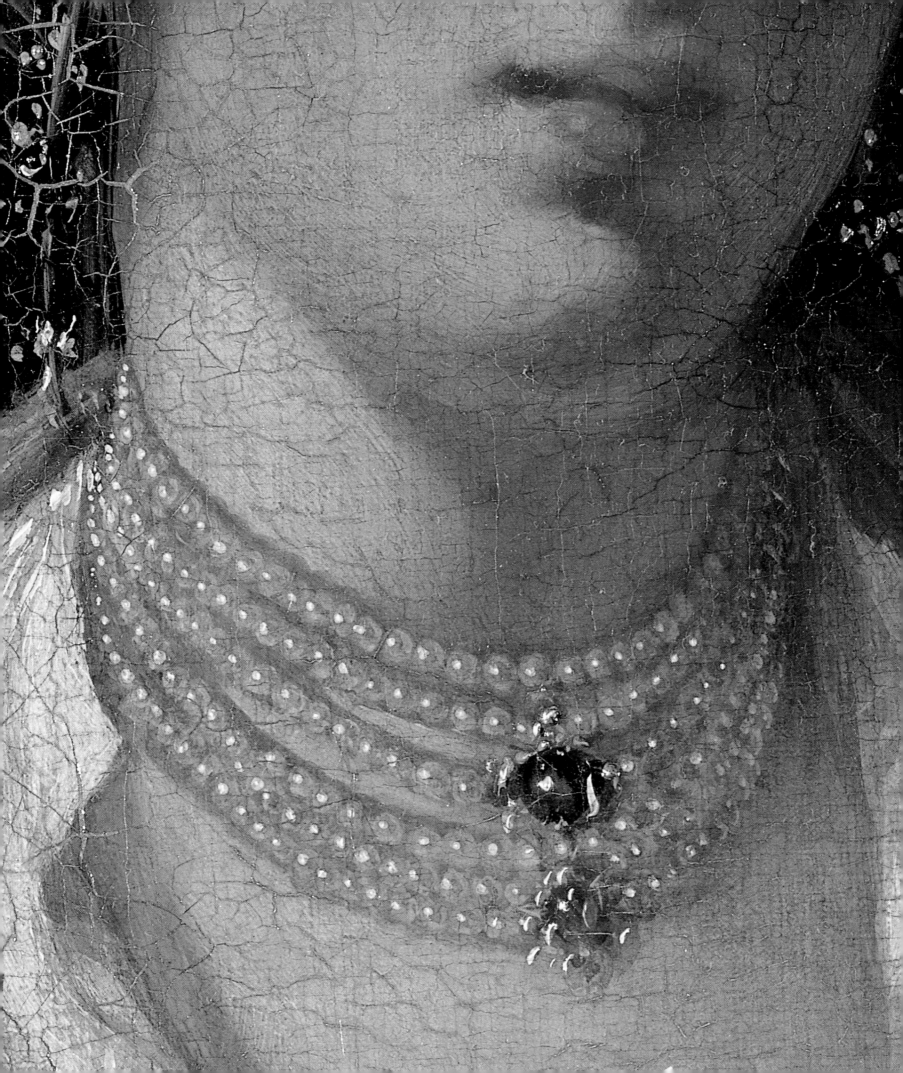

Portuguese of the islands.[47] Francesco Carletti (who traveled from 1594 to 1606), in his *I ragionamenti del mio viaggio intorno al mondo*, dedicated to Don Ferdinando dei Medici, the Grand Duke of Tuscany, gives a similar description of pearl fishing, but claims that the Portuguese bought the best pearls and left those of inferior quality to the locals.[48] Speaking of Goa in India, the same author described the clothing and ornamentation of the women. Around their necks they wore pearl necklaces and gold chains but they also pierced their ears in two places, one above the other: they generally wore a diamond or a ruby in the upper hole and a pearl pendant in the lower.[49] In the royal kitchens at Goa, the so-called "royal food" was prepared, which consisted of a mixture of "meat of cooked capon, first boiled then roasted, sliced very finely and then pounded with almonds, sugar, amber, moss, ground pearls, rose-water and egg yolks, a blend that while it nourishes, also incites the worship of Venus."[50]

As in the times of ancient Greece and Rome, the Arabian Sea was spoken of in the sixteenth century as a sea where pearls were plentiful. Giovanni da Empoli wrote of Giulfar, later Cormus (Hormuz) on the coast of Oman to the west of Cape Musandam, "where large and small pearls are found in great abundance."[51] The island of Baaren (modern Bahrain, in vassalage to Hormuz) in the Persian Gulf was similarly favored,[52] and this was later confirmed by Andrea Corsali (who traveled between 1515–1517), in a letter to Lorenzo di Pierfrancesco dei Medici, the Duke of Urbino. It is interesting that in the Map Room in the Palazzo Vecchio in Florence, in the position of the island of Baaren there is written in a sixteenth-century hand, "Here, pearls are fished"!

Another traveler to speak of the Persian Gulf was Giovan Francesco Gemelli Careri. He recounts that diving for pearls took place twice a year: March through April and August through September. But according to him, pearls were created in a manner very different to ancient beliefs. He stated that a pearl was not generated in the shell by heavenly dew, as the oysters remained at a depth where it was impossible for the dew to reach them. As far as the number of pearls that a shell could contain, he wrote that seven or eight had been found in a single shell, though they were not of great size. It was, however, true that pearls were not found in all oysters since it was possible to open many without finding a single one.[53]

Da Empoli said that pearls could even be found in China,[54] and Corsali specified that the best places were Cathay and certain islands in Greater China.[55] This statement was confirmed by Gemelli Careri, but he added Japan to the list and reported that pearls were fished there haphazardly as the locals did not consider them to be of value.[56] He also wrote that the Philippines were rich with pearls but that the local people were not interested in diving for them. The coast of California would be full of them if those uncivilized locals would stop cooking the oyster which ruined the pearl inside. There were also pearls in Mexico, particularly off Acapulco, but of very poor quality even if Mexican women wore them anyway. They were also to be found along the coastline of Peru and Panama but not of the same quality as those found in the Orient.[57]

Mottoes and Emblems: Pearls in Personal Devices The symbolic values attributed to pearls during the Middle Ages shifted from the sacred dimension of mystical literature to the profane dimension in the private and symbolic world of intellectuals and aristocrats in the sixteenth century. The choice of an emblem, a coat of arms or a motto was prompted by the desire to identify oneself not just through one's lineage, but more importantly as an individual aware of one's historical, social, cultural and religious uniqueness. Numerous texts appeared in the sixteenth century that published emblems and mottoes, often taken from the heraldry of the kingdoms of Europe, but also containing those created by philosophers and thinkers. One particularly interesting publication for the wealth of material included and for the elaborateness of its general layout was the *Mundus Symbolicus*, published in Italy in 1669, in which its author, Filippo Picinelli, analyzed devices and badges for the benefit of those who were searching for, or wishing to create, their own. A long section was devoted to pearls. The Latin mottoes that accompanied the iconography of the pearl oyster on occasion highlight one or more of its symbolic aspects: for example, *Clarescunt aethere claro* draws attention to how the generation of the pearl, which depended more on the conditions of the sky than those of the sea, symbolizes the importance of one's origins since the quality of children depends on the virtues of the parents. The beauty of a pearl is also derived exclusively from the heavens as represented in the motto, *Solo aethere gaudet*, which symbolizes the spirit of the contemplative individual who, weighed down by earthly worries, turns his gaze to the heavens in search of a solution to his problems. A virtue of the pearl is that it does not absorb any nourishment from the sea, despite being immersed in it, and so the motto *Nil maris exugit* or *Nil ab aequore sugit* would be understood as a metaphor for a man who remains honest even when surrounded by crooks. Pearls lose their paleness in sunlight, so that *Sub sole rubescit* is explained on the spiritual plane by Picinelli as a symbol of those who preserve their moral purity by remaining distant from public life. The motto *A rore colorem* on the badge of Giusto Lipsio means that, just as the pearl takes its color from the dew that "fertilizes" the oyster, so everything excellent bears the mark of the heavens. *Nullus ab arte decor* suggests how the characteristics of pearls are only derived from nature, implying that female beauty should be without artifice. A string of pearls accompanied by the motto *Pretium de matre relicta* was the device assigned to Cristina of Sweden after her death; the metaphor in this case was that as a pearl only acquires value after it has been removed from its shell, the queen of Sweden only gained eternal life after renouncing the Protestant faith and abandoning her homeland.

François Gerard
(1770–1837),
Portrait of the
Empress
Josephine,
detail,
Fontainebleau,
Musée National
du Château.

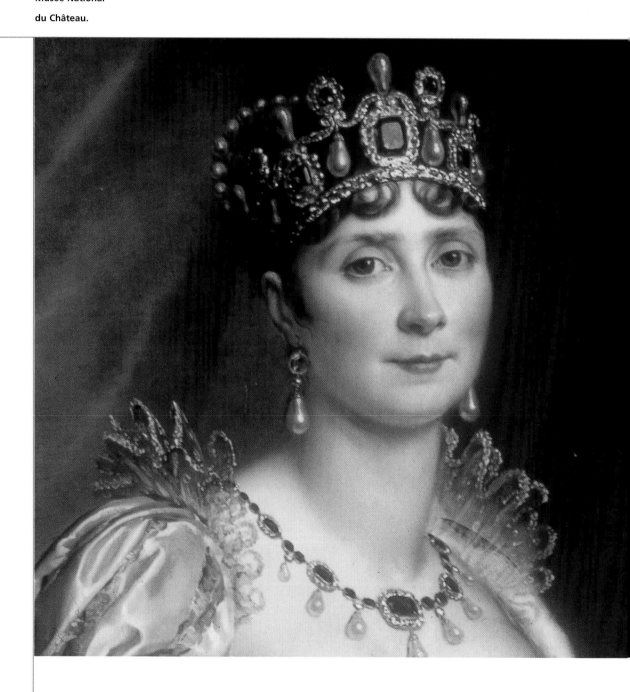

The device that shows a pearl in its shell beneath the sun and bearing the motto *Nec sine lumine dives* signifies that no moral merit or personal quality can exist without divine Grace. The motto *Obduruisse iuvat* is explained by Picinelli as follows: just as the pearl hardens in the shell as a result of the effect of the sun, so the human spirit is rewarded with virtues and merit by the practice of tolerance, patience, poverty and humility. When a pearl is combined with the motto *Nec te quaesiveris extra*, an allusion is made to the person who finds virtue in himself because he does not believe it is to be found elsewhere. Similarly, the image of a pearl still enclosed in its shell with the motto *Absconsione secura* was an allegory of virginity, which was to be maintained by keeping one's distance from other people.

The emblem of a pearl set in a gold ring accompanied by the motto *Deseruisse iuvat mare* was coined for Margherita, the queen of Spain and wife of Philip III: it referred symbolically to the idea that the pearl, when removed from the sea, found greater dignity when set in a precious metal just as the queen, after her death, was placed in her true milieu, the golden setting of glory and eternity. A pearl hidden in a shell with the motto *Amant pretiosa latere* represents a love of solitude, which is a sign of a sophisticated mind. *Fracta tamen melior* refers to the many medical prescriptions in which the powder of a ground pearl is used to bolster physical or mental weaknesses in the same way that the body of Christ, broken by his crucifixion, gave us back moral strength having redeemed us from Original Sin.[58]

Pearl Jewelry

Pearl Jewelry from Ancient Rome to the Ottonian Period of the Holy Roman Empire

Margaritae and _Margaritarii:_ Pearls in Ancient Rome　　　　The exploits of Alexander the Great gave rise to the new world known as the Hellenistic empire that, beneath the uniform golden patina of Greek domination, attempted to introduce a complex, cosmopolitan shift toward racial and, especially, cultural integration. The political situation of the empire was profoundly different from that of the highly evolved model of the _polis,_ the Greek city-state, which was civil and restricted in scope. The imperial aims were to introduce Greek customs and domination into countries like Egypt and Mesopotamia, whose civilizations were much older than that of the Greeks and, therefore, resistant to the exercise of imperial power. In fact, the process was so difficult that Alexander and his successors were obliged to make extreme efforts to adapt to the various local situations and, in some cases, to assimilate usages, traditions, tastes and cults in their entirety. The result was that Greek civilization and, consequently, its cultural expressions were profoundly altered. Prior to this complicated historical period, Hellenic art had existed in the narrow social setting of the _polis,_ reflecting the requirements of a tight and uniform society; its aims were democratic in that it was produced less for private or hedonistic purposes than for public and ethical commissions. As such, the best Greek art was closely connected with sanctuaries, understood not as simply religious buildings, but also as the hub of secular life in general. There are few examples of private jewelry from this era, and this seems to substantiate the theory that artistic production centered on the sanctuary. Much of the work of the jewelers of the epoch was absorbed by the colossal chryselephantine simulacrae that, rather than cult statues, were votive offerings. The catalogs of the offerings in the temples listed and described personal jewels that were for the most part made solely from metal, although skillfully worked using traditional techniques like embossing, engraving, filigree and granulation. Even the highly refined articles produced during this era in Etruria completely ignored the existence of gems and, in general, polychromy, preferring finely granulated gold. No trace has been found of the use of gems or pearls before the age of Alexander's conquests. So what took place to change tastes in ancient ornamentation?

The rulers Alexander the Great wanted to govern his new states found themselves in the difficult situation of having to choose between two options: to attempt to merge the Greek and local cultures, or to impose the new dominating elite by force. The second was the more frequently taken option, hence it was necessary to build an image of the ruler that would enhance his charisma.

Courts were established with ceremonies, protocol and a symbolic and royal splendor, and although Greek formal elements were strong, the contents were strongly influenced by the oriental Persian model. Alexander had, after all, married the Persian princess Roxana. Jewelry could not remain immune to the Persian influence; it underwent an enormous increase in production and was affected by the introduction of new materials that originated in the conquered countries. Interest grew in the use of gems in ornaments, with particular attention paid to pearls; these came from the Persian Gulf, where they were already considered regal attributes. Two new cities were added to the centers of Greek goldworking, Alexandria and Antioch, which both developed into capitals of Hellenistic culture and centers for the production of works of art and other high quality products. Their geographical position and established trade with the Middle and Far East meant that the two cities became natural markets for precious stones and pearls. Antioch in particular had close ties with Bactria and northern India, both centers of pearl production. Greater availability led to a wider use of pearls in ornamentation, and jewelry styles gradually moved away from the traditional, until a new cosmopolitan idiom was formed. We can only infer the materials used in jewelry during this period from written sources as very few examples are still in existence. Noticeable by their absence among excavated materials are pearls, which, due to their organic nature, are easily attacked by chemical components in the soil, especially if it is rich in acid humus which can cause their total decay.

Little has been found of the Hellenistic period in Greece, and it is in Taranto and Campania (provinces of Magna Grecia in Italy) and southern Russia that most of the archaeological material from this epoch has been unearthed. Even if many precious and semi-precious stones of varying quality have been discovered, some engraved, pearls from the fourth, third and second centuries B.C. are very rare.

During the Hellenistic era, Italy was in total decline. Etruria, with its tradition of refined jewelry, also succumbed to the blows inflicted by the power of Rome and lost all trace of its artistic independence. The Etruscan provinces were slowly depopulated and absorbed into the Roman domain; Rome swallowed up their artistic traditions without opposition and replaced them with its own culture, above all in the art of jewelry making. During the classical age and early Hellenism, Rome had been part of the artistic melting pot that stretched from Etruria to Campania, and it was only when the decline of peninsular Italy had run its course (after the Punic and Eastern wars) that Rome showed signs of a certain originality in its architecture and literature. What caused this unexpected creativity? Rome had come into direct contact with the

Early Christian art (3rd–4th c.), *Desiderius' Cross,* **Brescia, Museo Civico.**

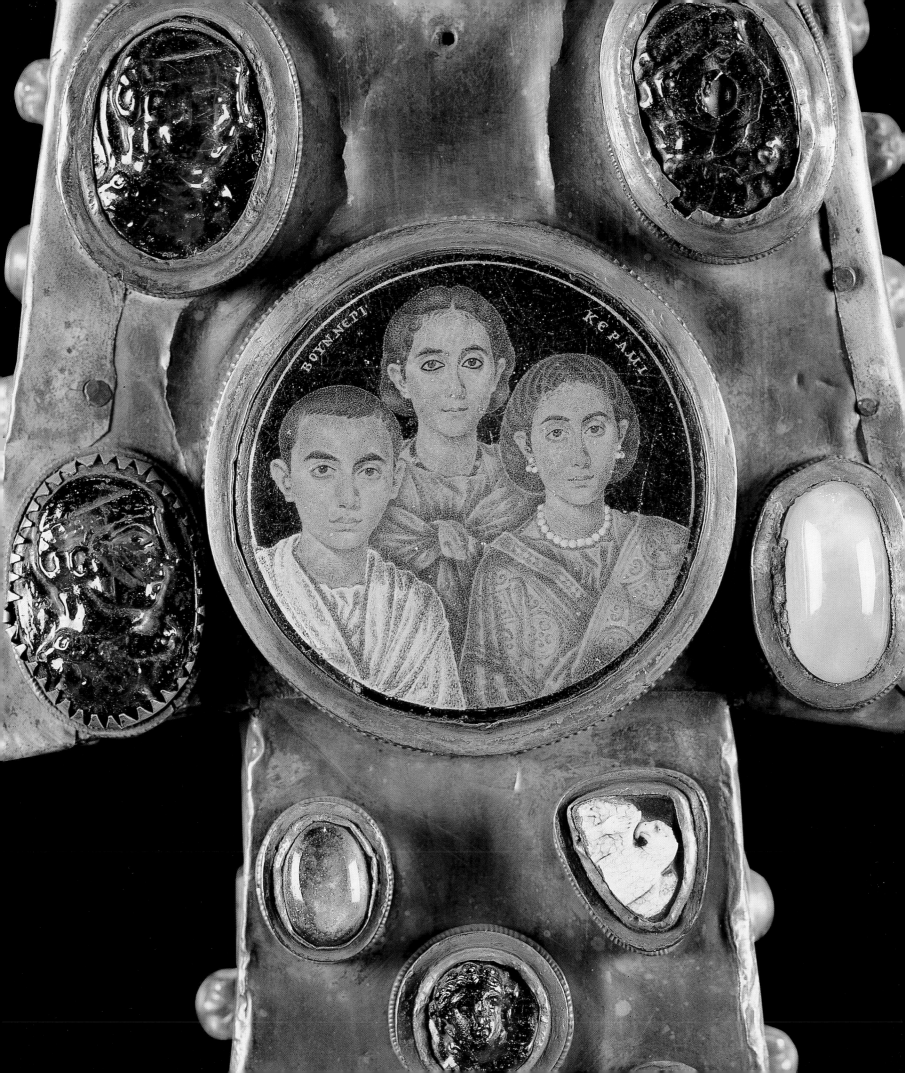

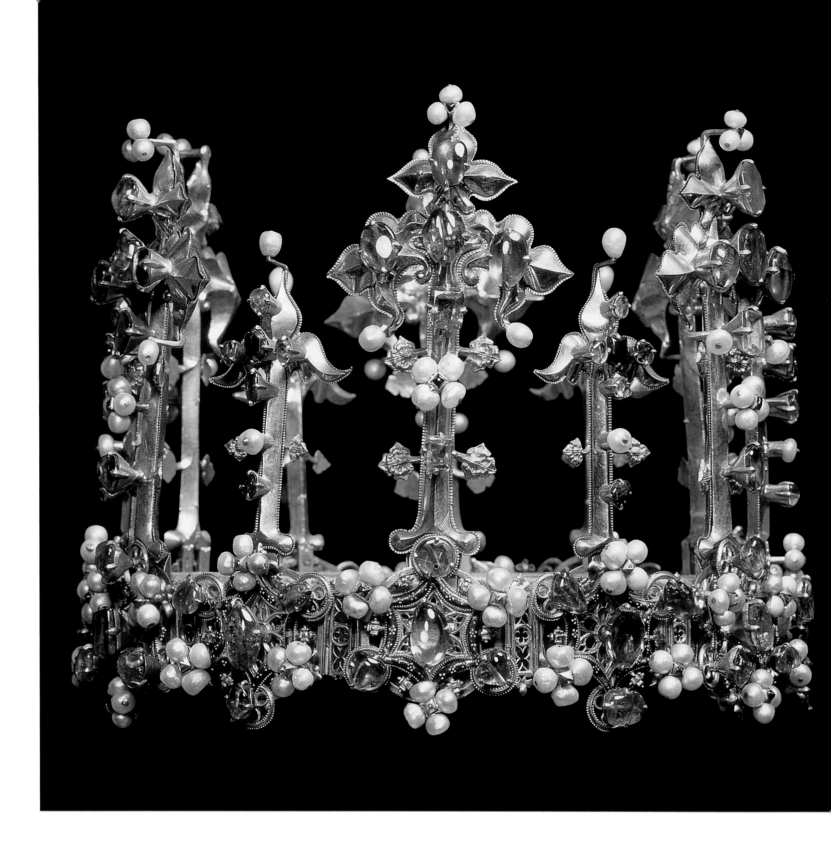

large Hellenistic kingdoms, and their conquest had triggered an enormous flow of wealth into the city, which in just a few decades became the economic capital of the Mediterranean. Its plundering of works of art turned Rome into an immense open air museum, where works of Hellenic art were mixed with a vast mass of valuable materials, but Romans were not prepared psychologically for this. The moral preconceptions of the virtuous citizen against corrupting art and the Catonian tradition of inflexible staidness and disdain for luxury were obstacles to the production and use of jewelry. When Syracuse, Capua, Taranto and, later, Macedonia, Asia and Greece herself were conquered, contact with so much wealth and refinement brought a flood of luxury to Rome and, in consequence, sumptuary laws were passed in reaction. The earliest was the *lex Oppia* in 215 B.C., defended in 195 B.C. by Cato (234–149 B.C.) which prohibited women from owning more than half an *uncia* (a unit of weight) of gold jewelry, while in 46 B.C., Caesar (101/100–44 B.C.) promulgated a law that regulated the use of purple clothing and pearls. Romans manifested their love for luxury by preparing banquets with superb silver objects and wearing a large number of rings on their fingers as a sign of distinction and wealth. Engraved gems were in great demand as collectors' items, whether they were Greek in origin or made in Rome in the workshops of the *gemmarii*. The art of the goldsmith was based on the skills of specialized workers: the *caelatores* who engraved gold and silver, the *aurifices* who produced gold articles for private individuals and the imperial house, and the *inauratores* who gilded. But one category was established in Rome following the conquest of the East and after contact had been made with Alexandria in Egypt: the *margaritarii*, dealers who specialized in the purchase and sale of highly sought-after pearls. As in Alexandria, the most important center for pearl distribution, the margaritarii were a rich and respected category of traders, and they entered the ranks of specialized jewelers with their shops in the Via Sacra. The housekeeper in large Roman houses was known as the *atriensis*; he was in charge of the domestic staff, composed of slaves, one of whom was responsible for the cleaning and the care of the jewelry. This slave was known as *ad margaritas*, or "He who is in charge of the pearls."

At the end of the Republican age, the passion of Roman matrons for pearls had reached epidemic proportions. They were mainly used to make necklaces and earrings in the same way that precious stones were bored, threaded onto gold pins and held in place with golden thread to form ornamental colored chains. Earrings set with glass paste and pearls of various styles and sizes became very popular. Pliny spoke of the custom of hanging more than one on an earring and recorded that this style of ornament had earned itself the name *crotalia,* for the clicking of the pearls against one another, similar to the sound of the *crotalus,* a

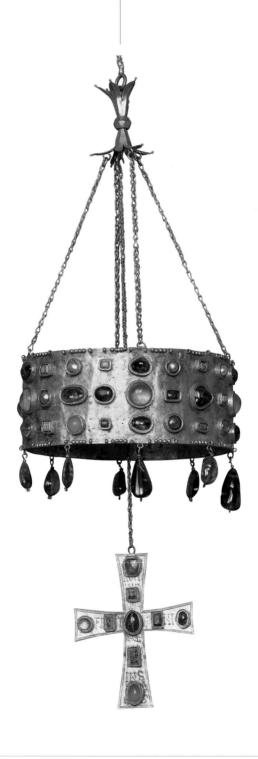

Visigoth goldwork (mid-7th c.), *Votive Crown from the Treasure of Guarrazar*, Paris, Musée de Cluny.

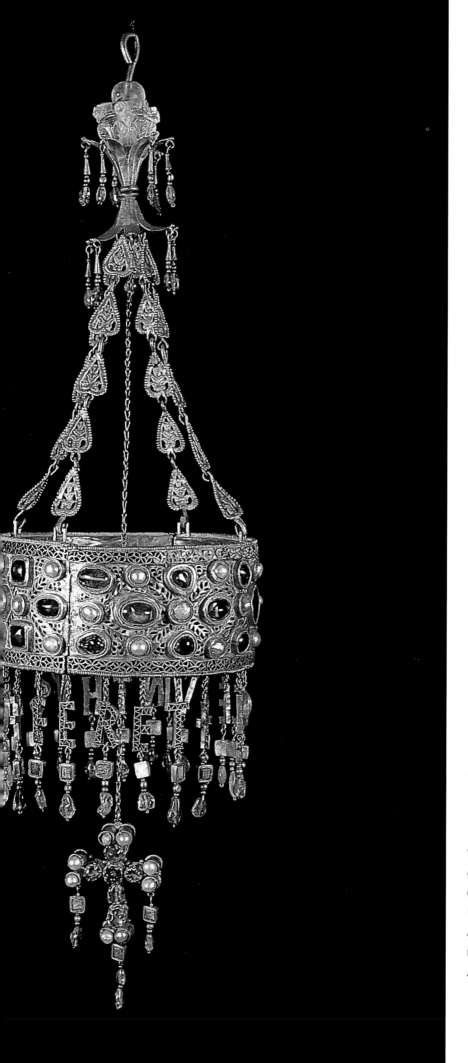

Visigoth
goldwork
(mid-7th c.),
*Votive Crown of
Recesvindo,*
Madrid, Museo
Arqueológico.

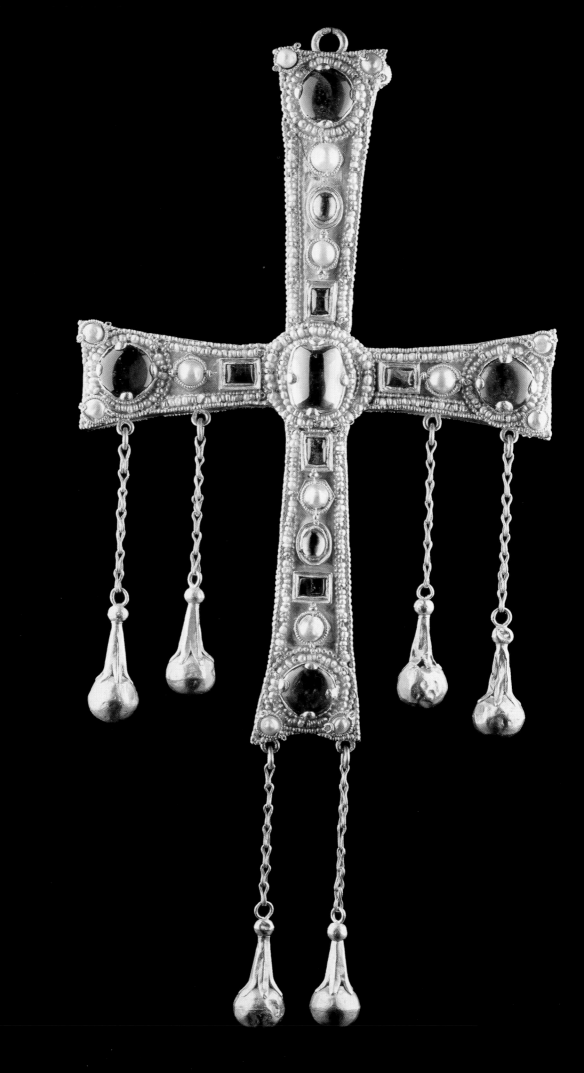

musical instrument that beat the rhythm in dances. Scintilla extracted earrings of this sort from a gold bag and proudly showed them to Fortunata during the banquet of Trimalchio (PETR. sat. 67, 9). The discovery of an unusual series of wall-pictures painted in the second century A.D. partly compensates for the scarcity of archaeological finds of jewels, which were still few in number, although more numerous during the Roman era than the Hellenistic period. The pictures, Roman-Egyptian portraits discovered in the necropolises of Fayoum near Cairo, depict various types of earrings: the simplest is formed by a small ring with a single pearl pendant, while a more complex version has several gems in addition to pearls, or simply a set of pearls hanging from the same small ring. One design of earring particularly stands out: it is made from square emeralds set in gold with hanging pearls.

The diadem was another form of ornament using pearls that met with great success during the late Roman empire. Oriental in origin, it was hated by the Roman people as a symbol of tyranny. Roman emperors tried to avoid using it for the distaste it aroused in Roman society, but Caracalla (186–217 A.D.) depicted himself wearing the diadem of the Parthians, with its double row of pearls, on the coins of Tarsus, to celebrate his victory over the Parthians themselves. Later, actual use of the diadem was taken up by Aurelian (215 ca.–275 A.D.) and Diocletian (240–313 A.D.). In the fourth century, the imperial diadem had become a band with precious stones and rows of pearls. It reflected the splendid, polychrome taste of the late empire, as well as the divine concept of imperial majesty, the *divina maiestas,* from which eastern and western emperors drew inspiration throughout the Middle Ages.

Sacred and Profane Treasures: Pearls in Use at Court and in Medieval Church Ceremonies The division of the vast and variegated Roman empire in the fourth century accelerated the slow and progressive process of political breakup with all its attendant economic and social implications. The West was riven by devastating raids of warriors from the north and northeast who shared a violent and profane attitude toward the power and tradition of the Roman empire. Yet while the Italian peninsula was plundered and became the defenseless prey of barbarian armies, the capital of the eastern empire, Constantinople, became a radiant stronghold of a stagnant yet still splendid tradition. Its geographical location in the new political structure made Byzantium, founded in 330 B.C., more than the capital of the empire and a direct heir to what Antioch and Alexandria had represented before the decisive division of the empire. Gold arrived in the city from Asia Minor, the Balkans and Greece while ivory, precious stones and pearls flowed in from India and Persia. Trade in precious materials flourished and the artistic quality of the craftsmen was extraordinarily high. The intensification of the absolutist concept of power that had started before the division of the empire fostered a process of divinization of the emperor, who stood at the very apex of every political and administrative structure. The rigid bureaucracy was accompanied by a complex court protocol, which was translated on a formal level into grand palace ceremonies, shimmering ornaments, sumptuous clothes and magnificent jewels. In this context jewels had the official function of indicating and inspiring respect for social status or for a political or administrative role, and it was therefore necessary to impose sumptuary laws to govern their use. In the codex promulgated in 529 by Emperor Justinian (482–565), it was established that pearls, emeralds and sapphires were reserved for the exclusive use of the emperor and the members of his family. It cannot be confirmed that this law was universally respected within the bounds of the empire but it was very probable that once precious materials of the best quality arrived in the capital, they were immediately consigned to the court workshops, where a hereditary caste of skillful craftsmen produced ornaments for the emperor, his family and his court. Pearls were highly valued, as the mosaic in the basilica of San Vitale in Ravenna indicates. Here the empress Theodora (500–548) is portrayed in an official parade with a procession of court ladies, adorned with an elaborate crown that turns into a sort of bejeweled head ornament. A cascade of pearls falls onto Theodora's shoulders, in line with her pendant earrings, gems and pearls, and merges with the rich embroidery that trims the neckline of her tunic. In the matching mosaic, Emperor Justinian is similarly richly ornamented. The use of pearls and precious stones with certain goldworking techniques had an influential precedent in Hellenistic jewelry, though the Byzantine examples are original in design. The necklaces of alternating pearls and jewels, for example, were Hellenistic in

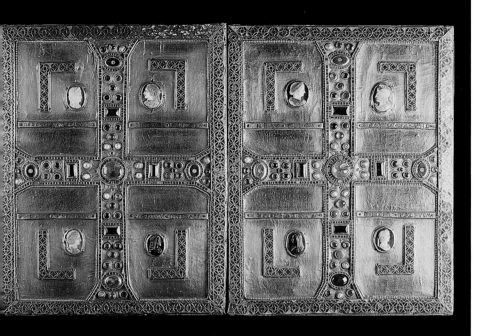

Byzantine-like goldwork (end 6th–beginning 7th c.), *Theodolinda's Evangeliary*, Monza, Tesoro del Duomo.

Carolingian goldwork (9th c.), *Reliquary of the Tooth of St. John*, Monza, Tesoro del Duomo.

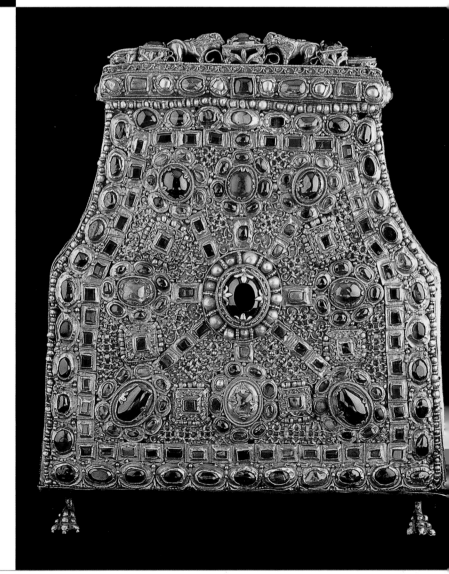

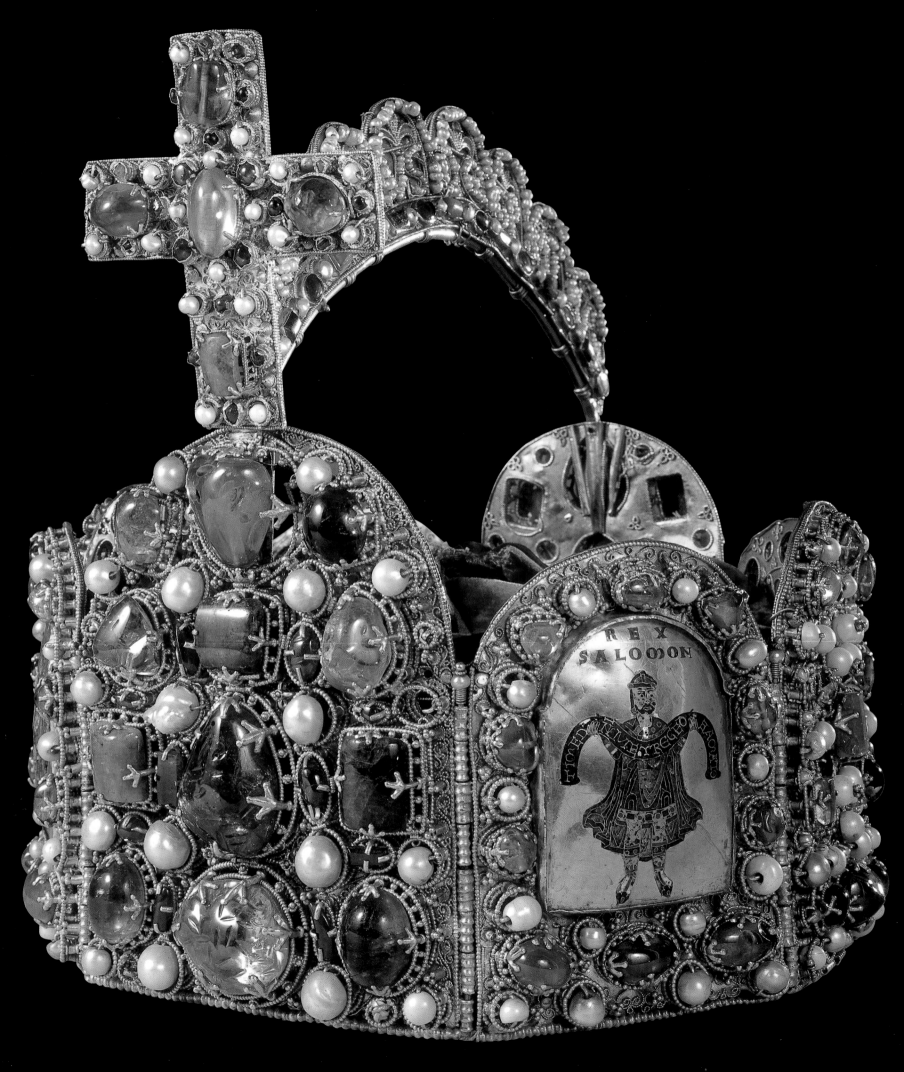

origin, as were the pendant earrings, often decorated with bored spherical pearls and precious stones. Yet the magnificence of these ornaments was imbued with a novel aspect: the sheer abundance of gems was intended to give imperial images the appearance of hieratic idols or remote icons to be worshipped.

Court jewelry was also unusually spectacular as a result of the copious use of gems, especially pearls. More than any other gem, pearls seemed to be suited for a particular use: once bored, they could easily be sewn onto clothes to create effects of extraordinary richness compared to other jewels. It seems that it was the effects that were created rather than the materials themselves that inspired Byzantine jewelers; the phantasmagoric fittings and jewelry with which they provided the emperor raised him to a superhuman dimension.

The Church, an established ally of the emperor, also adorned itself with rich and shimmering vestments during the age of Justinian. In the church of Santa Sofia in Constantinople, the emperor had the capitals of the columns covered with gold; the doors lined with sheets of silver, gold and ivory; the choir railing, the seats and the throne of the patriarch lined with sheets of gold and silver and studded with garnets and pearls; the gold altar crowned by a silver tabernacle; and, higher up, the immense dome decorated by a gigantic cross. The profusion of gold ornamentation and its chromatic glow seemed to dispel every reference to earthly, everyday life and to evoke the hypnotic form of the presence of the divine. So many glittering riches could not but make an impression on the West.

And what was happening in the West at this time? The fact that the invaders of the western empire had been called "barbarians" as a sign of scorn by the Romans, who were ground down by robbery and oppression, does not mean that the newcomers did not also have their own, though different, artistic civilization. Archaeological finds have shown the high levels of skill of the Viking, Ostrogoth, Saxon and Merovingian craftsmen, especially in metalworking. Viking jewelry demonstrates their deep knowledge of the traditional techniques of ancient goldworking, while Ostrogoth articles show a preference for color and cloisonné inlays using semi-precious stones and enamel. Stones, such as garnets, were decidedly more popular than pearls in the decoration of Ostrogoth clasps, perhaps because they were more readily available. However the artistic influences seen in the improperly named "barbaric" jewelry are so wide-ranging and difficult to isolate that even Byzantine elements seem to be present. The Goths were among the first northern peoples to settle in Italy and did not hesitate to introduce explicit Byzantine features alongside their own cultural elements. Another enthusiasm shared by East and West was a love for bright, luminous colors in their artifacts. The votive crown found in Guarrazar in Spain that was part of a seventh-century Visigoth treasure was set with large pearls on a metal surface on which the tracery closely resembled the Roman and Byzantine *opus interrasile*. It is possible that the Visigoths had established trading routes with the eastern Mediterranean and Asia Minor, which also brought them into contact

with new materials and artistic forms. Furthermore, since the time of Justinian and Theodora it had been the practice to mollify the Barbarians with valuable gifts of gold jewelry and large quantities of precious stones and pearls. This custom became progressively established through the Middle Ages until it was actually codified during the reign of Constantine Porphyrogenitus (905–912). Skilled craftsmen from Constantinople worked in various places around the Italian peninsula, maintaining stylistic features and materials that must have been admired by the Barbarians; one such work of special interest is the Treasure of the Cathedral of Monza. In this, two works, perhaps from a Roman workshop, the sixth- or seventh-century Cross of *Agilulf* and the cover of *Theodolinda's evangeliary*, are thought to be the work of a Constantinopolitan jeweler, because of the explicit Byzantine taste in the cloisonné enamelwork, the polychromy of the precious stones, the use of ancient cameos and the presence of exceptionally large pearls, and many small ones, on the cover and the cross. The story is that both the cross and the cover were a gift from Pope Gregory Magnus (535–604) to Queen Theodolinda (589–625); Agilulf (known of 591–604) was Theodolinda's second husband and a central figure in Longobard history for having renounced Aryanism and embraced Christian orthodoxy.

At the time of Justinian, imperial domination extended across the entire peninsula but the reasons for the influence of the art of the Byzantine jeweler throughout the West are not limited to this; in addition to the attraction exerted by the technical refinement and aesthetic beauty of Byzantine artifacts, their influence was felt as a result of the extent of the empire's cultural and commercial relations and because of its political importance and standing. The authority of the Constantinopolitan church was an additional and important factor. All these aspects reached their apogee in the Carolingian *renovatio* associated with the figure of Charlemagne (742–814), the first Holy Roman Emperor.

When Charlemagne, the king of the "barbarian" Franks, had himself crowned emperor in St. Peter's Church in Rome by the Pope himself on Christmas Day 800, he accomplished a

strongly symbolic act that clearly announced a highly ambitious political agenda. He wanted to recreate around himself the splendor of the long past Roman empire, modeling his power on the marriage of State and Church that had been so successful in Constantinople, and his royal charisma on that of the divine Byzantine emperors. Empire and church became the two cultural guides in the West as well, in a new epoch in which a true aristocratic art developed, which, in its ceremonial pomp, made jewelry its symbol.

Similar to what had happened in Constantinople during the reign of Justinian, the palatine workshops produced magnificent pieces of jewelry for the exclusive use of the court and nobility, while the craftsmen in the abbeys and cathedrals produced works of great technical and aesthetic refinement to satisfy the elaborate liturgical requirements of a religion interwoven with a new mystical symbolism. The Treasure of Rheims Cathedral includes the *Talisman of Charlemagne*, an object whose extraordinary fascination is derived in part from the fact that it was found buried with the emperor himself, in a custom that had not been practiced for over two hundred years. The Talisman is a reliquary-pendant in which a lock of hair from the Virgin and a few fragments of wood from the Cross were compressed between two *cabochon* sapphires. Precious stones and pearls are mounted in gold on the frame. In the Treasure of Monza, a reliquary known as the "tooth of St. John" is an important work of Carolingian jewelry, in which pearls are included in the polychrome setting of precious stones. Pearls and other stones are also set in the Carolingian *Berengar's Cross,* a crown said to have been worn by Berengar (850–924) and his successors during their coronation ceremonies. Interest in gems and pearls, often to be found in the ceremonial apparatus of the church, had its roots in the philosophical and theological requirements of medieval mysticism.

The love of "fine materials" during the centuries of barbarian domination received a sort of justification on a philosophical plane when a collection of writings, incorrectly bearing the name of Dionysius the Areopagite (5th c.), were sent to Ludovic the Pious (778–840) by the emperor of the East, Michael Balbus (d. 829). Translated by John Scotus Erigena (9th c.), these writings opened the Carolingian world to Neoplatonic philosophy and to the concept that created beauty is diffused with the increate beauty of God.

In particular, the medieval world believed that beauty resided in objects of intense color and brilliance: light and color, materialized light, were not only characteristics that suggested the divine to medieval man, but were actual symbols, since light was considered an allegory of divine truth that made the virtues represented by colors both visible and active (CLEM. paed. 2,12).

It was only in the light of God that colors (or virtues) were seen in their symbolic splendor, and precious stones, light and color were imbued with beauty by God. This is why the Church did not hesitate to endow its ceremonial apparatus with the divine colors

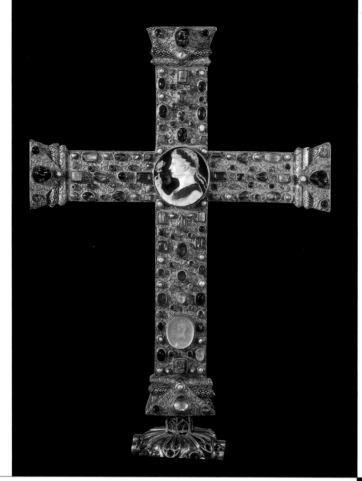

Ottonian
goldwork
(end 10th c.),
Lothar's Cross,
Aquisgrana,
Dom
Schatzkammer.

Sicilian
goldwork (13th
c.), *Costanza of
Aragon's
Headdress,*
Palermo, Tesoro
del Duomo.

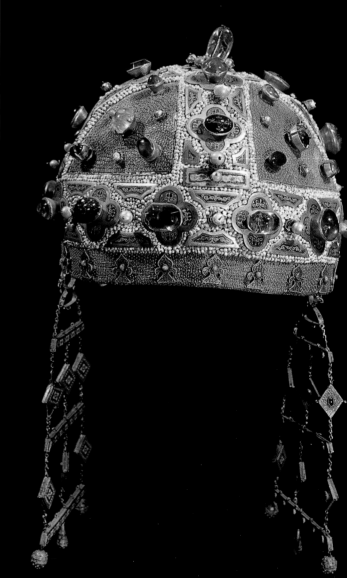

of precious stones, and with pearls for their mystic symbolism. During the Ottonian period of the Holy Roman empire (10th–11th c.), the resurgence of classical art received further impetus through the mediation of the Byzantine art that had appeared in the Carolingian epoch. The use of jewelry, limited to court and church ceremonial, became more established. An ad hoc marriage policy had made the relationship with Constantinople more explicit as Gisela, wife of emperor Conrad II (980–1039), and Theophano, wife of Otto II (955–983), were both from the city.

The crown made in 962 for the coronation of Otto the Great (912–973), the Holy Roman Emperor, was decorated with large pearls positioned beside intensely colored precious stones, and a royal procession executed in the favorite Byzantine technique of enamel cloisonné. Similarly, *Lothair's Cross* was adorned with pearls set like gems in tiny mountings among ancient cameos and precious stones of different sizes and colors.

In Italy, the craftsmen of Venice, Milan and Palermo were the most skilled. The Kingdom of Sicily carefully monitored commercial traffic across the Strait of Messina and imposed a toll on carriers, but in exchange offered a free port at Messina, with the possibility of offering the royal court of Palermo gems and pearls of the highest quality. In the Sicilian jewelers' shops of the Norman court, Greek, Moslem and local craftsmen produced articles and magnificent traceries of pearls inspired by Byzantine art, but in the style exemplified by the cap cum head-covering of Constance (end 12th c.), mother of Frederick II (1194–1250). Often, necklaces and bracelets were substituted with precious stones and pearls sewn onto the neckline of garments. Pearls were especially popular in this case, as their structure did not require a setting and they could easily be sewn to material with thread made from gold or silk. Even the lower hem and the buckles on footwear were occasionally decorated with pearls.

Royal and religious regulation of precious materials became so intense that toward the end of the thirteenth century a law was passed in France that prohibited common citizens from wearing precious stones and pearls. The purpose was to limit the natural development of ornamentation in costumes that had spread to the new social classes, an emerging *bourgeoisie*.

Important changes in the social order took place during the thirteenth century. These were the transition from a natural economy

to a money-based economy, the rise of towns, and rivalry between the aristocracy and the new middle classes. The production of jewelry, previously the exclusive preserve of court and church workshops, now became a proper profession with the rise of independent guilds of craftsmen. Guilds were created to protect the professionalism of their registered members and at the same time to ensure customers of the quality of the gold and gems used. For example, it was established that gems could not be substituted by glass paste, and that freshwater pearls could not be mounted on the same piece of jewelry as seawater pearls. However, the actual quantity of artifacts produced in this period was unlikely to have been much higher than the previous era.

The culture of chivalric society centered around sophisticated and varied castle life, where music, games and literature provided entertainment, and where clothes and jewelry were its outward, tangible and refined symbol. The cut of Gothic clothes, which tended to cover the female body completely with long sleeves, left little possibility of wearing bracelets whereas broad cloaks encouraged the use of brooches and clasps. Ladies placed crowns or *bandeaux* of pearls over hair worn loose, while bejeweled head-coverings were suitable for married gentlewomen.

The *Onyx of Sciaffusa* is the most important surviving item of Gothic jewelry. It is characteristic of Gothic art, which, as a whole, expressed the forms of the great new cathedrals, a new clarity in design and the use of pointed rather than rounded shapes. Yet the presence of a cameo in the center is indicative of the persistence of classical taste in Gothic art.

In 1204, the sacking of Constantinople had resulted in the flow of a large number of high quality Byzantine artifacts and precious materials into western Europe, including many splendid pearls that had been fished from the waters of the Persian Gulf and Indian Ocean. This sudden concentration of luxury items caused a number of sumptuary laws to be passed that limited the use of gems, and above all pearls, to the privileged classes. Clasps and brooches, widespread during the Gothic period, were often adorned with pearls, though not large in size.

The fourteenth century consolidated the trends of the previous one hundred years. New sumptuary laws attempted to slow the excess of finery and limit the use of precious stones and pearls, which were being used in ever more splendid fashion. The forms of jewelry grew in number along with the mastery of the art. The *Jewel of the Founder* is a brooch in the shape of the Gothic letter M.

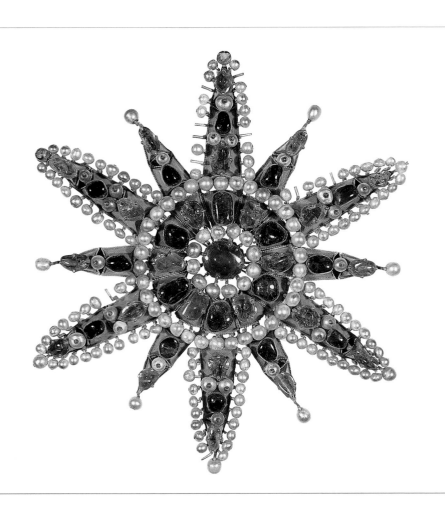

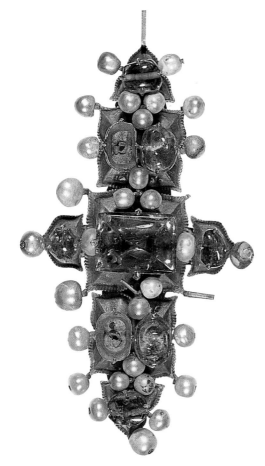

Gothic goldwork
(mid-14th c.), *Star-Shaped
Brooch in Gold, Precious
Stones and Pearls,* Verona,
Museo di Castelvecchio.

Gothic goldwork
(mid-14th c.), *Brooch in
Gold, Precious Stones and
Pearls,* Verona, Museo di
Castelvecchio.

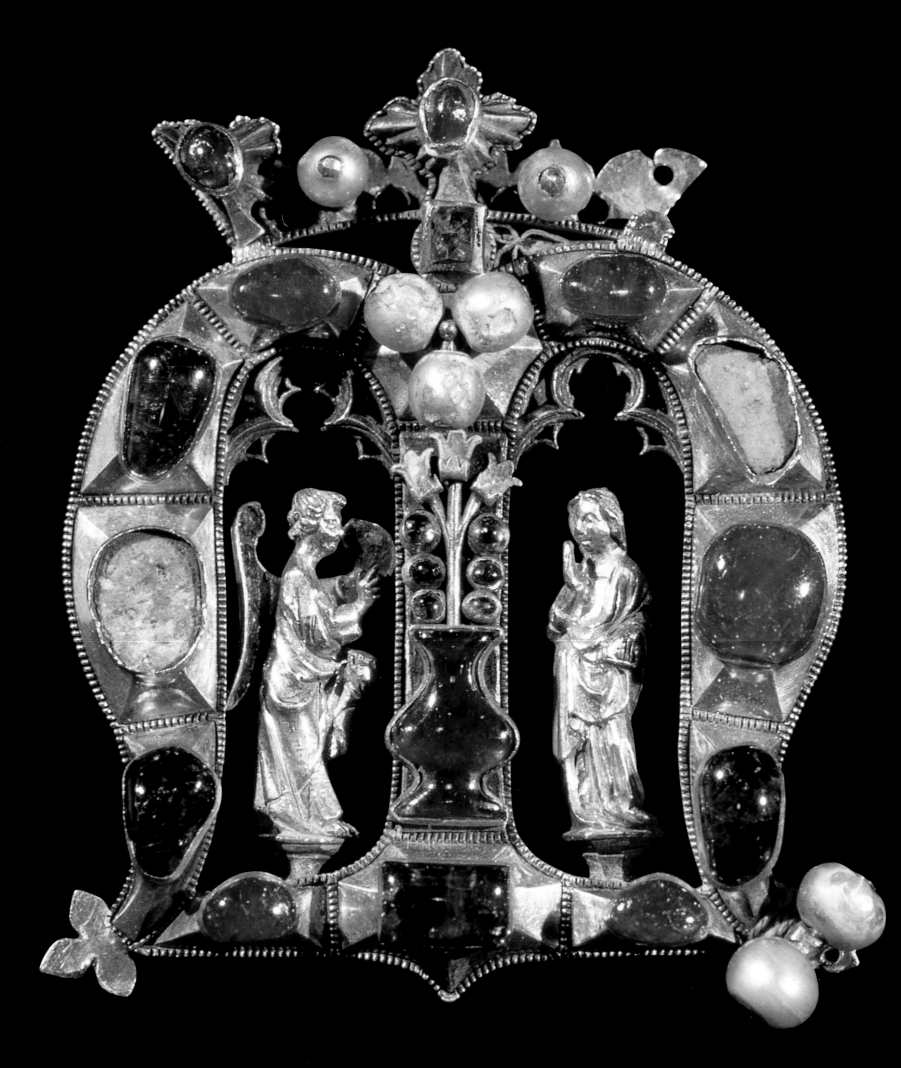

The two figures of Our Lady of the Annunciation and the Angel, modeled using the lost wax method, were set in the curves of the M while the body of the letter was set with cabochon emeralds and rubies. Small but luminous pearls attached to the metal using the *à potence* technique complete the ornament and set it off with extraordinary elegance. On another, star-shaped brooch, we find the same chromatic combination of emeralds and rubies, but the pearls are used to form a frame for the entire structure and to give it the pure luminosity of which only pearls are capable. Pearls too emphasize the light but rich structure of the crown, of English or French manufacture, made for the wedding of Blanche to Ludovic II, Elector Palatine, in 1402. Delicate pinnacles in the form of a fleur de lis culminate in three pearls, while more pearls arranged in groups of four around a central gem are set on the lower part of the crown perforated with the architectural shapes of roses and ogives. The pearls in this crown were also used to provide an effect of suffused light and to emphasize the elaborate and careful design of the stones, now very much removed from the solid and somewhat unrefined simplicity of Hellenistic jewels. Blanche's crown, produced at the turn of the century, heralded the growing importance of gems and pearls in the manufacture of jewelry. In the fifteenth century, these new items of jewelry were designed as vehicles for precious stones, which were given maximum prominence.

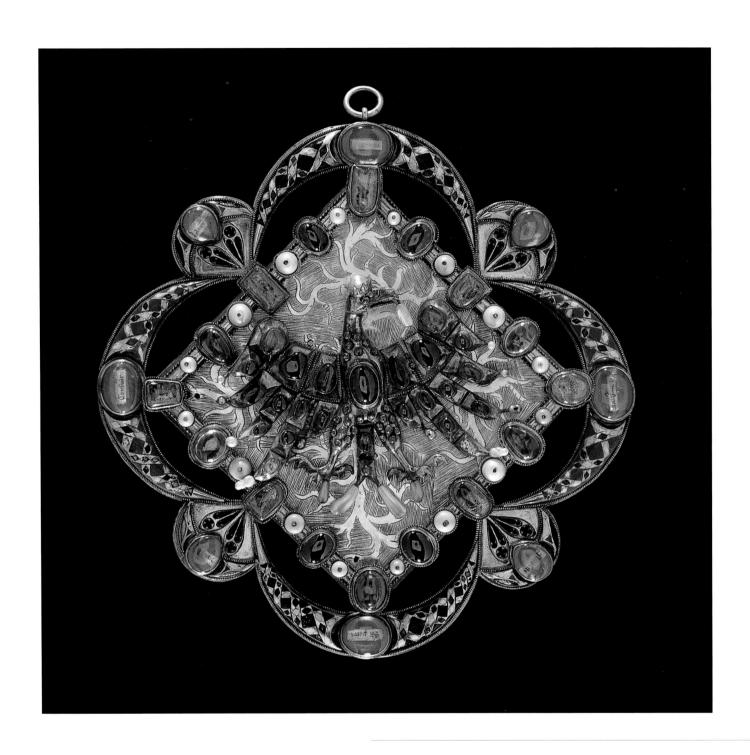

Gothic goldwork (end 14th c.), *Brooch with Eagle in Gold, Precious Stones and Pearls*, Paris, Musée de Cluny.

Burgundian goldwork (1430–40 c.), *Brooch with Newlyweds in Gold, Enamel, Precious Stones and Pearls*, Vienna, Kunsthistorisches Museum.

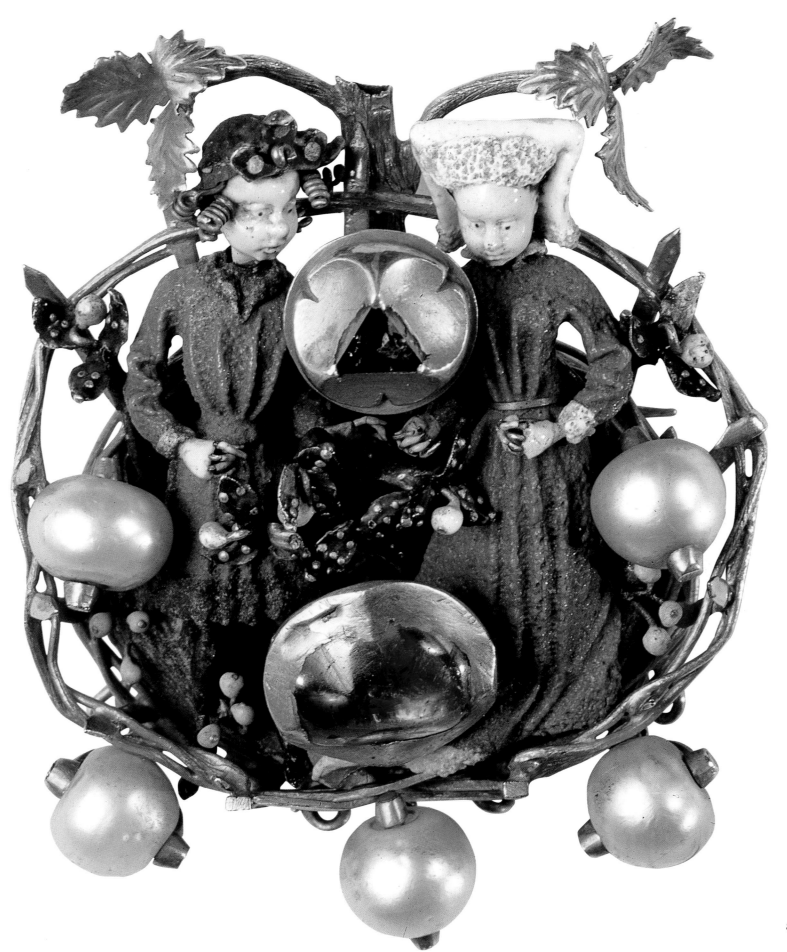

From the Late Middle Ages to the Splendors of the Baroque

The Court of Burgundy and Bourgeois Dress: Pearls and Elegance in the Early Renaissance The fifteenth century is usually defined as a century of transition. This reductive expression suggests that the culture of the period was a sort of hybrid product of both the previous and the following centuries, thus undervaluing the powerful historical currents always present in epochs of renewal. The art of the fifteenth century was anything but hybrid as it passed from the idyllic and serene world of late-Gothic chivalry to the erudite and poetical classicism of Renaissance humanism. The transition was gradual but nonetheless profound; it resulted from the unstoppable flow of economic and social changes that were taking place, which affected all culture and had direct consequences on the figurative and decorative arts.

A particularly instructive arena for observation of these changes was Burgundy, a wealthy region on the border between the kingdom of France and the Germanic world of the Holy Roman Empire. The culture of the sophisticated aristocracy of ladies and knights at the court of Philip the Good (1396–1467) centered on the skills of war and tournaments, poetry and the arts; the court patronized architects and sculptors and commissioned tailors and jewelers to produce clothes and ornaments for the numerous banquets, tournaments and splendid ducal ceremonies. The court of Burgundy was one of the most refined in

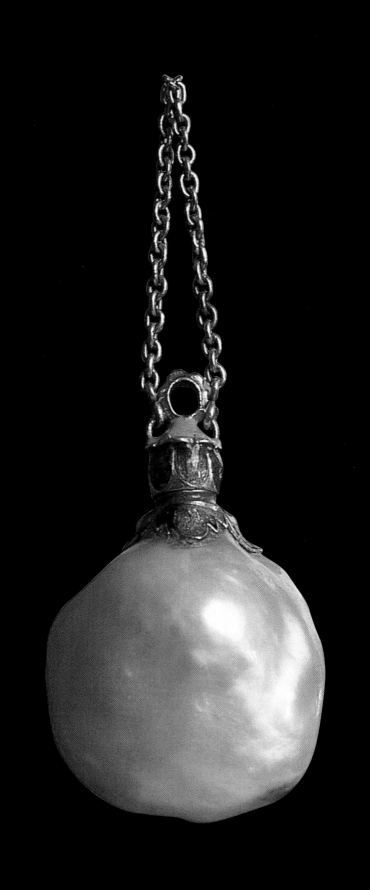

Europe, and contemporary accounts and inventories create the picture of a world in which incalculable personal fortunes provided ceremonies of state with the color and glitter of precious materials. It is said, for instance, that in 1442 Philip the Good went for a meeting with the emperor, Frederick III (1415–1493), wearing a gold stole bejeweled with a myriad of pearls and rubies of inestimable value. It was at the court of Burgundy that, for the first time, gold, precious stones and pearls were given the function, not just as complements to ornaments, but as decorative materials in their own right. Embroidery adorned with stones and pearls was often used on the neckline of ladies' dresses, which, according to the dictates of early-fifteenth-century fashion, were much lower than the previous era, and pearls were used to decorate elaborate, vertical head-coverings that completely hid the hair.

Large quantities of gems and pearls continued to flow into the cities of Flanders among the most favored goods that passed between East and West, and local craftsmen became increasingly skillful in the cutting and polishing of precious stones and the selection and boring of pearls. Credit for the extraordinary commercial success of these cities went to the new class of merchants who, by developing their markets, also fostered a large growth in the decorative arts and created a market for jewels and precious materials, available to anyone who could afford them. Technical progress linked to the enormous increase in production also resulted in the refinement of the art of the jeweler. The quality of a certain brooch made in Flanders is rendered all the more

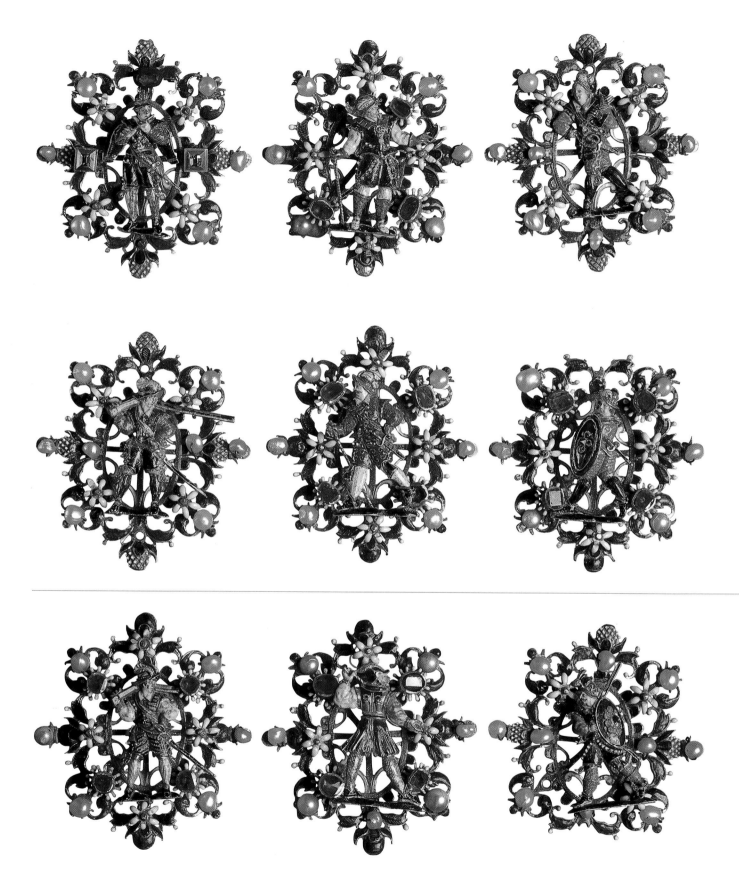

Flemish manufacture (end 16th c.), *Nine Buttons with Military Figures in Gold, Enamel, Precious Stones and Pearls,* **Florence, Museo degli Argenti.**

astonishing by its tiny size. The figure in the design emphasizes the distance that had been traveled from the abstract decorations of the previous century: the figure is of a dromedary, created using the lost wax method, then enameled with the *en ronde bosse* technique. A foliated frame is defined using the fanatical detail that was also present during the same period in the figurative arts. Small pearls fixed *à potence* to the structure give the brooch light and sparkle and soften the edges, a far cry from the pointed Gothic arches of previous eras.

Another extraordinary object displays human figures created using the lost wax method and also colored with *en ronde bosse* enamels. *À potence* pearls and leaf patterns in Flemish style form the background to the two figures, a man and a woman. The positions of the two closely resemble the iconography of the couple in the 1434 painting *The Arnolfini Marriage* by Jan van Eyck (1390 ca.–1441), which suggests that a close dialogue existed between the worlds of jewelry and painting. In fact, the fifteenth century is a historical moment for which paintings provide documentation, since surviving jewelry is so scarce. Ceaseless changes in fashion, in particular the development of figurative designs, which evolved at the same rate as figurative language, dictated that old-fashioned ornaments were no longer required. Advances in painting in this century make it possible to follow these changes in jewelry fashion, while portraits provide unique documentation of the evolution of stylistic features and the use of personal ornamentation. The *Adoration of the Lamb* polyptych (completed in 1432) by Jan and Hubert van Eyck (d. 1426) in the

Dutch
manufacture
(1695 c.), *Cradle*
with Child in
Gold Filigree
and a Pearl,
Florence, Museo
degli Argenti.

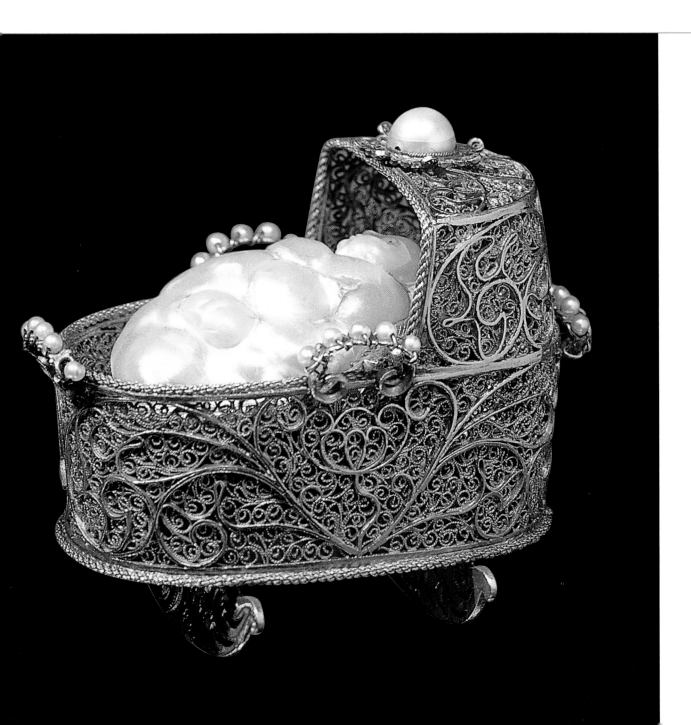

cathedral in Ghent in Belgium is a perfect example. The altarpiece is sacred in nature but set among all the magnificence of a court scene, thus giving an almost faithful pictorial transcription of the extraordinary treasures that existed in the court of Philip the Good. A crown at the feet of the bearded Christ seems to be a representation of a ceremonial crown described in Philip's inventories, which he wished to give to his daughter on the occasion of her marriage to the Duke of Savoy. The crown in the painting is given Gothic spires, but the sparkling of the precious stones and pearls blurs the design in order to draw attention to the holy nature of the crown's luminosity and colors. The pearls are arranged in a circle alternately around a ruby or sapphire set in gold mountings. This design is repeated several times to cover the entire structure of the crown, with the result that it gives off a warm, glowing light.

In the same altarpiece, singing and musician angels wear crowns of great beauty, less high than Christ's but studded with pearls in a design also referred to as *bandeaux*. These are not so much crowns with vertical designs as they are bands of a particular width that encircle the head and on which pearls, with a sapphire or ruby in the center, are applied at regular intervals in the same pattern as the crown with spires. The Angel and Mary in the Annunciation scene on the same polyptych also wear bandeaux, though more simply decorated with a single group of pearls in the center, and this schema is repeated on the clasp of the Virgin's cloak.

Shortly afterwards, Flemish painting, so careful in its realistic representation of each tiny detail, was put to the service of a new and wealthy social class, the merchants who had created the economic fortune of Flanders through its busy trade with the East,

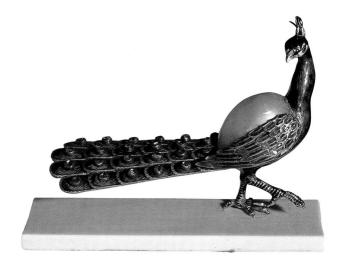

Flemish manufacture (17th c.),
Peacock in Gold, Enamel,
Diamonds and a Pearl,
Florence, Museo degli
Argenti.

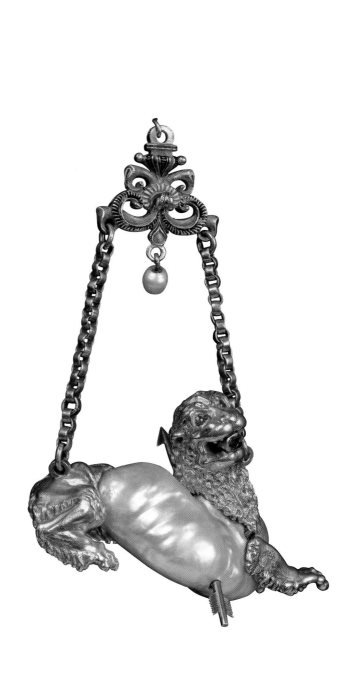

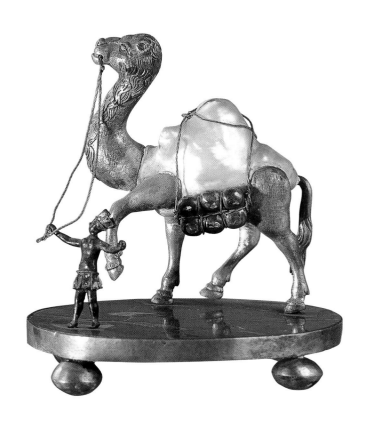

German manufacture
(end 17th c.), *Camel in Gilded*
Silver, Lapis Lazuli, Precious
Stones and a Pearl, Florence,
Museo degli Argenti.

Flemish manufacture
(16th c.), *Pendant in the Form*
of a Wounded Lion, in Gold,
Enamel, Precious Stones and
a Pearl, Florence, Museo degli
Argenti.

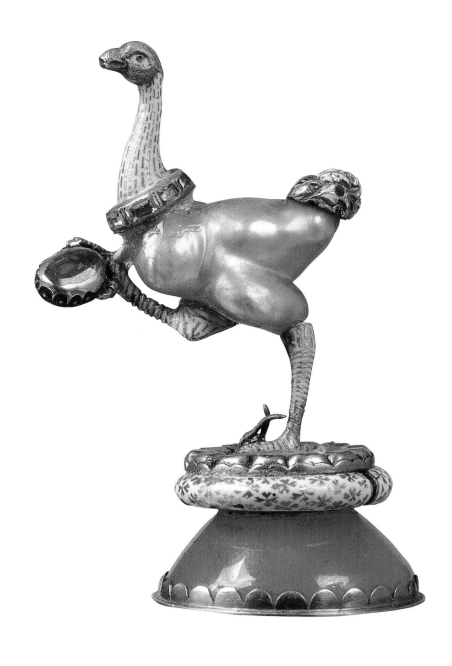

Flemish manufacture (end 16th c.), *Ostrich, in Gold, Enamel, Precious Stones and a Pearl*, Florence, Museo degli Argenti.

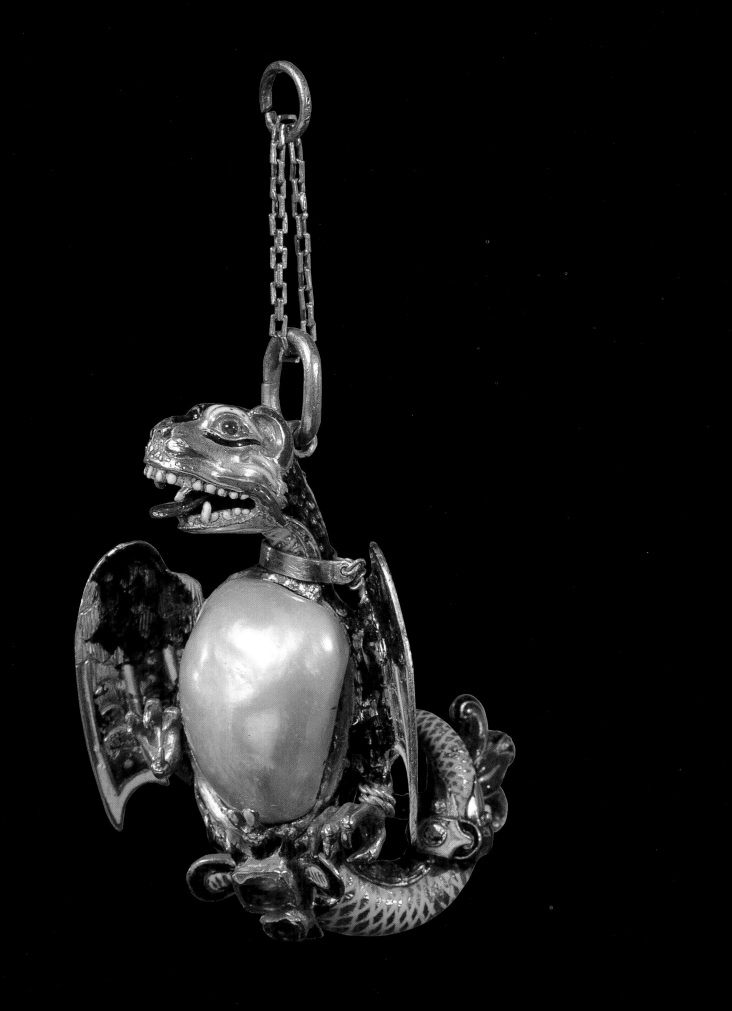

in particular the importation of gold, precious stones and pearls from India and Persia. Rich merchants became clients for portraits that were supposed to celebrate religious devotion, but which equally depict their subjects' accumulated wealth. The jewels of the merchants almost become attributes of their owners and, for the first time in the history of bourgeois society, become symbols of economic and cultural status rather than simply social rank. And it is this statement of secularization that introduces the notion that jewelry is no longer an overwhelming demonstration of power, but a costly accompaniment to women's and men's clothing, used purely for the sake of appearance.

In Florence, too, in the middle of the fifteenth century, a rich merchant class had held economic power since the previous era. It had frequent contacts with the markets of northern Europe and patronized painters, but it also loved to collect antiquities. Jewels, precious stones and pearls found most favor among the wealthiest members of society, who added a new element to their collections with engraved gems from the classical and Hellenistic periods, found during excavations of Roman remains. In the second half of the fifteenth century, there was a strong development in the relationship between clothing and jewelry. According to new aesthetic concepts, both were used to contribute a new notion of size and solidity to the volumes of the human body, while still respecting its natural forms. This was a reaction to the unnatural fashion of the previous century that had accentuated the lines of the body rather than its forms, in an often extreme emphasis of the vertical. The new sense of balance inspired

Flemish manufacture (16th c.), *Pendant in the Form of a Dragon Attacked by a Bee, in Gold, Enamel, Precious Stones and a Pearl,* Florence, Museo degli Argenti.

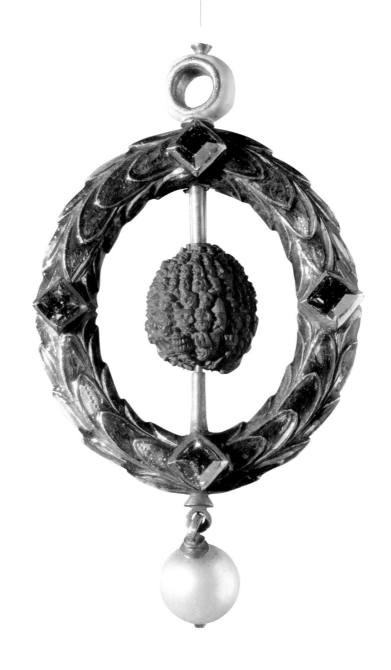

Properzia de' Rossi (attr. to mid-16th c.), *Pendant in Gold, Enamel, Inlaid Cherry Stone, Diamonds and a Pearl*, Florence, Museo degli Argenti.

by classical statuary formed an ideal combination of aesthetics and ethics. It became the function of jewelry to support woman-ly elegance and to skillfully create an effect of naturalness. Pearls played a singular role as a focal point of elegance and purity, being discreet yet seductive and equally graceful, whether worn unadorned or in combination with a precious metal. Loosed from the rigidity of late-fourteenth-century crowns, hairstyles and head coverings were given fanciful designs: hair was worn loose or plaited in intricate styles, with rows of pearls woven throughout its length. The elegant *bandeaux* were now rivaled by *fer-ronières*, an ornament for the head often made from pearls, so-named because they were used to prevent the natural tendency of long hair to fall in front of the face. After 1450, the custom of wearing items of jewelry on a head ornament became more com-mon, like the one painted by Piero della Francesca (1415/20–1492) in his portrait of Battista Sforza. This painting clearly evi-dences the iridescence of the pearls worn both on top of Battista's head and on her choker; in the latter, they are arranged in two rows above and below a row of enameled diamond shapes set with precious stones. Beautifully painted pearls also are attached with gold thread to a pendant that hangs from the choker. The artist depicts the gold and precious stones, showing a scientific interest in the problems of the pictorial rendition of color, transparency and the effects of refraction and reflection of the light, but he also demonstrates his knowledge of the Flemish approach to pictorial description.

The Flemish treatment of jewelry had also produced effects in Florence to which another significant factor was added after the middle of the century. The boundaries between painting, jewelry and sculpture became much less definite during the 1470s than

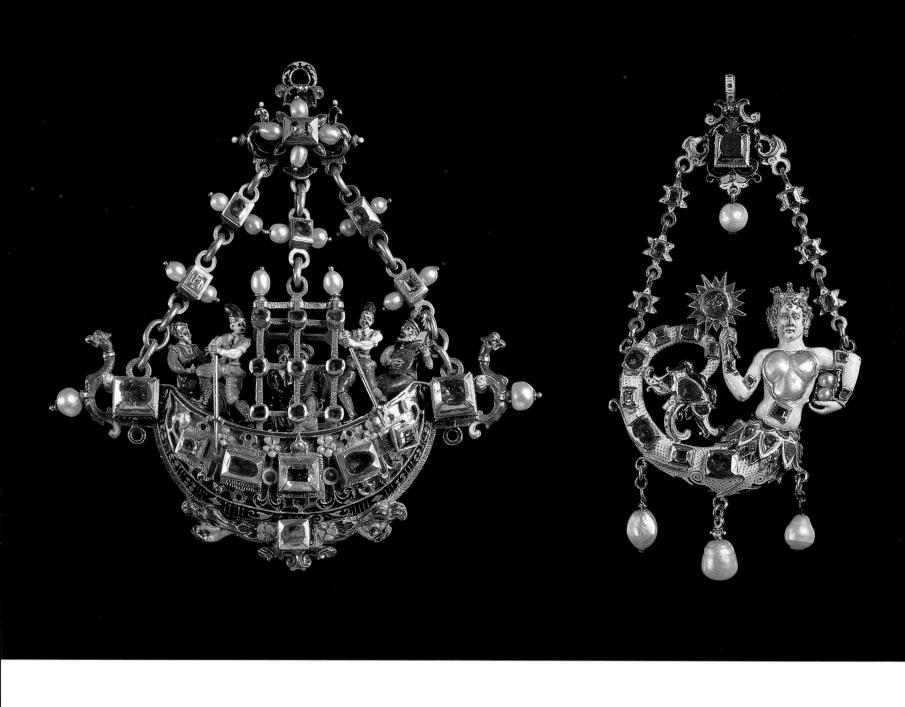

German manufacture (1570 c.)., *Pendant in the Form of a Gondola in Gold, Enamel, Precious Stones and Pearls*, Florence, Museo degli Argenti.

Flemish manufacture (16th c.), *Pendant with Siren, in Gold, Enamel, Precious Stones and Pearls*, Florence, Museo degli Argenti.

Flemish
manufacture
(16th c.),
Pendant in the
Form of a Triton,
in Gold,
Enamel,
Precious Stones
and Pearls,
Florence, Museo
degli Argenti.

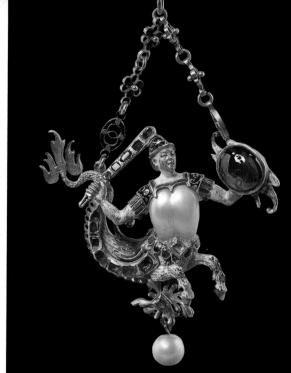

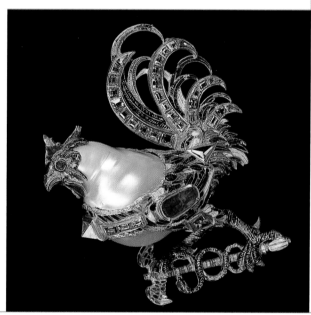

Flemish
manufacture
(16th c.),
Pendant in the
Form of a Cock,
in Gold, Enamel,
Precious Stones
and a Pearl,
Florence, Museo
degli Argenti.

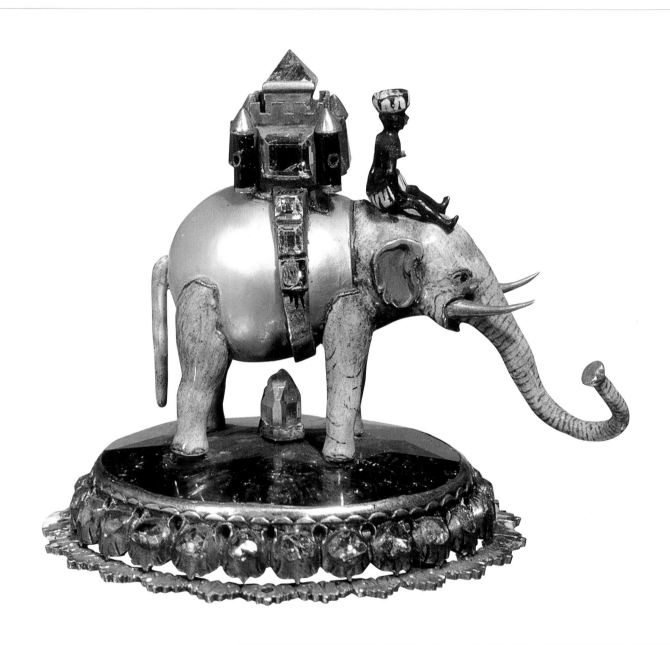

Dutch
manufacture
(end 17th c.),
*Elephant in
Emerald, Gold,
Enamel,
Diamonds and
Pearls*, Florence,
Museo degli
Argenti.

they had been previously. At this time, the jeweler's workshop was considered the best school for artists who were preparing for the major guilds, with the result that this interdisciplinary study created fertile ground for a dialogue between painting and jewelry, producing effects in both directions. The list of artists who studied jewelry includes many famous names: Ghiberti (1416–1496), Maso Finiguerra (1426–1464), Verrocchio (1435–1488), Antonio (1431–1498), Piero del Pollaiolo (1443–1496), Botticelli (1445–1510) and Ghirlandaio (1452–1525). This phenomenon also tended to soften the rigid prescriptions of the guilds, which, in the Middle Ages, had imposed restrictions on each craft in order to wield direct control over the activities of the various workshops. A consequence of this change in attitude was that jewelry was more frequently represented in Florentine painting, and pearls were suddenly omnipresent.

A pendant representing life adorns one of the Graces in the *Allegory of Spring* (1478) by Botticelli. It is formed by a delicate motif of enamel oak leaves set with gems and pearls. Strings and groups of pearls in the hair of the three mythical females complete their *parure,* enhancing their harmonious femininity. Simple versions of *pendentifs* were also used during the fifteenth century, where a gem set with one or more pearls falls down onto the décolletage. Often the pendants were hung with strings of pearls, as seen in Florentine painting from the first third of the century. But the strings seen in the paintings of the 1470s instead became a support for fanciful and elaborate objects that began to achieve a certain popularity during this period.

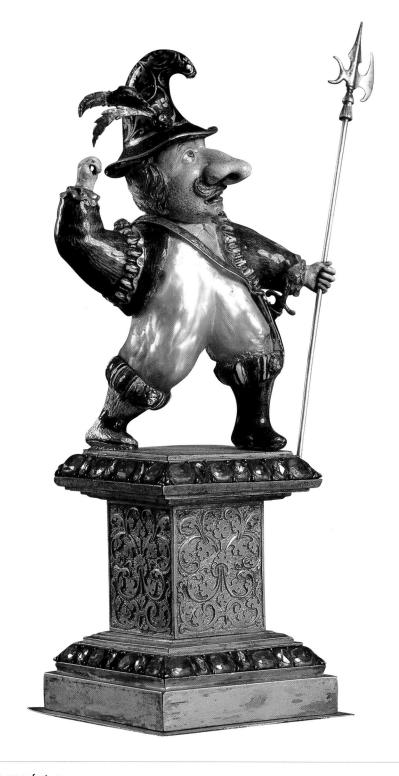

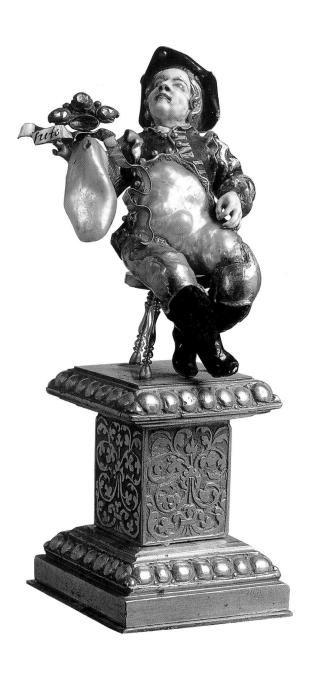

German manufacture
(end 17th c.), *Swiss Soldier, in
Gold, Enamel, Precious Stones
and a Pearl*, Florence, Museo
degli Argenti.

German manufacture
(end 17th c.), *Cobbler in Gold,
Enamel, Diamonds and Pearls*,
Florence, Museo degli
Argenti.

Brooches and clasps adorned with pearls continued to be produced for use with both women's and men's clothing. Brooches especially were flexible in their application and were often pinned at the center of a richly jeweled neckline or on sleeves or hats, but one of their most common functions was as a clasp for a cloak. A very frequent fashion throughout the fifteenth century was the insertion of costly elements, and pearls in particular, into clothing in the form of embroidered trimmings, so when the article of clothing had passed out of fashion or had become worn, the materials could be easily removed and reused. In this manner, the materials were also an excellent form of investment. In a letter from the Florentine gentlewoman Alessandra Macinghi Strozzi to her son, who was about to get married, she wrote that since pearls and pearl ornaments hold their value, they were preferable to other trimmings that were often equally costly but destined to fall out of fashion.

Baroque Pearls and Mannerist Affectations The sixteenth century was the golden age of jewelry, and pearls remained popular throughout, adapting effectively to changes in taste and costume. What was the cause of this popularity, which, if not sudden, was certainly greater than in previous centuries? There were many reasons, and they seem to revolve around the great political, economic and religious upheavals and changes that occurred in this turbulent age.

The early years of the century were marked by the emergence of moral values resulting from humanistic studies, reflected on the aesthetic plane by the search for a harmonious flow of forms and a new-fashioned but ancient elegance in life, art, dress and ornamentation. The sophisticated balance between clothing and jewelry that had been discovered at the end of the previous century became even more established during the first half of the new one. Closely linked with the classical notion of measured elegance, strings of pearls continued to be used in Florentine dress, following their appearance in the fifteenth century, and permeated fashion throughout all of the sixteenth.

The diffusion of pearl necklaces was such that the Grand Duke, Cosimo de Medici (1519–1574) was forced to place a ban on the wearing of necklaces that exceeded the value of five hundred scudos; this was a sumptuary law par excellence targeted at ordinary citizens, since splendid colliers of large round pearls were customarily worn by the ladies of the Medici household.

A simple string of pearls adorns the neck of Bia, the natural daughter of Cosimo I, in the portrait by Agnolo Bronzino (1503–1572), while the elegance of the string of large white pearls belonging to the duchess, Eleonora da Toledo (1545 ca.), is emphasized by a longer necklace, and by the net of pearls on the upper part of her dress that matches the one on her hair. The effect achieved is a balance in the relationship between the rich, finely-worked velvet dress and the lady's ornamentation. A pearl drop on the pendant that hangs from Eleonora's string of pearls illustrates the dual function of pearls in jewelry.

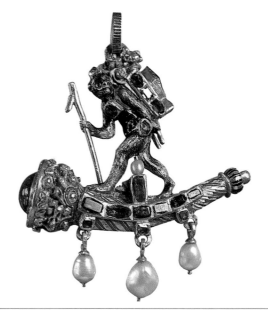

Flemish manufacture (16th c.), *Pendant in the Form of a Monkey on a Whistle, in Gold, Enamel, Precious Stones and Pearls,* Florence, Museo degli Argenti.

Flemish manufacture (16th c.), *Pendant in the Form of a Parrot, in Gold, Enamel and Pearls,* Florence, Museo degli Argenti.

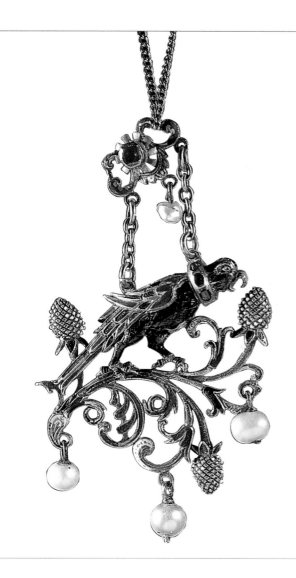

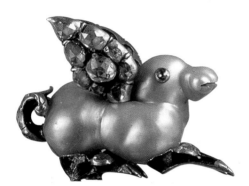 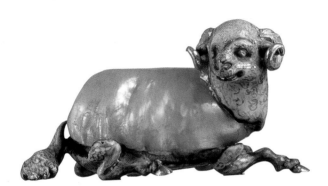 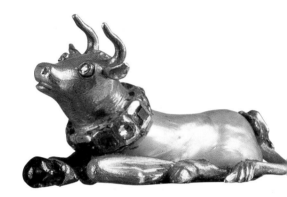

Flemish manufacture (end 16th c.), *Animals, in Gold, Enamel, Precious Stones and a Pearl*, Florence, Museo degli Argenti.

The rotundity and chemical composition of pearls allowed them to be bored easily; this gave them an advantage over stones of greater hardness, if an item of jewelry was being made that required a gem to be set in gold, or when a gem needed to be threaded with others to form a flexible and luminous string that adapted to the curved parts of the human body, such as the neck and head.

The advantage of strings of pearls, whether for use on the head or as a choker, was supplemented by the relative simplicity of their manufacture, as well as the fact that nothing could show off a high quality material better than a simple structure. It may have been this versatility that was responsible for the extraordinary fortune of pearls during the sixteenth century. Pearl drops were often added to pendants at the start of the century, to complete the design and to create a dangling effect suitable for clothes with deep necklines.

Florence and Venice shared the privilege of being trading centers for jewels, pearls and other luxury objects that spread across Europe. Large quantities of valuable goods and materials were shipped from the East to Venice, which had become the principal market for gems and pearls. An account of the period had the following entry: "Four long vessels bear spices, silk, precious stones and pearls from Syria, and the same number from Egypt. Another three collect gold, gems and slaves from Libya...four go beyond the Bosphorus to get spices, carpets and emeralds...." It is probable that the number of pearls that passed through Venice from India was much higher than those that reached Spain from the New World. After unloading at Venice (though also at Antwerp and Genoa), the pearls were bought by specialized purchasers sent by important bankers and were then set aside for

Flemish
manufacture
(end 16th c.),
*Lizard in Gold,
Enamel,
Diamonds and a
Pearl,* Florence,
Museo degli
Argenti.

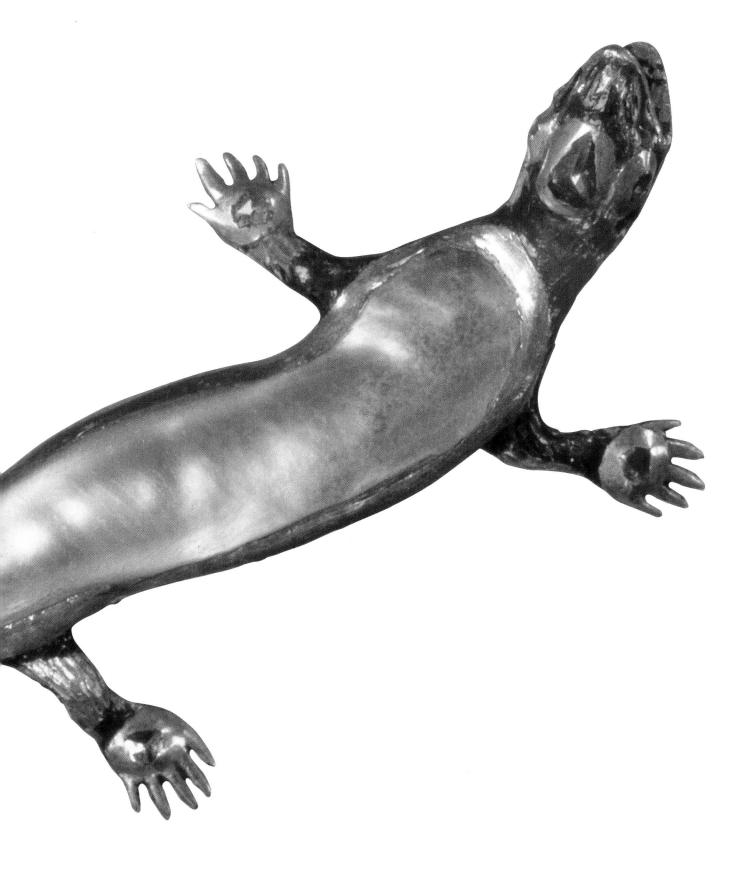

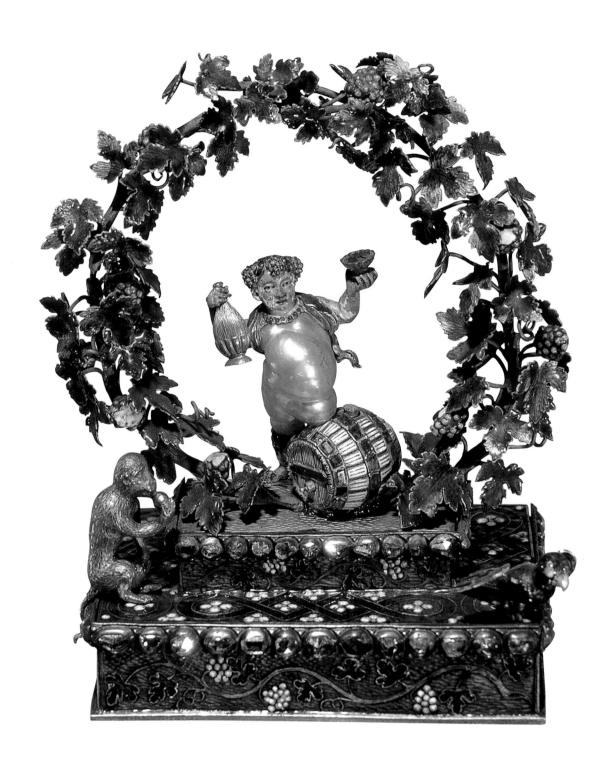

German manufacture (end 17th c.), *Bacchus in Gold, Enamel, Precious Stones and a Pearl*, Florence, Museo degli Argenti.

sale to those kings, dukes, grand dukes and collectors who had not sent their own functionaries to contract for them. Many pearls that arrived in Venice were allocated to the local market, so that splendid strings and drop earrings could be provided to the city's noblewomen. Whereas in Florence cut stones contended with pearls as the most popular gem, in Venice pearls were preferred above all else. In the middle of the century, Paolo Veronese (1528–1588) painted his pagan goddesses nude, but always adorned them with a string of pearls and earrings, while Titian (1490–1576) provided his *Venus of Urbino* (1538) with pale, iridescent pearl earrings to enhance her seductive, ivory coloring.

In Venice in the second quarter of the sixteenth century, gold necklaces, pearls and earrings had made their "appearance in society." It was recounted that in 1525, a noble Venetian lady had provoked great scandal and the personal displeasure of a relative by presenting herself with her ears pierced in "naval style" and adorned with an earring like that worn by the *Venus of Urbino*. The scandal was justified, since at the time, earrings were on the Index of Venetian sumptuary laws, in particular pendant earrings, as they were an expensive indicator of a taste bordering on exoticism. Strings of pearls were often worn as a single neck ornament but on occasion accompanied by long *sautoirs* that fell loose on wide tunics and were fixed or pinned to the center of the bodice by extravagant brooches. In Venice, the burgeoning number of sumptuary laws aimed at limiting the purchase and use of massive quantities of pearls underlines how much in favor these gems were. Courtesans, who were well represented in the lagoon city, were absolutely forbidden to wear pearl necklaces, as these were the favorite form of jewelry of noblewomen. On the other hand, the long *sautoirs* so loved by the aristocracy were considered completely unacceptable to Venetian propriety, because of their excessive cost.

During the second half of the century, changes in styles of dress brought elaborate developments in jewelry design, and from 1540 until the Thirty Years War, Europe found itself following the fashions of the royal court in Spain. The sixteenth century was Spain's glorious era of exploration and colonization, with a resultant influx of enormous treasures of gold, silver, precious stones and pearls, making the country the richest in the world. Strict Catholics, strenuous defenders of the faith and supporters of the Counter-Reformation, the monarchs moralized and criticized the customs and dress of the court and aristocracy. Women's clothing became stiff and high-necked and was made from rich, brocaded materials with hems in gold and silver, smooth velvet and brocaded satin. Jewelry became more complex in design. Besides long *sautoirs* of pearls, there were rich chokers and *cotiere* made from gold, enamel and precious stones, and buttons and small decorative ornaments in different shapes that were applied to the dress in great numbers, in a clear repudiation of the simplicity of classical dress, with the aim of producing an effect of glittering richness that caused the entire figure to glow.

As the century wore on, the high ruffs and tippets made from starched lace made the use of pendant earrings difficult; the only variant that continued to be worn, it seems, was the simplest of small rings with a pearl drop. The strings of pearls so favored in

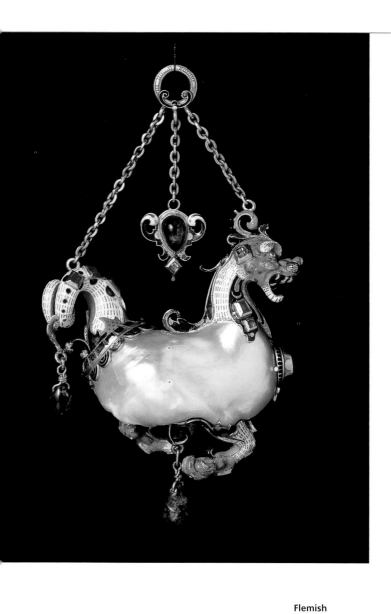

Flemish
manufacture
(16th c.),
Pendant in the
Form of a Sea
Monster, in
Gold, Enamel
and a Pearl,
Geneva,
Christie's.

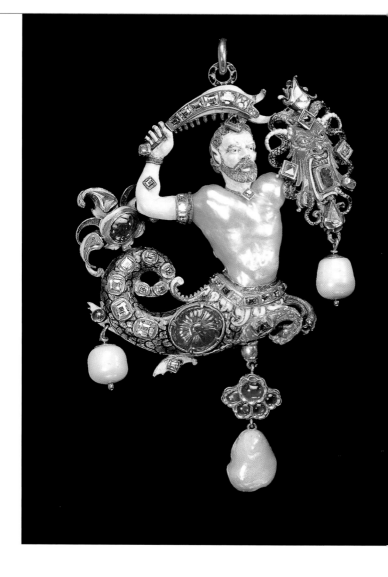

Flemish
manufacture
(16th c.),
Canning Jewel,
London, Victoria
and Albert
Museum.

the earlier part of the century also passed from fashion, but they remained in use in lascivious Venice, where women had been allowed to continue wearing low-cut dresses. Loops of *sautoirs* encircled bodices stiff like suits of armor but gleaming with gems and encrusted jewels, while imaginative devices such as aigrettes studded with pearls decorated ladies' heads. Pearls once again returned to their role as decorative gem, sewn directly onto material. The anonymous portrait of Queen Elizabeth I of England in the National Portrait Gallery in London is a fine example of this fashion and indicates the esteem in which the queen held pearls. Despite the huge quantity that had been imported into Europe by the middle of the century, the English crown's demand for pearls was so great that Elizabeth (1533–1603) was forced to buy artificial pearls to decorate her dresses. The necklace worn by the queen in the portrait has a long history. It was given to Catherine de Medici (1519–1589) by Pope Clement VII (1478–1534) in 1533, as a wedding present upon her marriage to Henri II of France (1519–1559). When Catherine and Henri's son, Francis II (1544–1587), married Mary, Queen of Scots (1542–1587), Mary received the necklace. Upon her husband's death, less than two years later, Mary returned to Scotland. The necklace was then inherited by Mary's son, James (1566–1625), who sold it to Elizabeth.

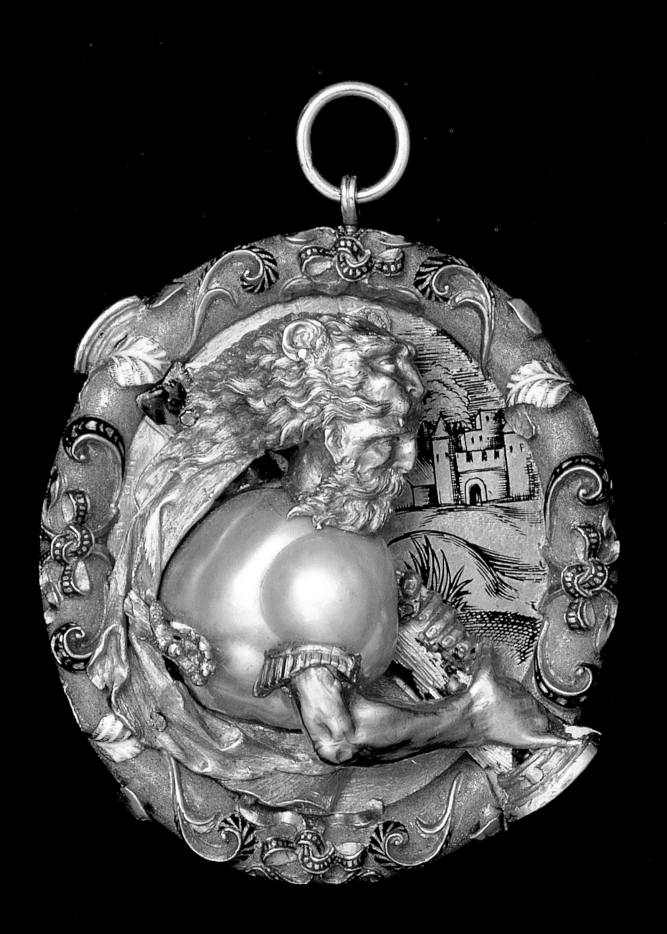

Elizabeth's bitter enemy, Philip II of Spain (1527–1598), also owned huge quantities of gems and pearls, which were continually shipped to Spain from his new territories in America. One of these was so large it was given a name, *La Peregrina* (the Rare One). Found in Panama, the pearl was taken to Spain around 1560 to enrich the treasure chest of the king. It has changed hands many times and is currently owned by Elizabeth Taylor.

Very often pearls were used to decorate head ornaments for both men and women. Their use with a setting and a metal support has been more enduring than as objects in their own right; necklaces and strings of pearls were never expected to last long due to their fragile nature.

As technical craftsmanship developed in the sixteenth century, decoration progressively veered toward elaborate, brilliant and skillful designs. Complex motifs of human figures, animals, gods and monsters began to replace the abstract styles of the previous century, and the simpler formats of a colored stone with a drop-shaped pearl gave way to more elaborate pendants. Small, lost wax sculptures in gold and *en ronde bosse* enamels were hung from chains in strange and wonderful designs. The most imaginative examples of sixteenth-century jewelry were made using large baroque pearls of surprising and irregular shapes, framed in precious metal and enamel to create animal or human forms. These designs formed a fantastic world populated by exotic animals, fauns, Neptunes and sirens that straddled the boundary between attractive and disturbing. Originating mostly from the

jewelry workshops of the Netherlands, these unusual ornaments were highly appreciated in the refined courts of Europe, but not just as mere decorations. In fact the roots of their success lay in the philosophical foundations that underlay the taste of the era. In the second half of the sixteenth century, a strong awareness of materials guided the international collectors, who expanded their collections of art and natural objects to include new interests that conceptually altered their philosophical meaning.

The rarity and value of gold and gems have made them the natural products that man has always most wanted to possess. The beauty of nature finds sublime synthesis in the intense colors of precious stones and the shine of gold, to the extent that these materials have become nature's most attractive symbols. Inspired by the theocentric notion of *reducere ad unum*, medieval lapidary literature had formerly celebrated nature as the sophisticated result of God's creative power through the classification and description of gems. To the medieval emphasis placed on nature and divine creation, the Renaissance added an interest in Man himself, whom God had created in his own image (Genesis 1, 26) and whom he had endowed with the gift of inventing and producing works of art (Exodus 35, 30). Illuminated by this idea, sixteenth-century collections were developed along two lines: the first concerned the *naturalia* products of God and the second the *artificialia* products of man, in a sort of imaginary contest between the beauty of nature and the beauty of art. Baroque pearls were not only as highly esteemed as regularly shaped pearls, but each

Flemish manufacture (16th c.), *Pendant in the Form of a Triton, in Gold, Enamel, Precious Stones and a Pearl,* **Geneva, Christie's.**

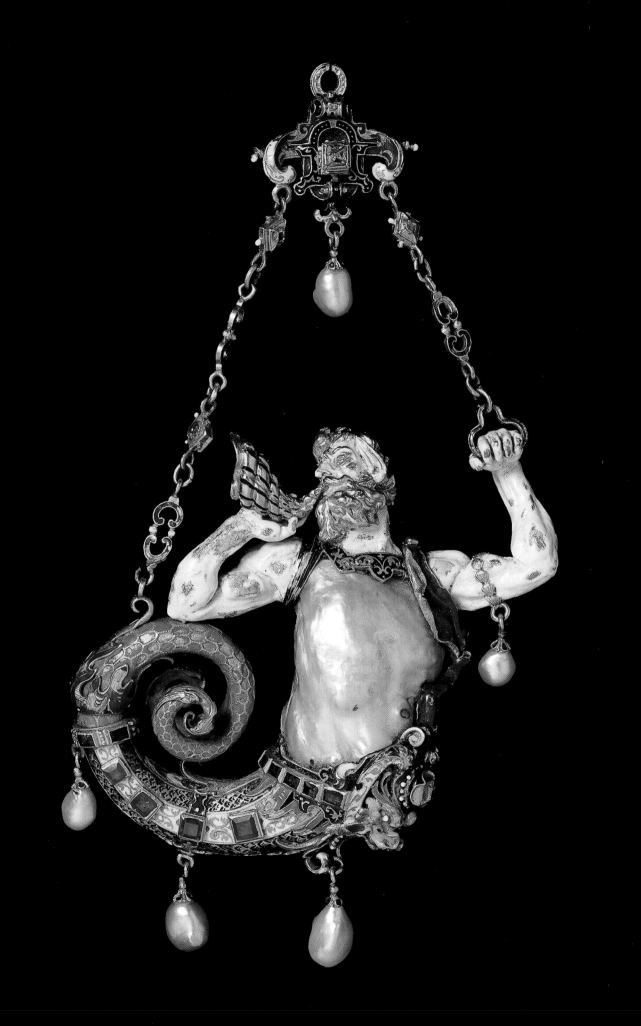

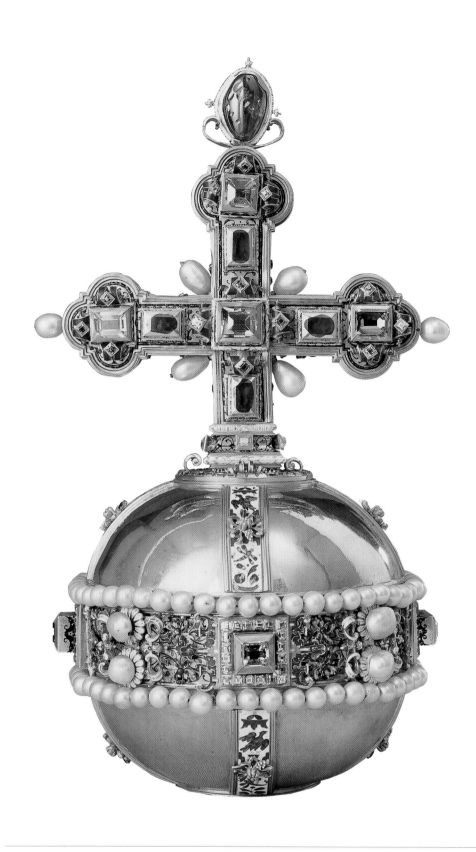

Andreas Osenbruck, *Imperial Globe*, Prague 1612–15, Vienna, Schatzkammer.

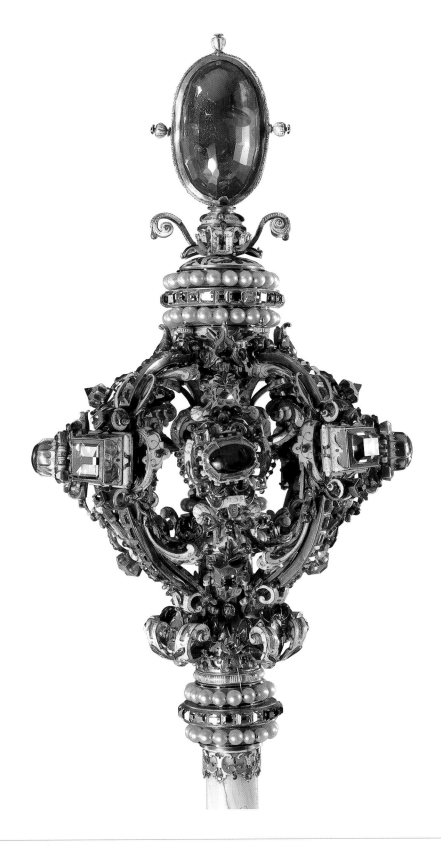

Andreas Osenbruck, *Imperial Scepter*, Prague 1615, Vienna, Schatzkammer.

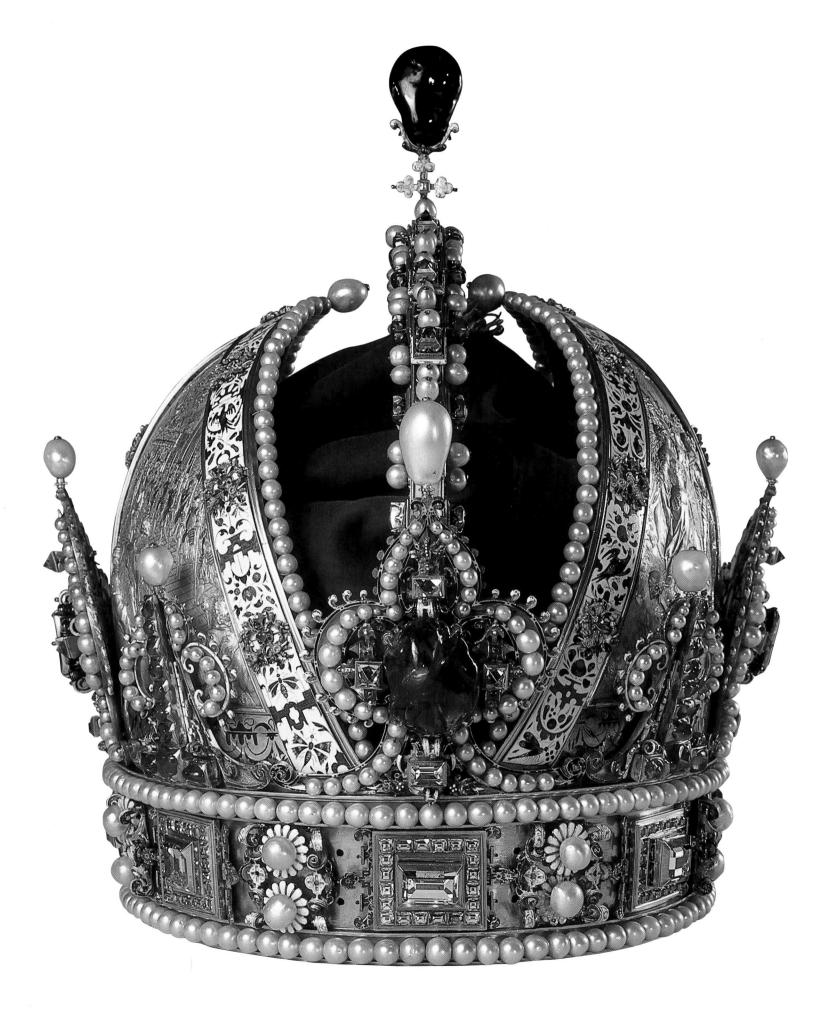

one was unique in form and appearance. These shapes were enhanced by the creative interpretations of jewelers who achieved delightful mixtures of *naturalia* and *artificialia* to create inventions that combined nature and technique in a manner that satisfied the contemporary philosophy of aesthetics. This sort of object found a home both in the courts of Europe as a jewel and in the unusual collections known as *Wunderkammer*, assembled by the most sophisticated and eccentric crowned heads. *Wunderkammer* collections contained articles that were bizarre and beautiful in equal measure; Rudolf II, Ferdinand of the Tyrol and Francesco I de Medici were typical proponents of this new trend.

The *galanterie ingioiellate* belonging to Anna Maria Ludovica de Medici (1667–1743) was an extraordinary collection of such objects and is now displayed in the Museo degli Argenti in Florence. In this collection, articles of different manufacture show an unusual stylistic unity, in which baroque pearls are used as the basis for a number of bizarre creations: gondolas, dragons, lions, deer, sirens, Tritons, horses, cocks, rabbits, oxen, frogs, spiders, ostriches, mice, tortoises, lizards, rams, lambs, butterflies, elephants, camels, monkeys, peacocks and even a profile view of a newborn baby in the cradle form part of the symbolic world of Anna Maria Ludovica's *galanterie ingioiellate,* items of jewelry and *objets de vertu* based on baroque pearls, the last talismans of the symbolic language of European Mannerism.

Jan Vermeyen,

Crown of

Emperor Rudolf II,

Prague 1602,

Vienna,

Schatzkammer.

German manufacture (?) (17th–18th c.), *Cameo Habillé in Onyx, Gold, Enamel and Pearls with Portrait of Anna Maria Luisa de Medici*, Florence, Museo degli Argenti.

German manufacture (?) (17th–18th c.), *Cameo Habillé in Onyx, Gold, Enamel and Pearls with Portrait of Johann Wilhelm, Elector Palatine,* Florence, Museo degli Argenti.

Baroque Opulence Displayed in Flowers, Bows and Pearl Necklaces　　　　With the outbreak of the Thirty Years War across Europe, a drastic wave of disapproval brought to a halt the uninterrupted repetition of Mannerist forms, now almost depleted of the philosophical values of the previous century. The war led to the end of Spain's influence in women's jewelry and fashions that had lasted from the end of the sixteenth century until the end of the war, and in its place saw the rise of trends from the Netherlands and France. During this period, Italy had been cut out of the struggle for European power and began an inevitable period of decline that was reflected in its artistic creativity, yet it still had the energy to produce a style that was to be assimilated by the other European countries and form a new international artistic language: the Baroque.

Baroque elements also filtered into the worlds of clothing and jewelry, creating reference points for a European-wide fashion based on a return to classicism as a reaction against the late-Mannerist complications that were now considered intellectually abstruse. The classical age softened the symbolic and extraneous values of Mannerist jewelry, with more emphasis on the purely decorative. With the abandonment of the stiff, heavy velvets of Spanish fashion, clothes became loose, comfortable and light with the use of shot silk and taffeta. The luxuriant physical beauty of opulent European noblewomen was emphasized by wide *décolletés*, skirts with trains, short but richly-worked sleeves, and a tight bodice around the waist to accentuate the figure. The large wigs worn

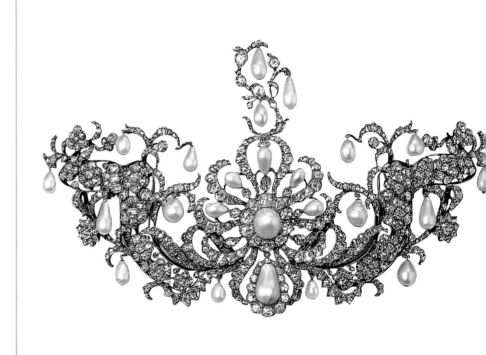

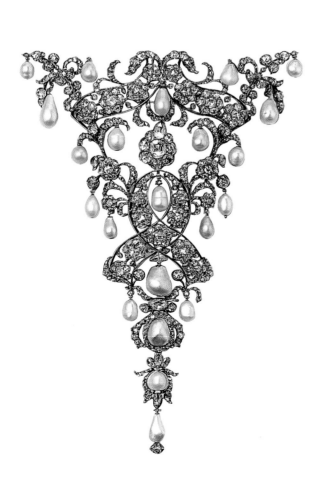

German
manufacture
(1710–1720),
*Corset Ornaments
in Gilded Silver,
Diamonds and
Pearls,* Munich,
Schatzkammer
der Residenz.

by men were almost the symbol of a fashion that wished to stress the grandeur of the individual by giving greater height, breadth and a sense of theatricality to the figure.

In this new notion of elegance, a small enameled jewel created using the lost wax method would inevitably pass unnoticed so the sudden rejection of Mannerist values was also absorbed by the jewelry trade and the new majestic dignity of the Baroque welcomed in its place. Multi-colored enamel figures gave way to the luminous brilliance of precious stones set purely and simply on a support of gold.

And pearls? They were more fashionable than ever, though they were rivaled for their position as the most popular gem by a new contender, the diamond. The discovery of diamond mines in India resulted in a growing flow of the stones into Europe via Flemish dealers. Major technical progress in the cutting of precious stones, particularly diamonds, had been made by the craftsmen of the Low Countries, overcoming the uncertainties and difficulties raised in previous centuries by the stones' physical hardness. Large numbers of round and drop-shaped pearls continued to flow into Flemish markets from the Orient, and the adoption of broader volumes in clothes meant that larger pearls were required to match. A painting by the Dutch painter Vermeer (1632–1675) shows a young woman with a small scale in her hand weighing a pile of small pearls. The painting, titled *A Woman Weighing Pearls* (1662/63 ca.), is evidence of a flourishing pearl market that required specific services from individuals for successful commercialization of the product. Round pearls were threaded onto simple strings or on long *sautoirs* that could be worn either singly or in multiple strands, loose or pinned to the center of the close fitting bodice with special pins called *devant le corsage*. A typical form of the pin in the seventeenth century was the *sevigné,* in the form of a complicated bow, named after Louis XIV's favorite marquess. Simple pearl bracelets were also popular, often worn in pairs, and earrings underwent a revival. In addition to the traditional pearl drop, common in the previous century, a more elaborate form entered fashion: this was the

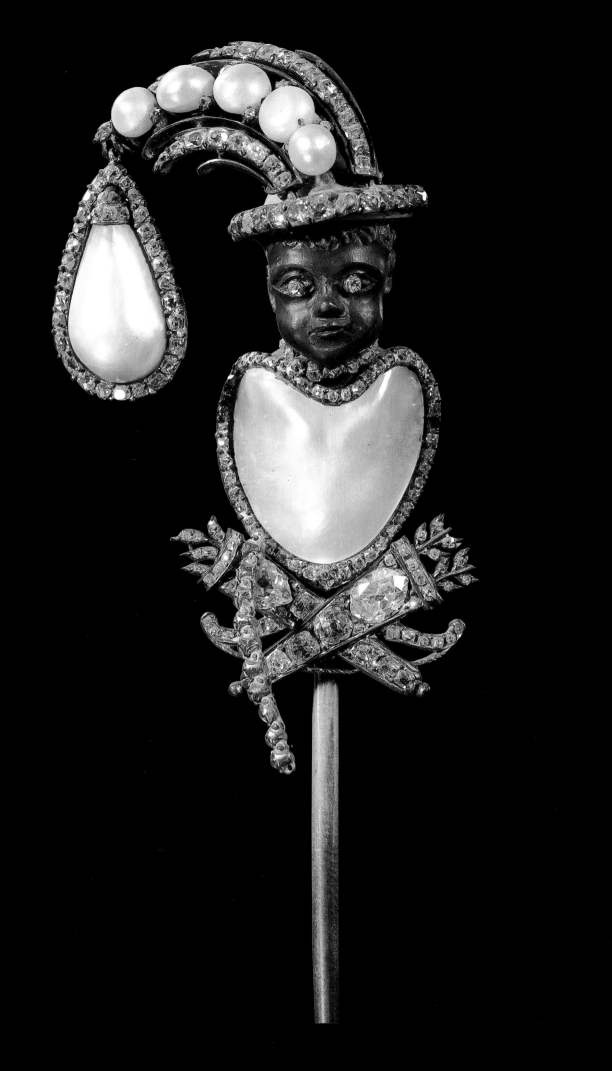

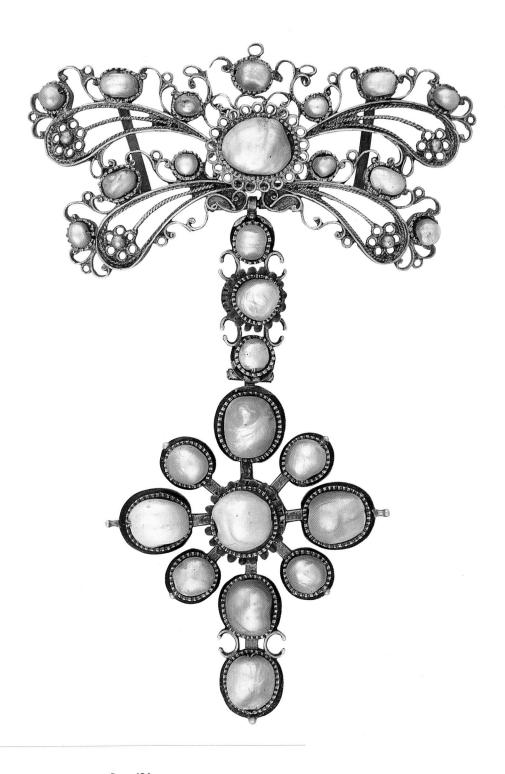

Page 134:
German manufacture
(17th–18th c.), *Aigrette in
Gold, Onyx, Diamonds and
Pearls,* Amsterdam,
Rijksmuseum.

Spanish manufacture
(end 17th c.), *Pendant in
Gold, Enamel and Pearls,*
Milan, Poldi Pezzoli.

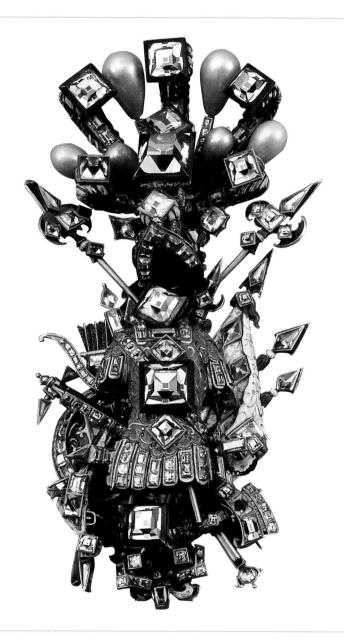

German
manufacture
(17th c.), *Panoply
Brooch in Gold,
Enamel,
Diamonds and
Pearls,* Munich,
Schatzkammer
der Residenz.

earring known as *à girandole* with a pendant in a precious metal that was also often decorated with pearls. Marine gems were ideally suited to display the new classical taste in fashion and jewelry, yet few examples from this era have survived to the modern day, particularly when compared to jewelry from the previous era. Ironically, the reason seems to be the seventeenth century's fondness for the gem. The material value of pearls in sixteenth-century jewels was worth far less than the artistic work of the jeweler. Disassembly and melting down of Renaissance jewelry was simply not worth the trouble for the limited materials they provided, whereas the abundance of precious stones and pearls made the reuse of jewelry from the following era worthwhile. Besides the love of decorative effect, Baroque jewelry was endowed with another distinctive feature: it was inspired by the forms and colors of nature, and flowers, in particular, were of unusual importance in art and jewelry during this period.

For the first time in the history of art, plants of all kinds became the central feature and dominating motif in much European pictorial art, with flowers especially becoming the unquestioned model for artists in every field. They also triumphed in jewelry; as a real subject present in nature, they gradually replaced sirens and other fantastic creatures as the most popular image in sixteenth-century jewels.

In Tuscany, the scientific interests of Cosimo I de Medici had opened the way to a dynasty of Grand Dukes who were alchemists and collectors of *artificialia* and *naturalia* of all types. Now, aristocrats' direct experience of nature provided a stimulus that caused naturalists, painters and decorators, weavers, cabinet makers, marble workers and jewelers in the Florentine court to unite in a bout of intense artistic activity. The garden became more than a botanical source of therapeutic substances and was celebrated as an aesthetic world, a paradise of delights and a source of all the perceptions possible through the five senses. In Paris at the end of the sixteenth century, the naturalist Jean Robin opened his garden so that decorators, embroiderers and jewelers could used his botanical curiosities as models. Sixteen thirty-four was the year of "tulip mania." The hobby of gardening spread through the aristocracy and the whole of Europe was caught up in the new euphoria. Numerous scientific treatises, so-called "florilegia," were produced for the benefit of artists, where detailed illustrations provided visual recognition of the flower or plant represented.

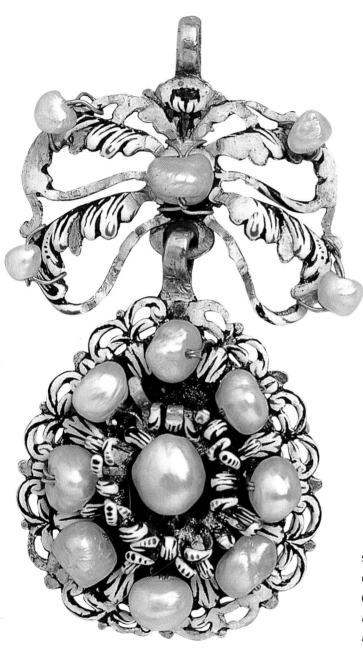

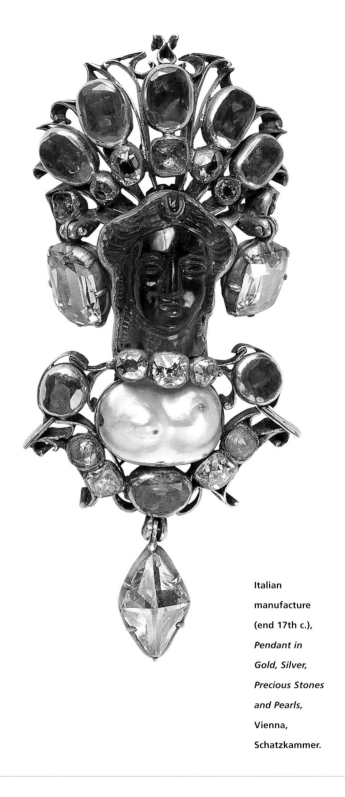

Spanish
manufacture
(mid-17th c.),
Earring in Gold,
Enamel and
Pearls, Milan,
Poldi Pezzoli.

Italian
manufacture
(end 17th c.),
Pendant in
Gold, Silver,
Precious Stones
and Pearls,
Vienna,
Schatzkammer.

The new fashion profoundly affected jewelry; polychrome enamel flowers covered the backs of clocks and brooches, ornamental bouquets adorned the décolletés of the wide, flimsy dresses, and flowered aigrettes made with colored stones completed the head coverings of seventeenth-century gentlewomen.

But it was above all in the court of Louis XIV of France (1638–1715) that the fashions and enthusiasms in the second half of the century had their origin. The Sun King inherited a love of jewelry from his mother, Anne of Austria (1601–1666), who had gold and silver toys made by the court goldsmith for Louis to play with as a boy. The king's collection of jewels was magnificent in its variety and in the splendor of the gems he liked to give away as presents. He gave a superb pair of pearl drops to his favorite, Maria Mancini, the niece of Cardinal Mazarin (1602–1661), which then became known as the "Mancini pearls." Gifts of jewels and precious stones became a costly and elitist habit in this glorious age. In a 1680 edition of the magazine *Mercure Galant*, a chronicler wrote of a singular episode of gallantry by the king of Spain: the day after a hunt, the king sent the queen his kill with a message that the gift soon would be followed by a suitable accompaniment, a well-seasoned salad. The next day, the queen was presented with the salad: it was a gold plate filled with emeralds, rubies, topaz and tiny pearls. The emeralds represented the leaves, the rubies the vinegar, the topaz the oil, while the salt in this bizarre dish was represented by dozens of tiny pearls.

Pearls for Evening and Day Wear from the Rococo to Nineteenth-Century Eclecticism

Eighteenth Century: The Diamond Takes Center Stage The eighteenth century was a time of unshakeable optimism and faith in human reason, when relentless social and economic tensions led to the French Revolution. This was the most extreme event to take place in a century-old crisis in which the hunger and poverty of the ordinary people was contrasted with the pomp and splendor of the aristocrats who used excess as their standard of judgment.

In the eighteenth century jewelry expressed fashions more than ever. It represented the obsession and hallmark of an aristocracy that, unaware of the changing times, displayed extreme disapproval for anyone who did not have the economic and social means to flaunt a lifestyle that revolved around hunting, banquets, salons and court festivals. At the start of the eighteenth century, the eyes of all Europe were on the French court where the magnificence of the Sun King seemed to shine on even after his death. His successor, Louis XV (1710–1774) did not have to do anything except develop the tastes of the previous century with lighter and more slender forms without, however, altering their basic conception; everything that was part of the life of a member of royalty or his court had to be exquisite. Each tiny accessory seemed to be bejeweled: snuffboxes, clocks, knobs on walking sticks, even shoe buckles were designed to be settings for precious stones. And new accessories were invented, such as *chatelaines* for clocks, and richly-worked equipages for gentlewomen who never went out without their *carnet* for taking down notes, their equipment for needlework or powder for their face makeup. Clothing became elaborate: wasp waists were enforced by the use of tight corsets, hooped skirts open at the front showed layers of petticoats, and wigs, which became very fashionable, were occasionally replaced

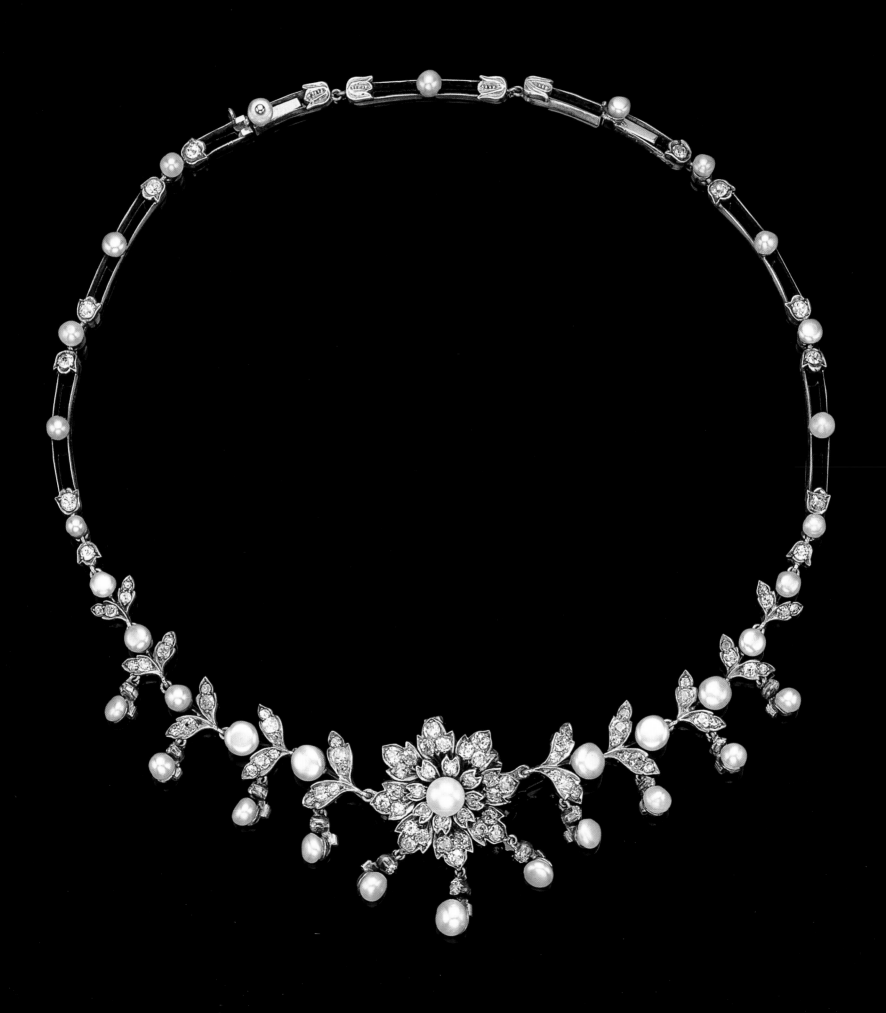

by powdered hair that framed porcelain faces on which false beauty spots were strategically placed. The classic motifs of flowers and feathers on aigrettes developed into more bizarre designs featuring birds and butterflies applied on metal spirals to create the effect *en tremblant.* Attention was drawn to ladies' necks with the use of elaborate *colliers de chien* that sparkled with gems or exquisite *rivières,* often accompanied by long en suite pendant earrings. And the materials used? Most popular was the diamond whose optical properties were enhanced by new cuts. At the end of the previous century, the fashion had arisen for evening gatherings in aristocrats' salons. Artificial lighting using candles gave diamonds the opportunity to emit their multifaceted sparkle so that, when new deposits were found in Brazil, a huge quantity was imported to Europe, creating a euphoria for jewelry in general and for diamonds in particular.

One famous *collier a rivière* studded with diamonds played a large role in the social crisis that culminated with the French Revolution. This was a necklace made from a string of seventeen large diamonds from which hung three festoons and three other pendants, all of diamonds. The whole was set off by a double *rivière* with four bow motifs. This ornament was commissioned by Louis XV for one of his favorite mistresses, Madame du Barry, but as it had not been completed on the king's death, it was offered to his successor, Louis XVI, who refused it as being too expensive. Jeanne de Saint Remy, the wife of the Count de La Motte, dreamed up an elaborate scheme to get her hands on the extraordinary necklace, whereby she took advantage of the unsuspecting Cardinal De Rohan. By passing herself off as a lady-in-waiting of the queen, Marie Antoinette (1755–1793), she requested

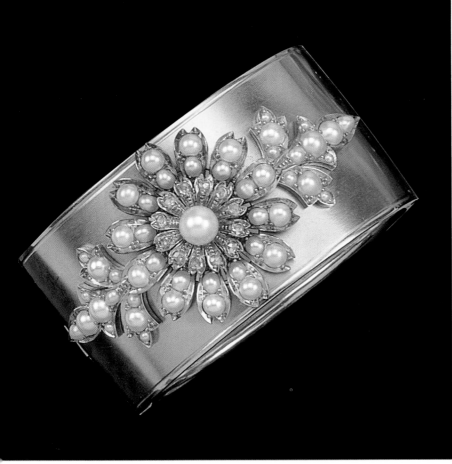

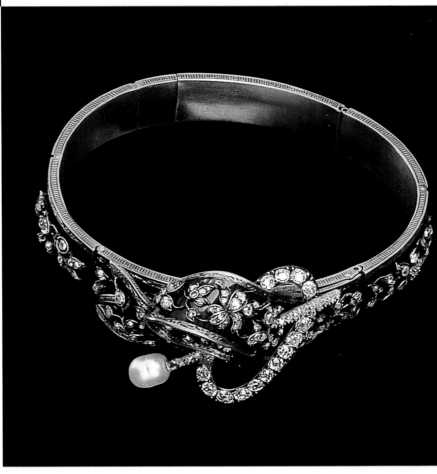

English manufacture (1850 c.), *Bracelet in Gold, Enamel, Diamonds and a Pearl*, London, Sotheby's.

Top, left: English manufacture (1880 c.), *Bracelet in Gold, Diamonds and Pearls*, London, Sotheby's.

Next page:
European manu-
facture (1890
c.), *Collier in
Gold,
Diamonds and
Pearls,* London,
Sotheby's.

and received funds from the cardinal for charitable purposes, in the queen's name. Later, she managed to persuade the cardinal that it was the queen's ardent desire to purchase the necklace, unknown to the king and with the cardinal acting as a mediator. Ignorant of the trick, the cardinal did as he was asked and the necklace was given to a servant of the queen, a sixteen-year old who fled to England and sold the diamonds. The necklace had been obtained on credit and when the jeweler asked the queen for payment, the fraud was discovered. In the complicated events that followed, which involved Giuseppe Balsamo, Count Cagliostro (1743–1795), who was an expert in cabal and advisor to the cardinal De Rohan was involved, too. He was obliged to spend some time in the Bastille, despite being judged innocent. Jeanne de Saint Remy was also sent to prison, but the entire affair inexorably stained the reputation of the innocent Marie Antoinette. The queen's passion for jewels and diamonds gave the aura of truth to the claims made by the adventuress, Saint Remy, who probably did not have to go to extremes to convince those involved of the queen's interest in the magnificent necklace. The 1791 inventory of the jewels belonging to the French monarchy reveals that the queen's crown contained twenty-five large round pearls and that she had a further three hundred and ten pearls arranged on eleven strings. Part of the treasure that belonged to the unfortunate queen was later sold to millionaire Franklin Laws Hutton.

Classic pearl jewels were also part of the *corbeilles* de *mariage* of the French and English aristocracy. When describing her own jewels, Queen Charlotte, wife of the English king George III (1738–1820), noted how it contained large pearls known by the king

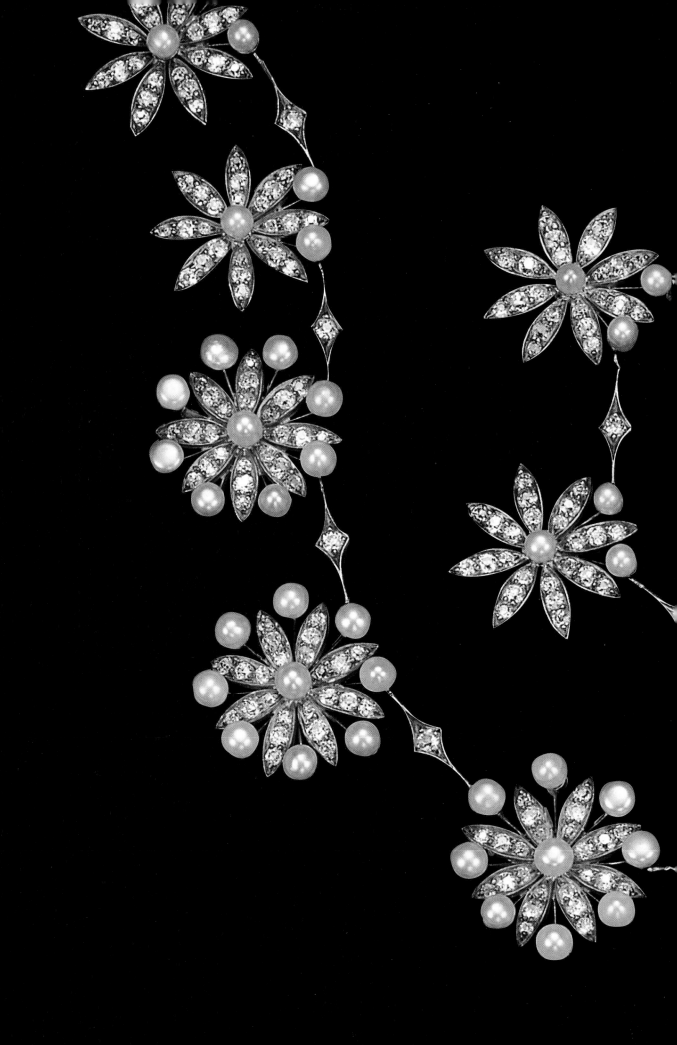

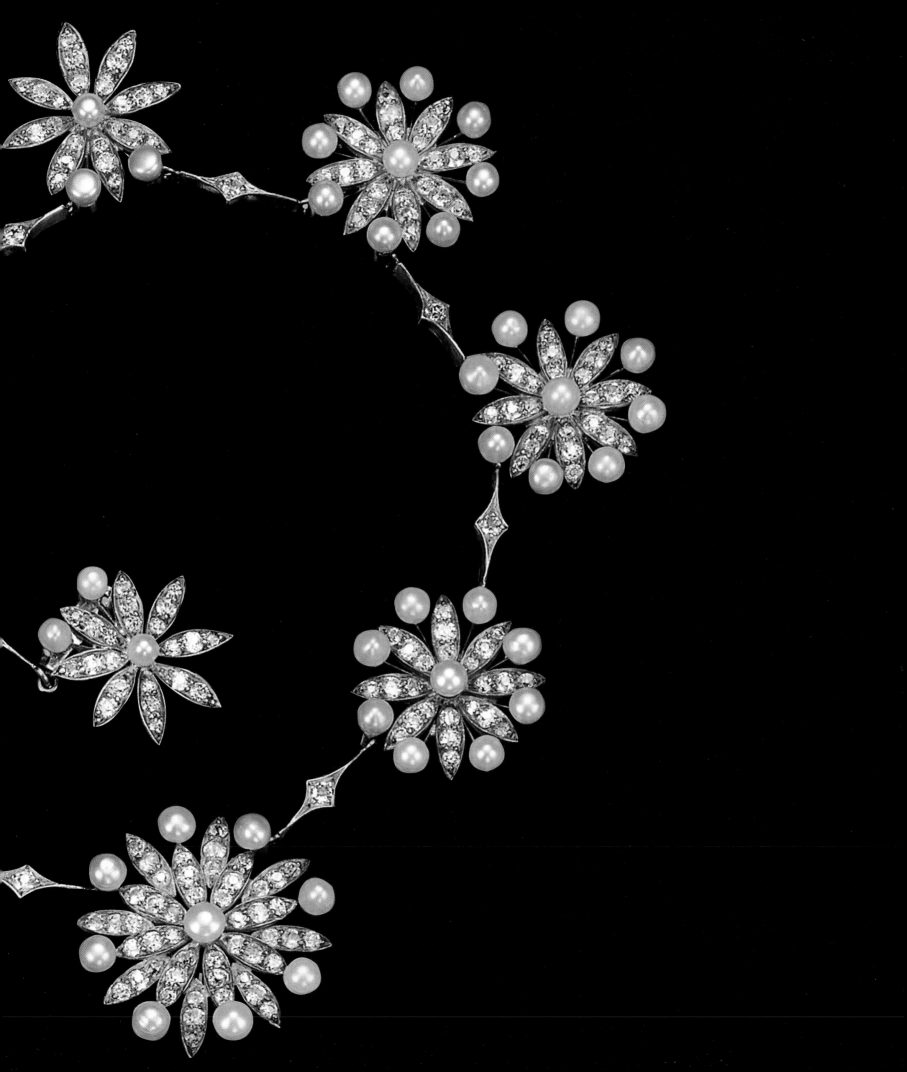

as the "family pearls." Mounted on a necklace, the forty-one pearls had been given to Charlotte on her arrival in England, along with a pair of pearl drops surrounded by diamonds.

In Italy, pearls were second only to diamonds as the preferred components in a luminous but fundamentally neutral piece of jewelery. Long *sautoirs* of pearls were worn over the bodice while short sleeves, as dictated by the fashion of the period, left the wrists free to be adorned by twin bracelets of several parallel rows of pearls. Pearls also adorned head-coverings and were used with diamonds to embroider the clothes of the royal families, while traditional pearl drop earrings, though overshadowed by sparkling *pendeloques* of diamonds, remained part of women's *parures* throughout the century. The many pearl ornaments in the inventories of the Savoy family at this time included an enormous single pearl that weighed forty-three carats, called "La Pellegrina" (the Pilgrim). A century earlier it had been mounted with two other drop-shaped pearls on a brooch that bore a large diamond at its center. The similarity of the Italian name suggests it was possibly the large pearl, La Peregrina, found in Panama in the middle of the sixteenth century, which entered the property of Philip II of Spain. If that were the case, the Savoys were then one of the owners of the famous gem that found its way to the hands of Elizabeth Taylor.

The pearls of the eighteenth century were also worn on the fingers, set in rings. In Venice, the noblewoman Lucrezia Basadonna Mocenigo was famous for her *corbeille* of jewels and strings of pearls, among which was the legendary pearl ring that gave rise to the family nickname "Mocenigo delle perle."

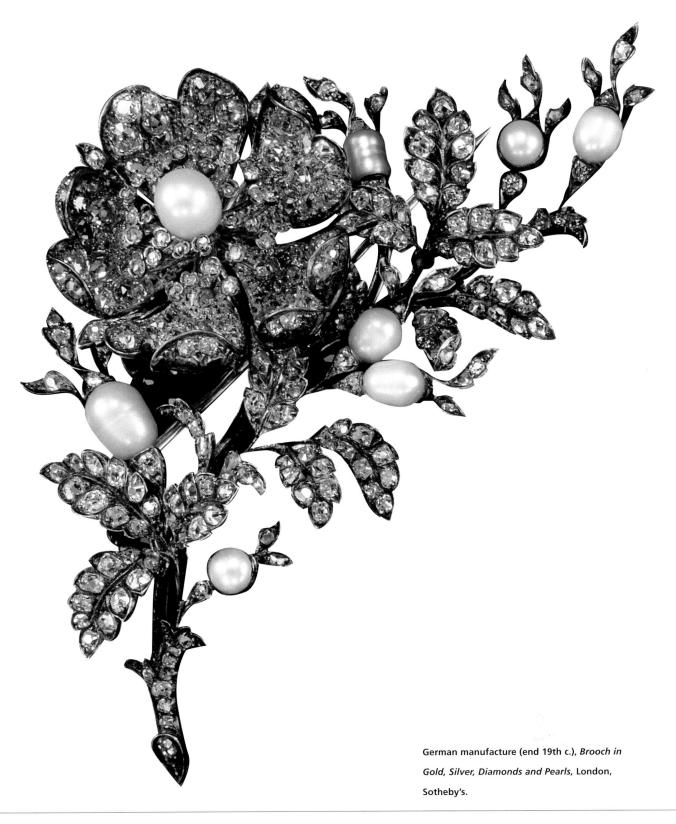

German manufacture (end 19th c.), *Brooch in Gold, Silver, Diamonds and Pearls*, London, Sotheby's.

Next page: German manufacture (?) (1890 c.), *Plaque for a Choker in Gold, Silver Diamonds, Amethyst and Pearls*, London, Sotheby's.

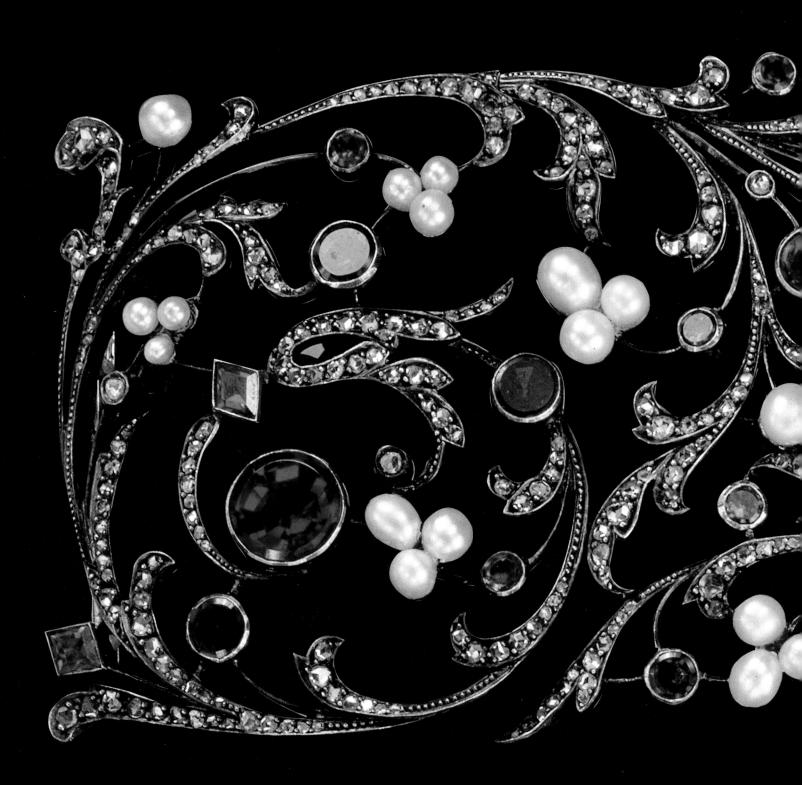

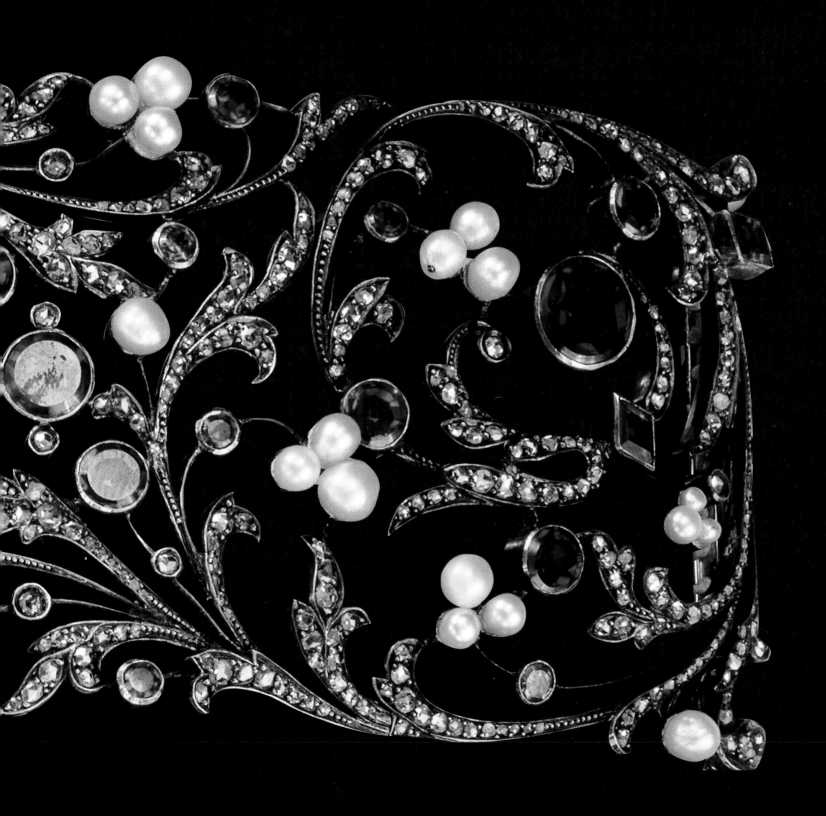

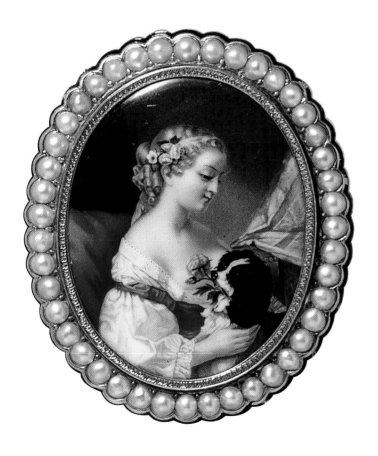

English manufacture (?)
(19th c.), *Cross Pendant in
Gold, Lapis Lazuli and Pearls*,
London, Christie's.

French manufacture (?)
(19th c.), *Brooch with a
Miniature in Gold, Enamel
and Pearls,* London, Christie's.

Romantic Jewelry: Pearl Flowers and Symbolic Animals The French Revolution marked the moment when, along with the French royal family and nobility, magnificent items of jewelry fell into disrepute as the most outward sign of excess. The pitiless blows of the guillotine resulted in the abandonment of crowns, diadems, sparkling earrings, and pearl and diamond aigrettes, considered the useless ostentation of the excessive wealth that contrasted with the poverty of ordinary people. During the gloom of the Terror, even the possession of a pair of silver shoe buckles could be compromising, setting the stage for candidature to the guillotine. The Constituent Assembly had dissolved the Company of Goldsmiths in 1791, so that jewelers found themselves practically without work, if not actually in hiding for having served the hated aristocracy. The Crown Jewels were put up for sale in 1795, in disdain for what they had once represented, and to meet impelling economic necessities. But this "iconoclastic" wave fizzled out after a few years, and by 1802 it was no longer considered an insult to democracy to wear diamonds. The following year, Napoleon (1769–1821) was able to have what remained of the Crown's treasure restored, to adorn his wife Josephine Beauharnais (1763–1814), whose passion for jewels and gems is well known. Official paintings show her literally covered with pearl ornaments. Although not traditionally beautiful, the empress was elegant and fascinating and knew the art of dressing well and enhancing her regal graciousness with jewels and pearls. The means at her disposal were never sufficient to satisfy her enormous desires, which made her a favored customer of nearly all the Parisian jewelers. Her jewelry was described in an inventory in 1809: three pearl necklaces of various lengths and styles, two pairs of pearl earrings, a *parure* of pearls, and cameos consisting of a *bandeau,* a necklace, a comb, a pair of earrings and a belt.

French manufacture (?) (19th c.), *Bracelet in Gold, Enamel and Pearls,* London, Christie's.

English manufacture (?) (19th c.), *Necklace in Gold, Emeralds and Pearls,* London, Christie's.

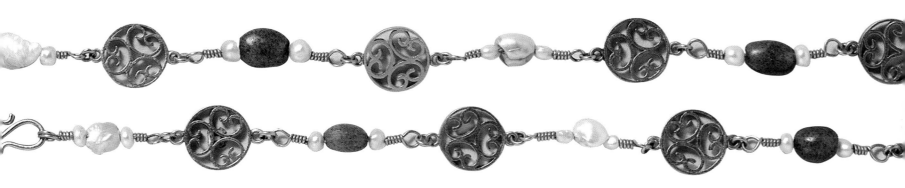

In addition to Josephine's well-loved pearls and gems, which she brought back into fashion after a period of enforced obliv-ion, a new but ancient decorative motif began to find popularity in the nineteenth century, the cameo. The Greco-Roman inspiration of Napoleonic jewelry was clearly derived from the way in which the jewels were worn and from the styles of the orna-ments themselves. As during the sixteenth century, classical statuary came back to influence contemporary taste. For example, inspired by the laurel wreaths on Roman busts, the empress wore magnificent diadems of golden leaves with diamonds hanging over her forehead, to hide the attachment of the brown wigs arranged *à la grecque,* in keeping with the fashion of the day. The revival of classical taste in cameos spread through France from Napoleon's Italian campaign onwards. Pieces of jewelry of all kinds began to be decorated with cameos, whether made from agate or shell, such as diadems, necklaces and the bands that were worn in matching pairs on the upper arms and forearms. Often the cameos were ancient originals adapted to modern ornaments; they were used to decorate shirt fronts, belts and brooches in the center of the *decolletage* and were also worn on the shoulders. They were set with diamonds, but often also with pearls on the frame. Upon the dissolution of her childless marriage, Josephine was replaced by Marie Louise (1791–1847), the Austrian princess whose more modest demands and less certain likes and dislikes caused Napoleon himself to take charge of her *corbeille de mariage.* He bought her a pearl the size of a pigeon's egg, which was given the sonorous name "La Regente" and used to adorn a specially-made diadem. In the jewelry case of the new empress of France, twenty-four cameos from the king's collection were set with tiny pearls in a *parure* made from numerous pieces.

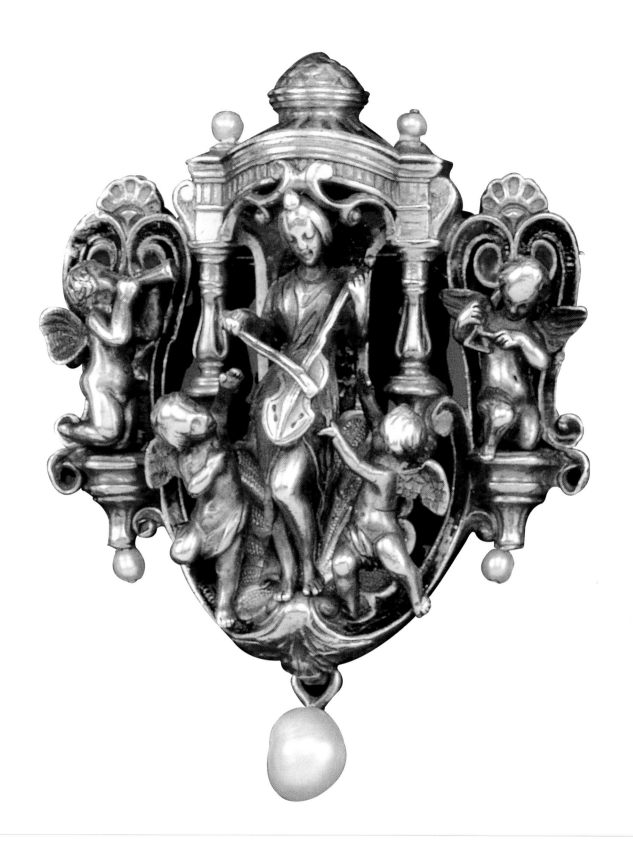

François Froment-Meurice
(1802–1855), *Brooch with
Allegorical Personification of
Harmony, in Silver and Gilded
Silver, Enamel and Pearls,*
London, Sotheby's.

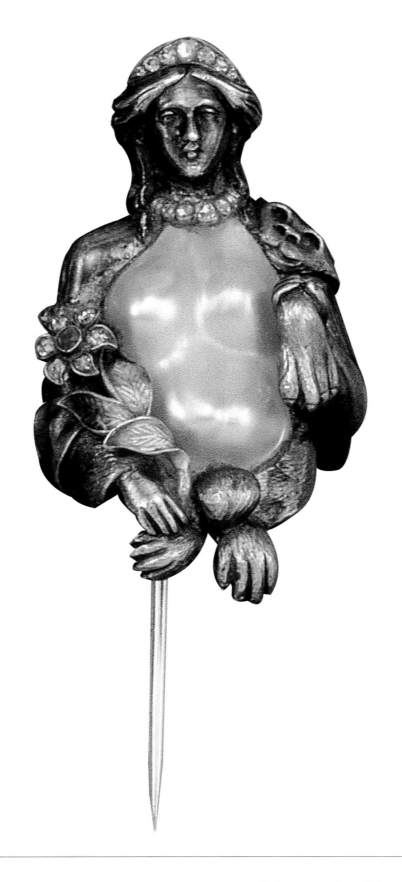

French manufacture (19th c.), *Tie-pin with Omphale, in Gold, Burnished Silver, Enamel, Precious Stones and a Pearl*, London, Sotheby's.

Page 160–161: Augusto Castellani (mid-19th c.), *Necklace and Earrings in Gold and Pearls*, Rome, Medagliere Capitolino.

At the start of the nineteenth century, pearls were given the dual functions they had had during the Renaissance. Large, round pearls were bored to make one or two-stringed necklaces and armbands, while baroque or drop-shaped pearls were used to decorate brooches, pendants and diadems made from gold or silver and set with precious stones. In addition to these uses, pearls were also associated with the difference established during the previous century between jewels for evening wear and for day wear. Extraordinarily versatile, pearls successfully lent themselves to the most splendid ornamentation, for use on special occasions, but also to the less worldly but equally imaginative displays of daytime *parures* that met with great success during the nineteenth century. Nothing was considered more elegant for an evening gala than the wearing of large pearl drop earrings, and a pearl necklace was suggested by fashion journals as the ideal ornament for ladies who wished to highlight their silky complexion at a ball.

The return of the Bourbons to the throne in 1814 was set against the poverty suffered by France as a result of the revolution and the Napoleonic campaigns. The aristocrats who had fled during the Terror refound their place in society on their return, but they no longer enjoyed the inherited wealth that had at one time supported their costly habits at court. Both the penniless nobility and Napoleon's ex-functionaries attempted to integrate themselves with the Bourbon entourage, and the resulting social mix had tangible effects on taste. The brilliant uniforms of the ex-imperial court were flanked by the powdered wigs from the age of Louis XVI; jewelry was extravagant, but the stones used were almost always semi-precious with aquamarines, topaz and

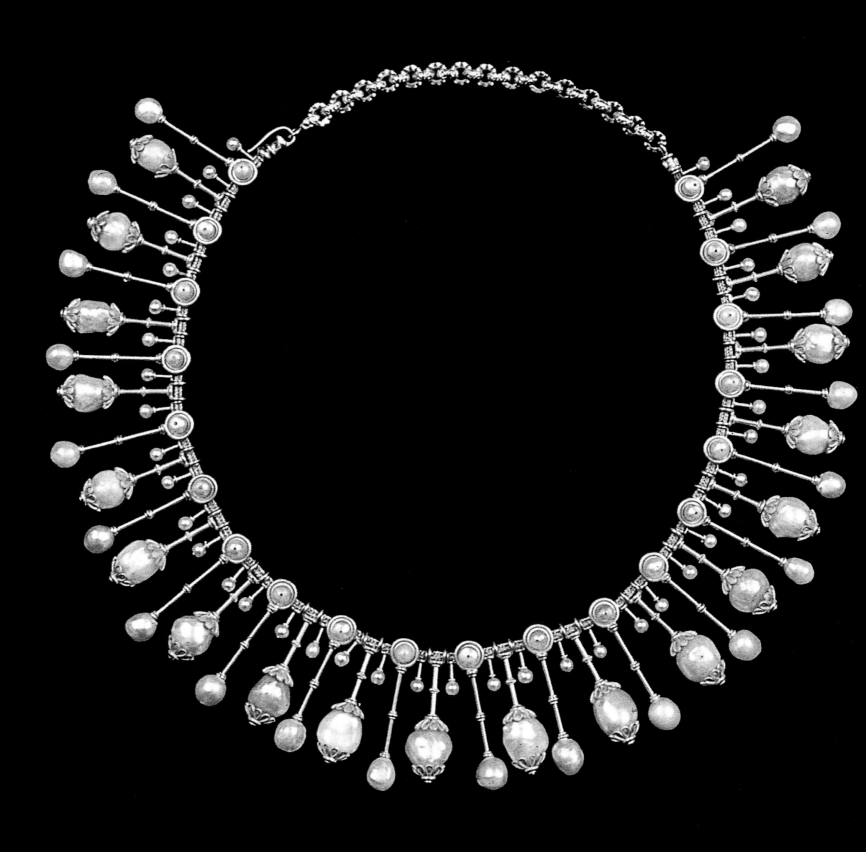

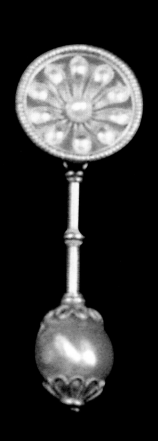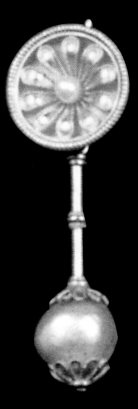

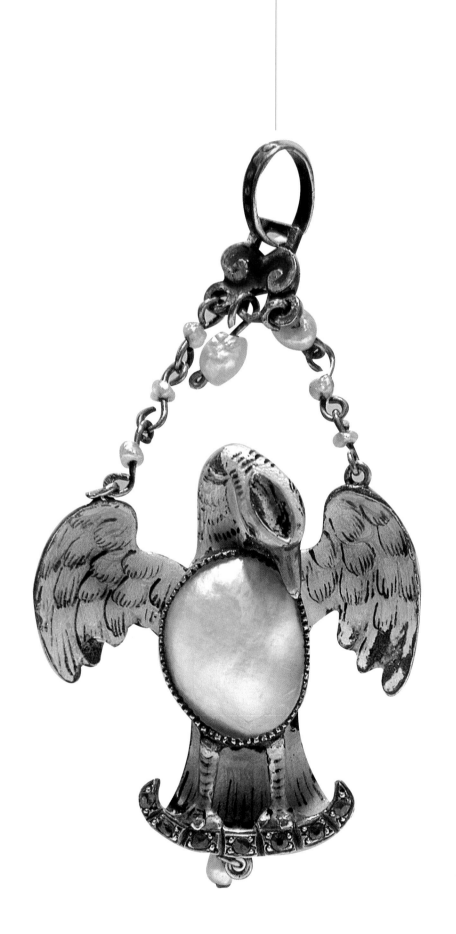

Austro-Hungarian manufacture (mid-19th c.), *Pelican in Gold, Silver, Enamel, Rubies and a Pearl,* Florence, private collection.

amethysts from Brazil and Mexico being popular. The desire to match personal ornaments to particular moments of the day caused each material to be associated with a social role or certain occasion, but pearls, though costly, maintained their primary role in *parures* as a sophisticated and prized component of female beauty. The habits of Louis Philippe (1773–1850), who preferred a quiet life to the pomp of the court, only succeeded in narrowing the gap between the aristocracy, impoverished of its inheritances, and the new, moneyed bourgeoisie that was infinitely more solid and optimistic, and desirous of acquiring those symbols that signified their new tenor of life. It was during this period that Romantic jewelry reached its apogee. But what was Romantic jewelry? And what role did pearls play in this new genre that differentiated it from the brilliance of court jewelry?

Romanticism was not a style like the Baroque, Rococo or Neoclassical; it was more a movement that, disregarding both the subject and the narrative language, established itself in the creative arts, where it exalted individual values and aspirations above those of society. In jewelry, as in sculpture and painting, a different view of nature was made manifest: pictorial themes such as snakes entwined around a tree or birds perched by their nests on leafy branches multiplied. Brooches and diadems were decorated with representations of flowers or fruit, and armbands realistically reproduced the appearance of wood with its trompe-l'oeil effects of knots and veining. Animals and plants were used symbolically to create a sort of allegorical realism that subverted the hierarchy of artistic genres in the academies and redeemed nature as a fitting subject for art. Pearls, enamel and diamonds were often given a major role in this context, though in discreet quantities or, rather, in small sizes.

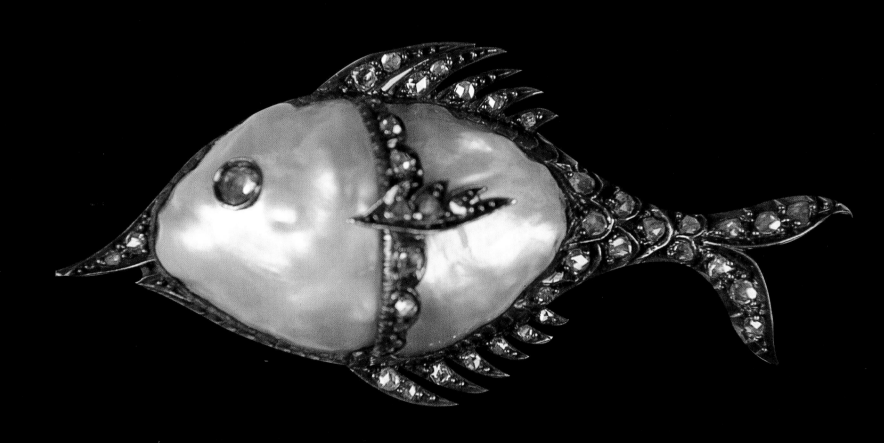

Nature was not the only source of inspiration in Romantic jewelry, and other motifs with a sentimental symbolism increased in number, such as knots, arrows, anchors and bows. Victorian England contributed to the growth of this genre and its unqualified success. At the center of the new fashion was the charismatic and enduring figure of Queen Victoria (1819–1901), a great lover of pearls. Among the many valuable presents she received for her fourteenth birthday was a much appreciated necklace of superb pearls from two aunts, the Duchess of Gloucester and Princess Sophie, and an uncle, the Duke of Sussex. Perhaps remembering that early much-loved present, the queen ensured that one of her daughters, Princess Louise, received the pearls that had belonged to the mother of her husband, Prince Albert (1819–1861).

It was a direct consequence of their need to be often rethreaded that made pearls so suited to the variations in fashion as a neck ornament, thus they were never set aside, but used generation after generation in ever new designs. In this manner, pearls became family heirlooms, traditional but always *à la page* with the passing of time and changes in fashions.

Paris was the nineteenth-century fashion capital of the world and therefore also the capital of jewelry. The period 1852 to 1870, which coincided with the empire of Napoleon III (1808–1873), represented a moment of co-existence for many artistic styles and their varied inspirations. Although he had little artistic appreciation, Louis Napoleon had the role of wise patron of the arts and crafts, as they provided work and contributed to the wealth of the country. He undertook the huge task of restoring the furniture in the palace of Versailles employing a large number of craftsmen, and the same process was applied to the Crown Jewels, in his colossal project of renewing the artistic image of the Second Empire. He personally encouraged the craftsmen of Paris to display original products at the 1851 Great Exhibition in London that would stand out in their skills and refinement and that would give luster to the France he was determined to restore to economic health. Consequently, his resetting in a modern brooch of the famous pearl weighing 337 grains that Napoleon I had purchased from his jeweler Nitot in 1811 for Marie Louise was a political act. The gesture not only demonstrated great faith in the technical ability and discernment of contemporary French jewelers, but also the wish to relate himself to the magnificence of the First Empire, ignoring the period of the Restoration. Similarly, the emperor wanted to use the imperial carriage in which Napoleon I and Josephine had been carried to the imperial coronation in 1804 for his own marriage to the blonde and radiant Eugénie de Montijo (1826–1920). The new empress, a woman of great beauty who was knowledgeable about personal ornamentation, was a great lover of jewelry who preferred emeralds, pearls and jewels based on a naturalistic design. Among the jewels she wore at the imperial wedding were two *parures,* one consisting of a small crown, a bracelet and a collier of pearls and rubies, the other simply of black pearls, an authentic rarity of nature and an absolute novelty in dress, which created a new and exotic fashion. Princess Matilda, cousin to the emperor, also had a large collection of pearls that, in a patriotic gesture in 1848, she gave to Louis Napoleon in emulation of what Pauline Bonaparte had done after her brother Napoleon I returned from exile on the island of Elba. Napoleon III had also presented Countess Walewska with a pair of extraordinary pearls, certain that his gift would be appreciated.

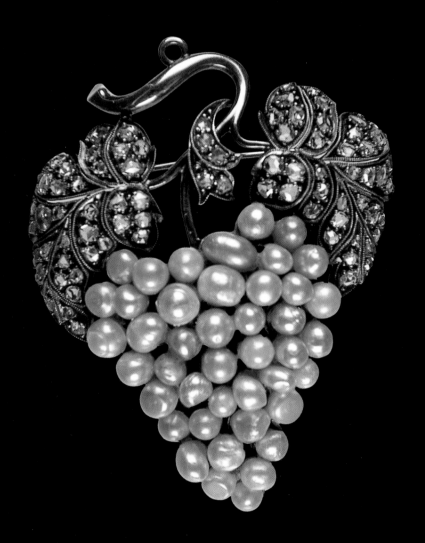

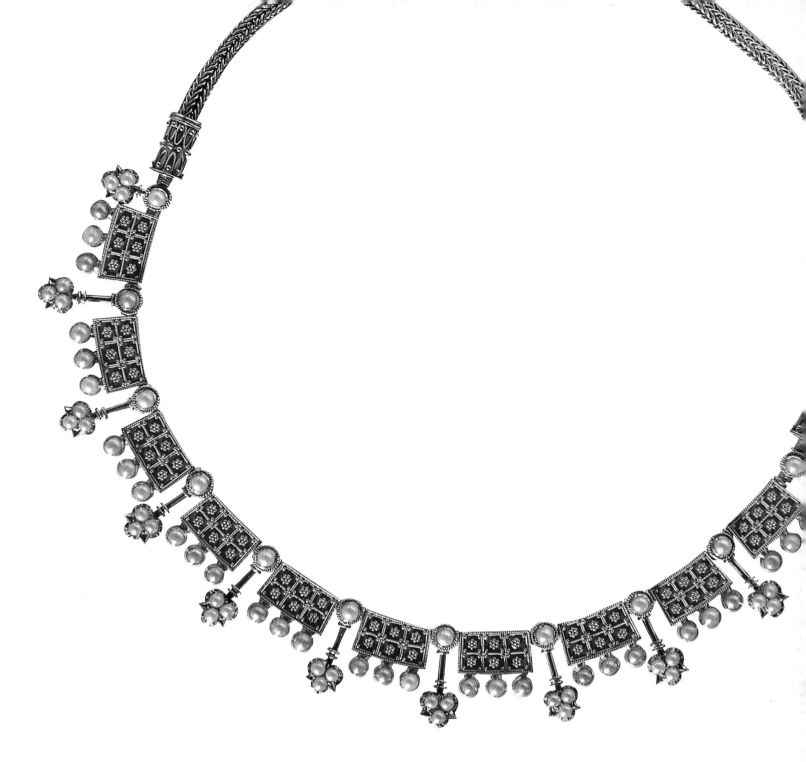

French
manufacture
(end 19th c.),
*Brooch in the
Form of a Bunch
of Grapes, in
Gold, Silver,
Diamonds and
Pearls,* Siena,
private
collection.

Italian manufacture (mid-19th c.), *Etruscan-Style Collier, in Gold and Pearls,* Florence, private collection.

The growing security that the well-to-do classes had been enjoying for sometime stimulated a burst of creativity among jewelers and gave rise to a varied production of precious objects. Earrings, often with pearl drops, tended to become longer, until they reached almost six inches in length, particularly in 1860 when hair was worn away from the ears. Twin bands of pearls and precious stones, worn both on the wrist and above the elbow, returned triumphantly to the ballroom in the Tuileries, embassy receptions and official government luncheon parties. Every excess was permitted and emulated in a sort of mad and endless contest between the moneyed aristocracy, proud of its position, and the *demi-monde* of courtesans, actresses, dancers and adventuresses, who were the ruin of so many financiers and young bloods of good family. These unrestrained *demi-monde* lovers of luxury were insatiable clients of the large Parisian jewelers, where they negligently ran through the capital of their lovers, who had often been wealthy for generations. "The whiteness of pearls," said Vever, a historian of French jewelry, "perfectly matches female beauty and there is a sort of instinct, a natural affinity, that forces women to seek out and love these tears of Venus created, like the goddess of the waves, splendid in her shell. In a mysterious and mutual exchange, the glorious orient of a pearl exalts the smooth beauty of the female complexion while the orient is also exalted by contact with the skin which seems to imbue it with a life and splendor that are absolutely new."

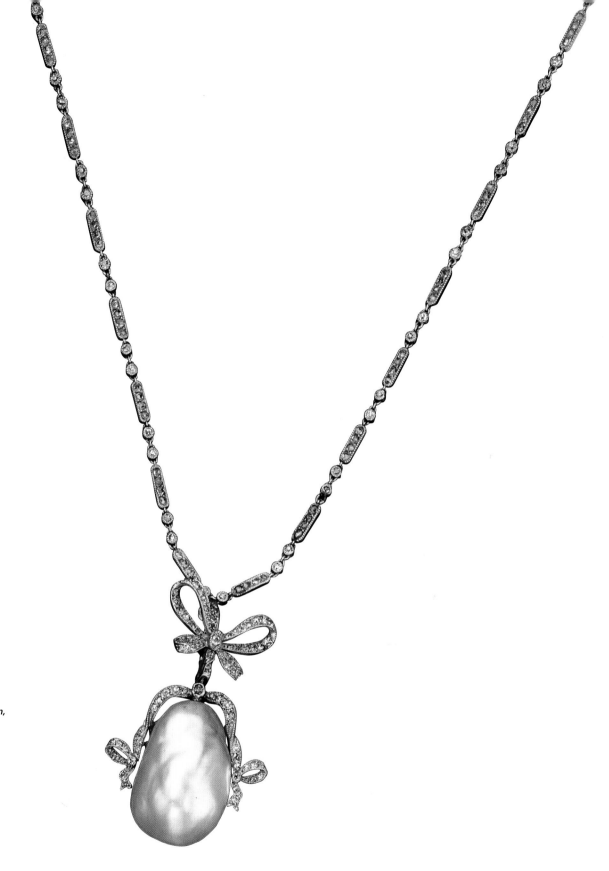

Italian manufacture (1900 c.), *Necklace and Pendant in Platinum,*
Diamonds and a Baroque Pearl, Milan, Finarte.

169

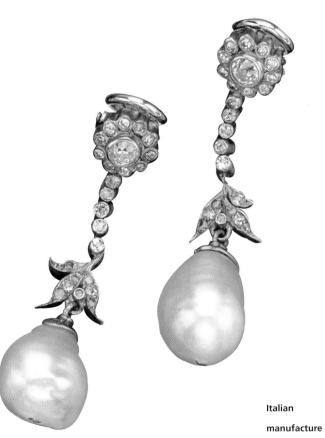

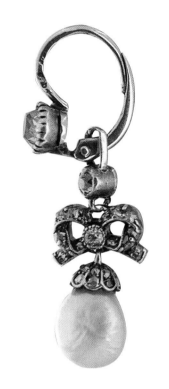

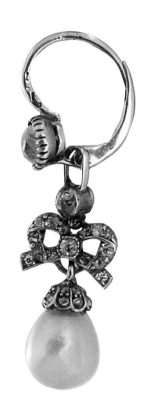

Italian manufacture (start 20th c.), *Earrings in Gold, Silver, Diamonds and Pearls*, Milan, Finarte.

Austro-Hungarian manufacture (1900 c.), *Earrings in Gold, Silver, Diamonds and Pearls*, Florence, private collection.

Page 172,173: English and French manufactures (end of 19th c.–beginning of 20th c.), *Stickpins in Gold, Precious Stones, Enamel and Pearls*, London, Sotheby's.

Among her many other splendid jewels, Elisa Parker, later to become Madame Musard, owned a dress embroidered with more than three thousand pearls and the *Diamant à al Croix*, a forty-one-carat solitaire that had belonged to the Crown of Naples and was cut to display a cross instead of the usual flat rectangular upper facet. Thérèse Lachman, known as "la Païva" and renowned among the *Grandes Orizontales* of the Second Empire, also numbered magnificent pearls among other gems in her overflowing jewel casket. After the death of Napoleon III in England, the empress Eugènie was obliged to sell her jewels, and a three-string pearl necklace was bought by an employee of a large Parisian jeweler on behalf of la Païva. Napoleon III's most well-known mistress, the Countess of Castille, owned magnificent pearls of incalculable value, while the beautiful Julia Barucci, of Italian origin and the model for many artists, became one of the most well-rewarded courtesans in the capital. It is said that on the occasion of a visit from a friend, the famous *fille de joie* announced that her jewels were "all that a beautiful woman can achieve without any sacrifice other than the voluptuous abandonment of her body." Having said that, she opened a large case to display a dazzle of precious stones and pearls that had been sorted into small padded drawers lined with silk.

Diplomatic relations with the Far and Middle East intensified during this period, and Paris became the European capital of culture and enjoyment. Ottoman sultans and Shahs from Persia came to the city to add to their own glittering collections of jewels and *objets de vertu* with the best of what French artists and craftsmen could offer. In order to suitably receive the imperial couple at

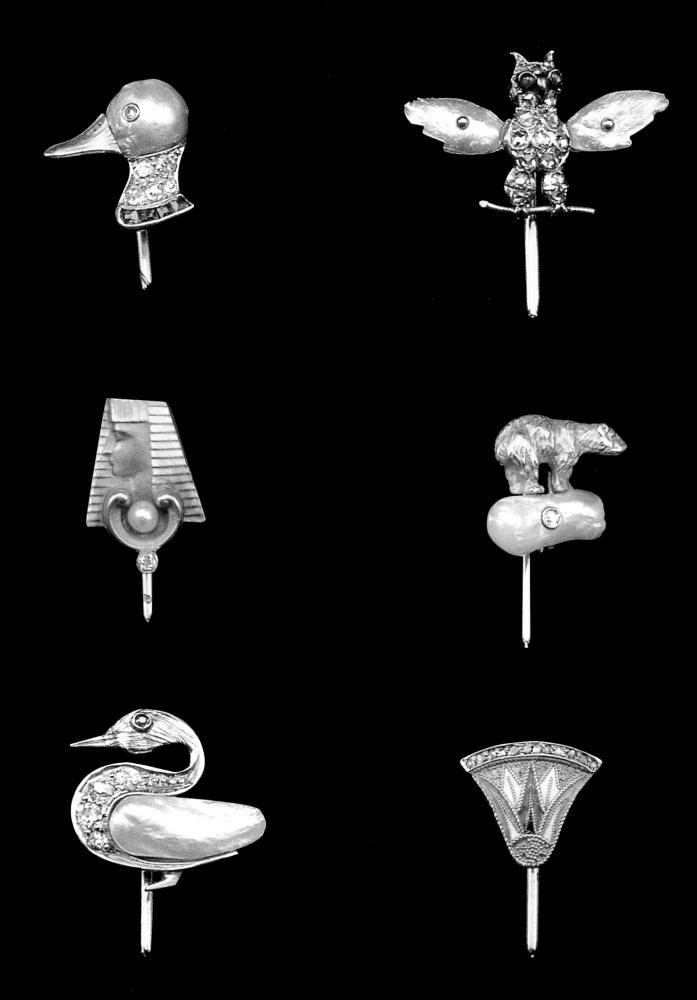

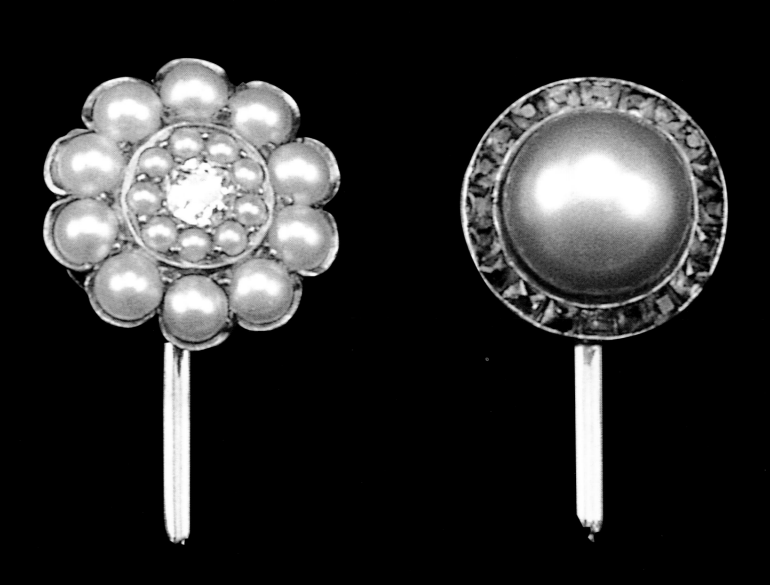

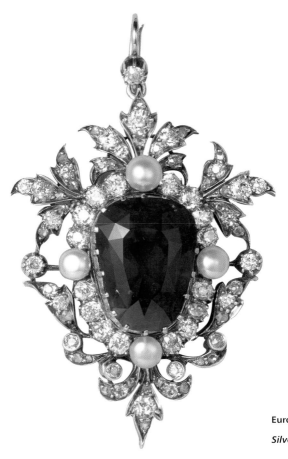

European manufacture (end of 19th c.), *Pendant in Gold, Silver, Diamonds, Sapphire and Pearls,* London, Christie's.

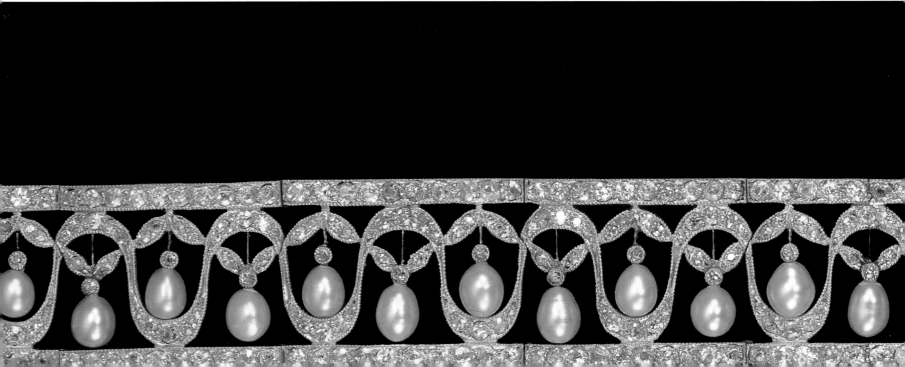

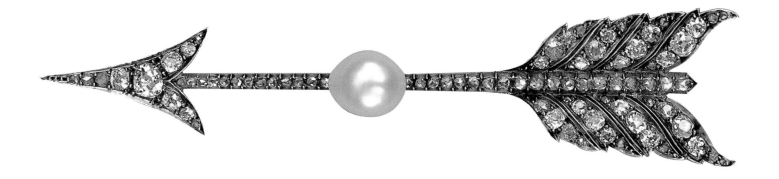

European manufacture (end of 19th c.), *Brooch in Gold, Silver, Diamonds and a Pearl,* London, Christie's.

European manufacture (1900 c.), *Choker in Gold, Diamonds and Pearls,* London, Christie's.

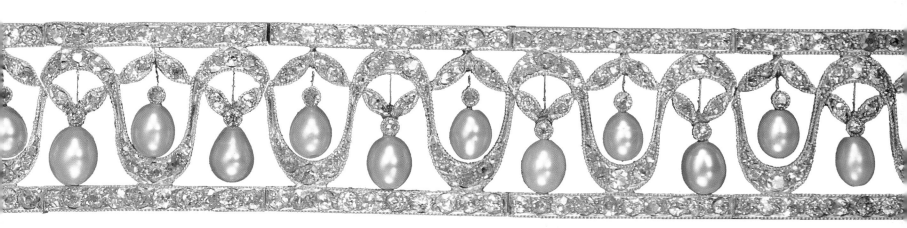

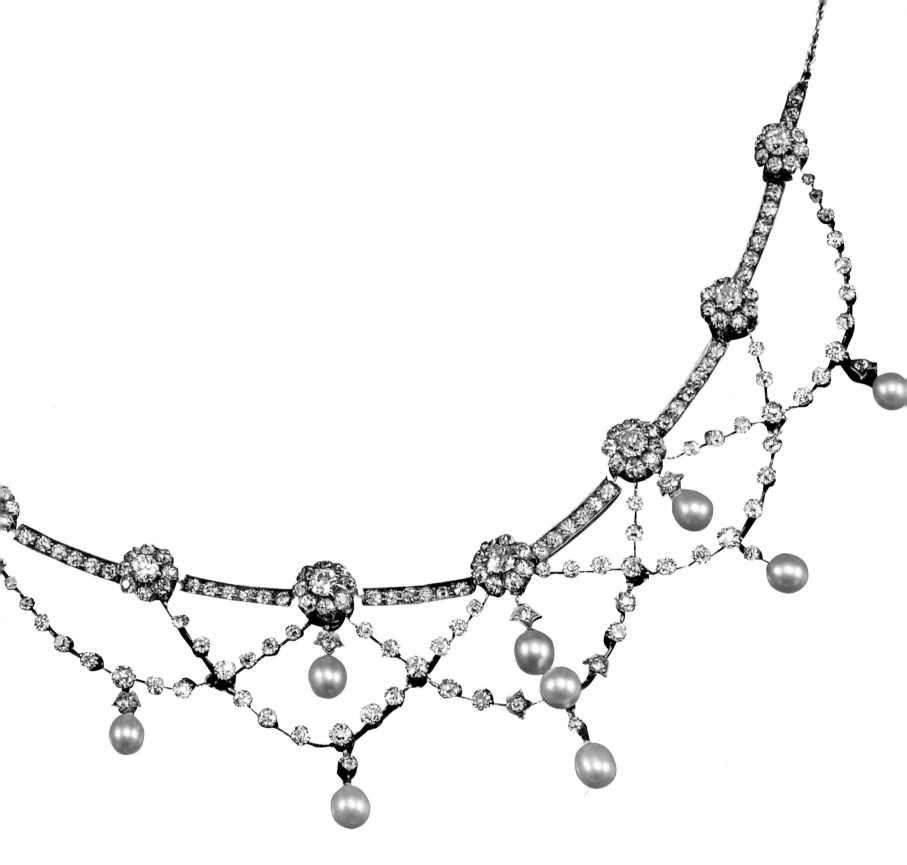

English manufacture (1900 c.), *Collier in Gold, Silver, Diamonds and Pearls*, London, Sotheby's.

lunch in his accommodations in the Tuileries, Said Pasha, Viceroy of Egypt, commissioned a dinner service from the jeweler Fontenay, consisting of forty-two places (plates and cutlery) in solid gold enameled and set with diamonds, and a centerpiece of two gold, six-armed candelabras set with diamonds, rubies and emeralds with several enormous drop-shaped pearls hanging from the arms.

A profusion of pearls was displayed in the window of the Parisian jeweler Beaugrand at the 1855 Exhibition. He had created an extraordinary collier for the empress in which a series of bejeweled frills covered the entire *decolleté*. The accessory comprised a myriad of diamonds and a number of pearl drops, but the impossibility of finding enough of the latter of the same color and size meant he was obliged to resort to artificial materials. Fontenay had also produced a diamond tiara for the empress that included a number of pearl drops that hung from the diadem's bejeweled arches.

English manufacture (1910), *Collier Negligè in Platinum, Diamonds and Pearls,* London, Sotheby's.

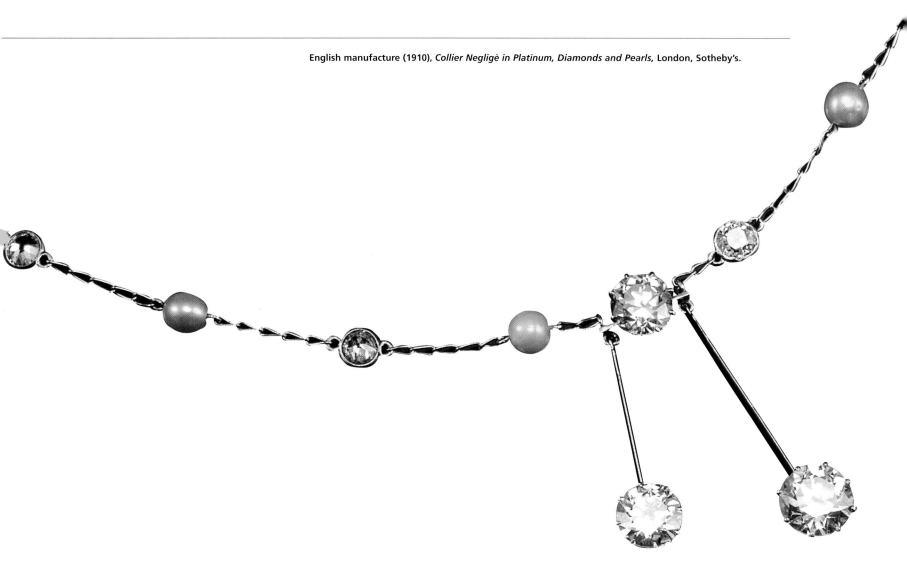

Pearls in Nineteenth-Century Art and Fashions The theme in art of nature as a mirror of human feelings was joined during the nineteenth century by the theme of history as the study of an artistic past to be celebrated and to offer moral and aesthetic inspiration. Numerous elements of Gothic and Renaissance art were used that provided fresh impetus and poetic form to the sentimental and dreamlike imagery of the Romantic artist. The studios of the Parisian jewelers followed the new trends, creating objets de vertu and jewels in which pointed shapes recalled the architectural features of the great Gothic cathedrals with the result that they were referred to as being in style *cathédrale.* In addition to traditional medieval sources of inspiration taken from the world of chivalry or the troubadour, the medieval niello technique was used to give objects a particularly archaic feel, with the contrast of the pale silver against the inlaid burnished metal. Similarly, the ladies *à la page* wore a *ferronière* on the forehead, a band around the head with a decoration often made from pearls, that was very popular in the late fifteenth and sixteenth centuries and which had been named after the painting by Leonardo da Vinci known as *La belle Ferronière.*

François Desiré Froment Meurice (1802–1855) was one of the main jewelers to produce works of this sort. In a brooch depicting the allegory of harmony, effects are created by use of the sophisticated and sculptural lost wax technique and by the chromatic contrast of the various metals used. Small pearls were used to provide touches of diaphanous light in the only concession of the artist-sculptor to the concept of ornament. The ability of the French jeweler was fully expressed in his production of Renaissance and Gothic artifacts, which was continued by his son Emile for most of the Second Empire. The works of the Froment Meurice workshop used a mixture of the techniques of lost wax, embossing, engraving and enameling to create brooches, pins, clasps, pendants and

armbands in which scrolls decorated by exaggerated faces were held up by realistically sculpted satyrs, griffins and harpies. A magnificent example by François Desiré is a gold and silver armband in which small, luminous pearls provide a radiance against the intense chromatic effect of the enamels, rubies and dark *cabochon* sapphire on a bejeweled urn; on either side, the silver, lost wax figures of two nymphs confer a sophisticated Mannerist tone.

The revival of Renaissance styles was to last through the whole of Napoleon III's reign, for example, in the creations of Philippi who was inspired by the jewelry of the sixteenth century, in particular from Germany and Holland. A pendant-siren that uses a baroque pearl in the bust of the sea creature takes its cue so manifestly from certain Dutch pendants from the late sixteenth century that it seems a faithful copy of a lost archetype rather than an original creation using stylistic features from the Renaissance. A nineteenth-century tie pin is a conscious reproduction of the Renaissance theme of the baroque pearl, whose shape was used by the designer to create the body of the mythical creature Omphale.

To complete the picture of Parisian jewelry during the Second Empire, Egyptian themes triumphed at the Exhibition of 1867 with fringed colliers like pharaonic pectorals, "*berthe*" (neck ornaments made from gold, gems and pearls), and motifs of sphinxes, pyramids, scarabs and vultures' wings.

English manufacture (end 19th c.), *Choker in Gold, Diamonds, Rubies and Pearls,* **Florence, private collection.**

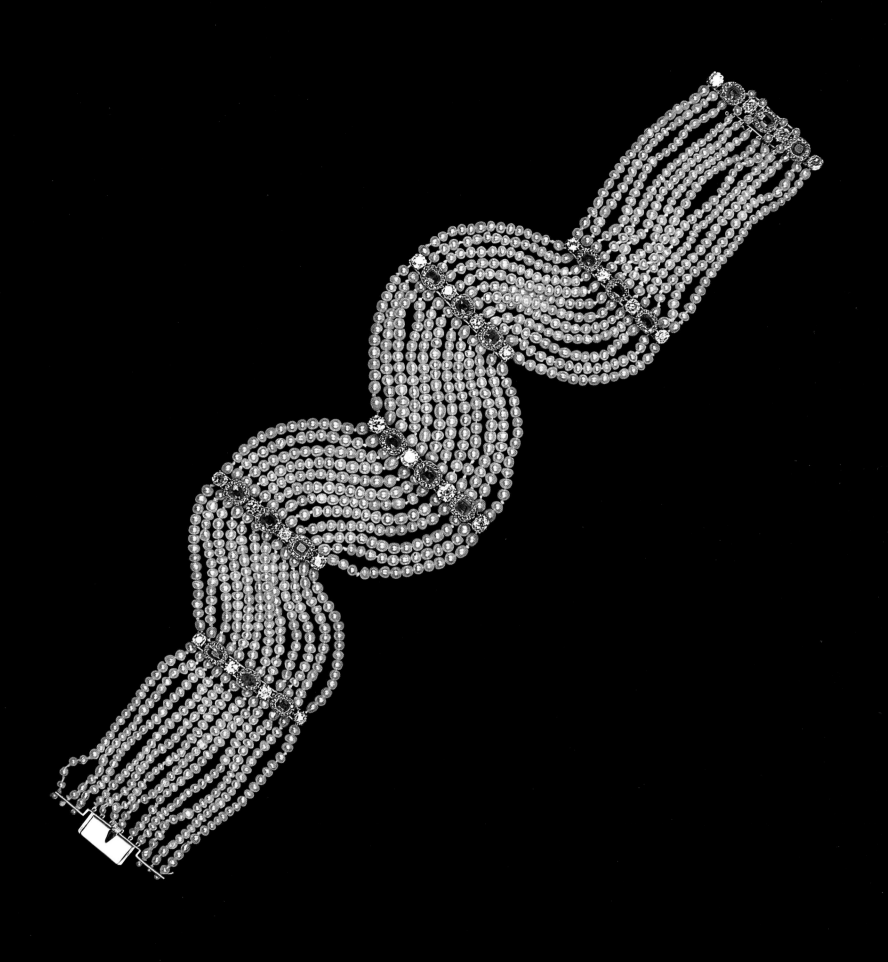

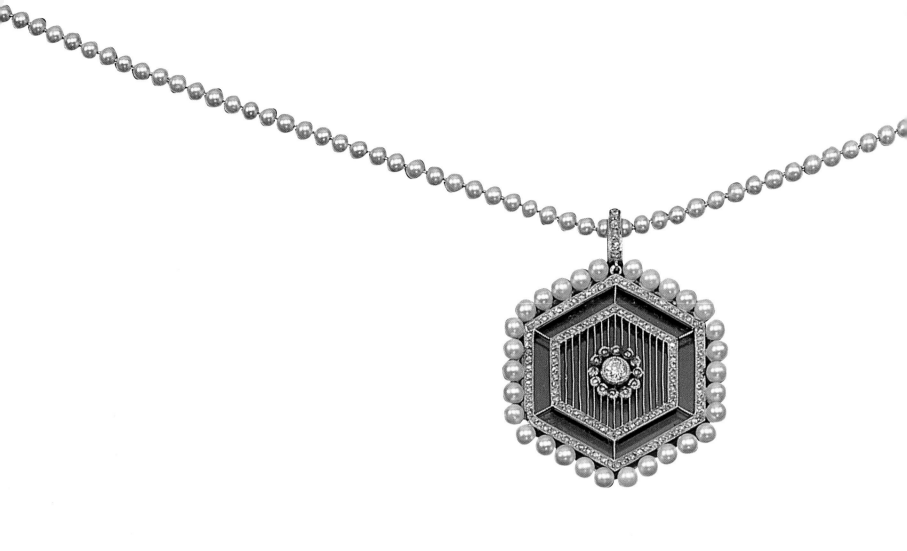

French manufacture (1910 c.), *Collier with Pendant in Platinum, Diamonds and Pearls,* London, Sotheby's.

A love of the past and the restoration and opening of the palace of Versailles to one and all (1837) revealed a world of forgotten or unknown forms to artists and collectors. The new Romantic sensibility was fascinated and almost obsessed by it: to the emerging classes, the Ancient World represented a style whose durability offered a sense of security, whereas to the aristocracy it was the nostalgic commemoration of a glorious past of luxury and elegance. This convergence of artistic interests provided the foundation for the success of Eclecticism, the product of modern technical abilities and a feeling for the past that created a new style using forms and formulas from previous movements and which, though not revolutionary, was filled with creative optimism. The basis of nineteenth-century Eclecticism was the concept that the past ought to be not only studied and copied, but combined like words in a dictionary to create different but sophisticated and precise solutions for various situations.

This was the period when an archaeological revival was unleashed in France, following the arrival in Paris of the Campana jewelry collection purchased by Napoleon III after long negotiations. The collection comprised 1200 Greek, Etruscan and Roman jewels that the Marquis of Campana had illegally bought with money belonging to the bank Monte di Pietà di Roma, of which he was director. When his action was discovered, to pay back the money he owed, he was forced to sell the collection of diadems, *colliers*, *fibulae*, earrings, rings and bracelets that had been produced using granulation, filigree and engraving techniques. A crowd of artists, craftsmen and collectors thronged the Palace of Industry in Paris to see this treasure before it was consigned to the Louvre in 1863, where it was to remain.

The collection made possible a philological reconstruction of decorative features and metalworking techniques used in antiquity, and the world of jewelry was filled with a spirit completely different from the one pervaded by the enthusiasms of collectors during the erudite eighteenth century and the First Empire. Ingres (1780–1867) commented: *"Il y a là des choses d'un type tout nouveau qui surprennent ceux qui croyent connaître l'antiquité"* (It contains completely new things that surprise even those who believed they were familiar with antiquity).

The purchase of the Campana collection had been mediated by Alessandro Castellani (1824–1883), a member of a Roman family of jewelers, connoisseurs, collectors, restorers of excavated jewels and producers of very fine jewels based on archaeological styles. In Rome, jewelry inspired by the ancient world had become legitimate art around 1840 when the jeweler Fortunato Pio Castellani (1793–1865), Alessandro's father, founded a school of historicist jewelry whose purpose, besides producing skilled jewelers, was to pass on to its students the passion of its precociously Romantic founder, a scholar of the Enlightenment.

Since the end of the eighteenth century, Italy had been the preferred destination of foreigners making the Grand Tour. The purpose of the Grand Tour was to drink at the fountains of Knowledge and Beauty that traditionally were to be found across the whole of the peninsula but particularly in the cities of Venice, Naples, Pompeii, Herculaneum, Rome, Florence, Fiesole, all of northern and southern Etruria, Calabria and Sicily. For tourists on the Grand Tour, Italy represented the home of the spirit and the mind, a fount of creative imagination where it was possible to retrace the origins of all western cultures in their original, primigenial state. The excavations of ancient art that were slowly revealed to the incredulous eyes of visitors at Pompeii, Herculaneum and Rome had a powerful influence on the imagination of the era and suggested new aesthetic canons imbued with the rational harmony characteristic of Greco-Roman art. Besides providing pleasure, archaeology also supplied artists with abundant material for study that was gradually used to develop a modern language inspired by archaeological style.

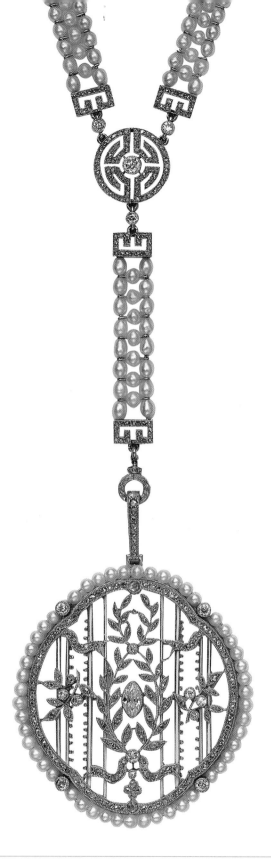

French manufacture (?) (1900 c.), *Sautoir with Pendant in Platinum, Diamonds and Pearls,* Christie's London

Having originated in the previous century, the fashion for the Grand Tour became established in the nineteenth century, with the result that a flourishing market for souvenirs developed in Rome in this unusual cultural climate. The goods were authentic finds from excavations and broken collections, copies from ancient originals, and related products of all kinds in imaginative interpretations of archaeological themes.

Fortunato Pio Castellani was a connoisseur of excavated jewelry. In 1863, he had been personally present at the opening of the Regolini-Galassi tomb at Etruscan Cerveteri which had contained a splendid set of jewels and bronzes. His link with the Marquis of Campana, a morally debatable figure but an enthusiastic collector of ancient jewels, gave him the opportunity to study the collection closely before it was sold to Napoleon III.

The objects found in excavations in Etruria were miracles of granulation and filigree work but boasted few precious stones and were completely devoid of pearls; however, Castellani used stones and enamels in his creations principally for the coloristic effects they created. Often the stones were modest in size and quality and cut as cabochon gems, while small pearls were used in objects inspired by the ancient world, though they were artistic products in their own right. For instance, attractive baroque pearls were used on a *parure,* consisting of a necklace and pendant earrings inspired by the ancient world. The high technical quality and intrinsic simplicity of the materials made Castellani products the favorites among a sophisticated intellectual élite of female poets and writers who had chosen to live in Italy.

Castellani made some references to paleo-Christian art and the medieval barbarian traditions, but allusions to ancient Egypt and the Renaissance were entirely lacking. Renaissance-Mannerist themes were, however, taken up in the artifacts of Carlo Giuliano (died 1895) and gave him the scope to express his creativity through the use of original, contemporary jewelry techniques. Giuliano worked for the Castellani jewelry house and produced works of similar technical and stylistic quality, but when he went to London in 1860 with Alessandro Castellani to open a branch of the Roman workshop in Soho, he mysteriously severed all links with the parent company and set up shop himself in a studio on Frith Street.

Although all his early production was similar in archaeological style to that of his former employers, he soon emancipated himself and developed his own, highly colorful Renaissance revival. He too made use of ancient gems, but his most typical items of

jewelry were those in which *champlevé* or *en ronde bosse* enamel and multi-colored semi-precious stones composed a sparkling symphony. Diamonds and pearls were also used, but they played a subordinate role and were not indispensable. The pale radiance of pearls was often made use of in the polychromy of Giuliano's refined works, whose taste conformed to the international style of Eclecticism.

An important factor was the friendship of the Italian jeweler with the Pre-Raphaelite painter Edward Burne-Jones (1833–1898), which resulted in an artistic collaboration where the jeweler often produced works designed by the Englishman, in an osmotic exchange of artistic stimuli. A famous work of this type was based on a design by Burne-Jones, a second generation Pre-Raphaelite, for a brooch in the form of a bird made from gold, green enamel and a *pavé* of turquoise, coral and pearls.

Who were the Pre-Raphaelites and what significance did they have for jewelry? The Pre-Raphaelite Brotherhood of artists came into being in Victorian England in 1848 when three young idealistic painters, Dante Gabriel Rossetti (1828–1882), William Holman Hunt (1827–1910) and John Everett Millais (1829–1896) set themselves the objective of refinding truth in art, basing their work on nature and utterly refuting the artificial and intellectual elaboration that they attributed to Raphael and the painters that came after him. For the three painters, the Middle Ages represented the Golden Age, a magical moment in art in which every detail of every work was carefully considered. It was the belief of the Pre-Raphaelites that a piece of porcelain, glass or a jewel was just as valid a subject for the creative impulse as a painting or a sculpture. This idea had considerable historical consequences: by supporting handcrafts in the face of the progressive industrialization of everyday objects, the Pre-Raphaelites were unknowingly opening the way to the multi-form and multi-colored movement of art nouveau. In jewelry, these aspirations were translated into a new desire to create works of art rather than sparkling status symbols of precious stones. Pre-Raphaelite theory suggested the use of enamel and gems for the intense chromatic possibilities that they offered, and not simply for the effects of splendor they could produce. Pearls offered a versatile ingredient, luminous but not gaudy, that were appreciated not just by the ladies of high society but also by a more intellectually sophisticated public, while small pearls were not only less costly, they were also available in quantity.

Art Nouveau and Art Deco: Sophisticated Fashions for Great Innovators

Fabergé and Lalique: Pearls and the New Cosmopolitan Style The end of the nineteenth century in France was accompanied by a strengthening in the economic, political and social situation that had begun to take form during the reign of Napoleon III and the Third Republic. Paris was the international capital of pleasure—of entertainment, style and fashion. It was visited by tourists from all over the world as though it were a giant theater that featured women of every color and type of beauty, reflecting the multi-faceted cosmopolitanism of the city. Jewelry was their favorite makeup. The Belle Époque's great economic boom intensified the competition between aristocrats by birth and the new rich, both having fallen into the same life of luxury since the middle of the previous century. Jewelry continued to adapt to the most diverse and bizarre necessities that ranged from the traditional and refined to the eccentric and sophisticated. This was the period when the house of Cartier consolidated its success with its *guirlande* design that gave it the leading role in the deco style. The most popular metal was platinum, as its malleability enabled it to be used to create delicate settings, leaving plenty of space for the gems in fashion: diamonds and pearls.

In the Kingdom of Italy, it was the aptly-named Queen Margherita (1851–1926) who excelled in elegance, being literally covered with pearls on every occasion. She owned an extraordinary necklace, a gift from her husband Umberto (1844–1900), to which she added a new string of pearls each year until, in 1888, it numbered fourteen strings of the pale marine gems. This was the period in which exceptionally light tiaras, sparkling with diamonds and pearl drops, framed the faces of princesses and queens, and wide decolletés were adorned with multi-string necklaces or *colliers de chien*, or chokers, the latest fashion. This new type of necklace almost completely covered the neck and was made by parallel horizontal rows of small pearls crossed vertically at

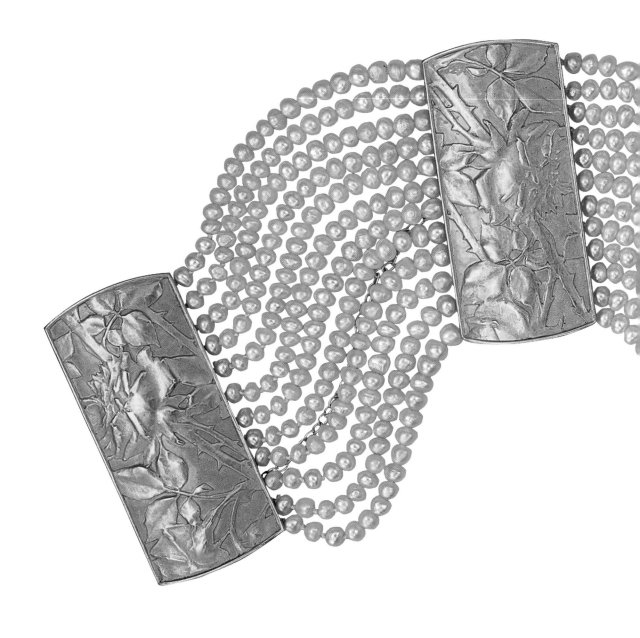

René Lalique
(1860–1945), *Choker*
in Gold, Enamel and
Pearls, Geneva,
Christie's.

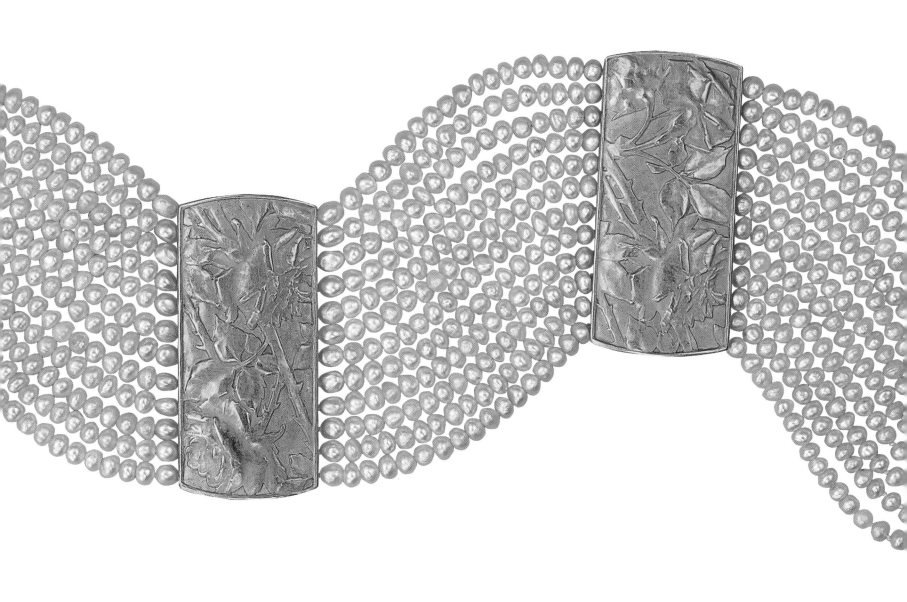

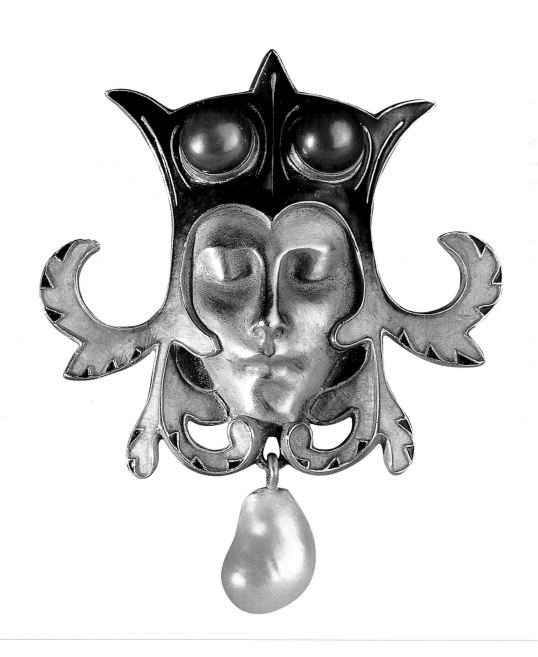

regular intervals by small rows of diamonds or with a single central plaque in finely worked precious metal decorated by precious stones. This kind of ornament was particularly loved by Princess Alexandra of Wales (1844–1925) who, it is said, adopted the style to hide a small scar on her neck. She also very much loved single string pearl necklaces and she wore one on the day she accompanied her husband to open Parliament. Single strings worn around the neck or long down to the waist, either loose or pinned, were in vogue. On the occasion of her marriage to the Duke of Marlborough in 1895, American millionairess Consuelo Vanderbilt received extraordinary pearls from her mother, one string of which was rumored to have belonged to the Tzarina Catherine I of Russia (1684–1727) and another to the empress of France, Eugénie. Brooches decorated with drop-shaped pearls and cascades of diamonds put the finishing touches to decolletés, while diamond and pearl pendant earrings and bracelets in the same materials completed the *parure* of the chic fin de siècle lady. Bejeweled bolero jackets and magnificent jewelry for tight tops were produced in France on request for lovers of finery. An end of century daguerreotype portrayed *la Belle Otero,* a famous Parisian courtesan, wearing a bolero studded with pearls. Then, this sparkling and elegant but monochrome and rather traditionalist design was confronted with a flowering of new ideas that burst upon the scene at the 1900 Paris Exhibition, profoundly altering the aesthetic landscape: art nouveau.

In France during the Belle Époque, art nouveau jumped from being a graphic style in the frontispiece of books to being three-dimensional in the glasswork of Emile Gallé (1846–1904) and in the jewelry of René Lalique (1860–1945). Its main source of inspiration was nature, either contemplated directly or filtered through the stylizing of Japanese figurative art, while the philosophical premises of the style had their roots in the Pre-Raphaelite aesthetics of the Arts and Crafts Movement created by William Morris (1834–1896) in the mid-nineteenth century. The aim of Morris' movement was to overturn the hierarchy of artistic genres that had solidified into being "official art" and to restore dignity to the decorative arts which, until that moment, had been relegated to the category of pure and simple crafts.

René Lalique
(1860–1945),
Clown's Head, in
Gold, Enamel
and Pearls, **Paris,**
Musée des Arts
Décoratifs.

French jewelry had used plant-related themes throughout the nineteenth century, sometimes with the use of enamel and sometimes with precious stones, to the extent that nature had become almost its key feature. Although a continuity of themes with earlier jewelry was present, the fully art nouveau forms seen at the Paris Exhibition of 1900 were totally innovative and took plant themes to the limits of stylization. Nor was the inspiration derived from Japanese art a bolt from the blue, since the earlier works of Lucien Falize (1839–1897) depicting red and turquoise cloisonné enamel birds were typical of Japanese figurative art. But the spirit of the new style was different; it was expressed with unusual homogeneity in all fields of art and, on its arrival from London, was welcomed with enthusiasm in the French capital.

The Italian name of the new art, Liberty, was taken from the workshop of Samuel Bing, which opened in Paris in 1895, and where many artists following the new style showed their work. One of the most regular visitors to the shop was René Lalique who, having studied the new artistic language in London, developed its decorative possibilities to daring extremes. Lalique increased the number of elements taken from Japanese art as well as from plants and animals, but the nature that Lalique depicted was realistic, at times brutal and harsh and not at all idealized. Scarabs, locusts, bats and snakes betray a certain sadism in their use as ornaments, almost a subtle, grisly metaphor of the male assault on the female body. He also developed a new and singular interest in movement, with his creations of mysterious and ethereal sylphs that paired the body of Venus with the wings of dragonflies, or his ballerinas with silky, fluttering skirts that were archetypes of a femininity eternally suspended between bodily reality and the fiction of fable in dance.

Utterly innovative in art nouveau was the dynamic representation of human and animal figures. The choice of materials revolved around this development in the attempt to express the incessant metamorphosis of nature. It was certainly not the preciousness of the materials that prompted Lalique in his choice, but the effects of changing colors of materials when subjected to different qualities of light. He combined his use of glass and enamels, not with stones of dense and compact colors, but with changing *claires de lune,* starlit opals and of course pearls, with their magical luster and iridescent chromatism; these became the versatile components in many of his creations. Two black and one white pearl in the shape of a pear were the only gems he used in the representation of a somewhat maniacal minstrel that was closer to being a death mask than the comic face of a clown. A pearl in the clutch of a bird of prey's translucent enamel claws was a theme he used on a ring, and pinkish baroque pearls held by the feet of two opposing locusts ornament a necklace made from horn.

René Lalique
(1860–1945),
*Ring in Gold,
Enamel and a
Pearl*, Paris,
Musée des Arts
Décoratifs.

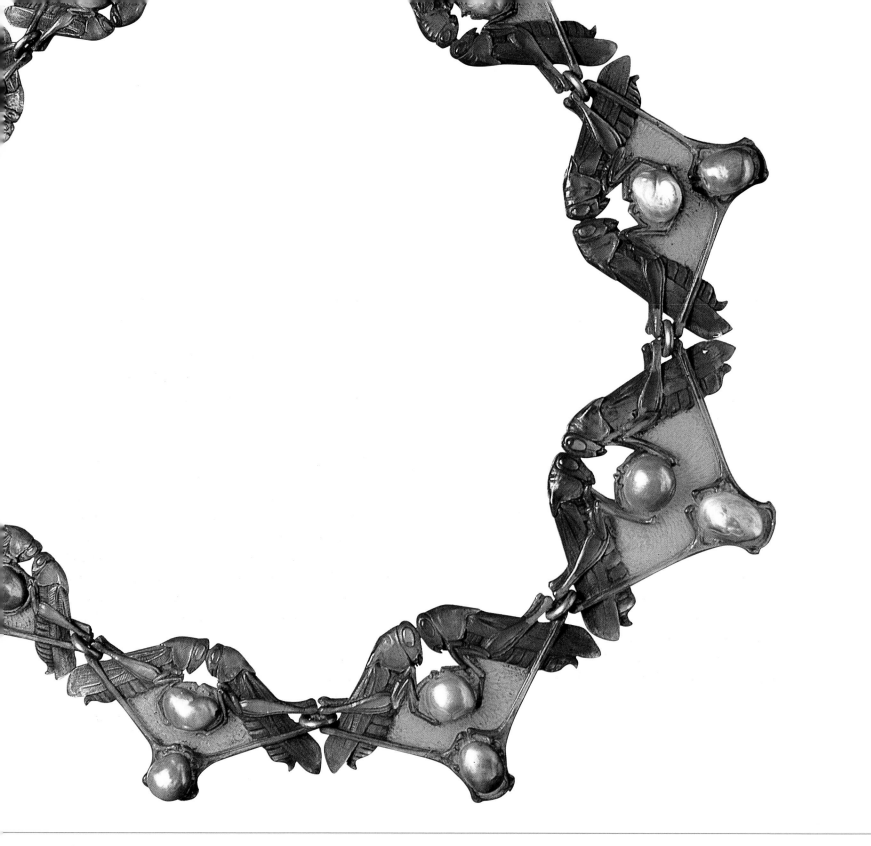

René Lalique (1860–1945), *Collier in Horn and Pearls*, Lisbon, Museo Calouste Gulbenkian.

Lalique's customers were new, anti-conformist, adventurous and seductive women; they were complex personalities, independent or scandalous artists like Sarah Bernhardt and Liane de Pougy, the famous Parisian actress, who died wearing a religious habit after a life of dissipation.

Another interpreter of French art nouveau was Georges Fouquet (1862–1957). An extraordinary jeweler, he worked closely with the draftsman Alphonse Muscha (1860–1939), who designed the furniture in his Parisian atelier and many jewels in art nouveau style. Fouquet also used pearls in his creations: baroque and round, white and pink, pendant and set, they often appear with *plique à jour* enamels in his sophisticated creations inspired by nature.

Art nouveau was largely an international style. Rooted in the Anglo-Saxon reaction to mass production, it received its stylistic definition in France but produced exquisite fruits in all of Europe: in Belgium and Spain; in Germany where it took the name of *Jugendstil*; in Austria, which made it the stylistic language of the Secession; and in Italy, where it triumphed with the name of *Floreale* or Liberty. Further successes were had in Denmark; in England, where its roots lay; and in the United States, where it had one of its greatest interpreters in Louis Comfort Tiffany (1848–1933). The subtle stylistic differences that distinguished art nouveau in different countries did not contradict its original thesis of a genuine and deep-seated desire to react to the then lifeless forms of nineteenth-century Eclecticism and the historicist pastiche that had become the official language of power and the academies. Versatile, multiform and delicately colored pearls were often used in the creations of Ashbee (1863–1942), Wilson (1864–1934) and Paul Cooper (1869–1933) in England, and of Josef Hoffman (1870–1956) and Koloman Moser (1868–1918) of the Austrian Wienerwerkstätte, in floral and geometrical forms produced with new and inexpensive materials, and enamel, silver and semi-precious stones.

The work of Carl Fabergé (1846–1920), the Russian jeweler and court artist admired by high society around the world, was contemporary yet independent. The last of the eclectics, Fabergé used art nouveau forms almost as words to describe his eclecticism and created a place in the market for himself where his untrammeled and inventive spirit found a balance using the stylistic essentials of traditional art in combination with elements of the new. The artistic co-existence of an Eclectic background with components of art nouveau gave free rein to his production, which brought together elements from Italian Mannerism with

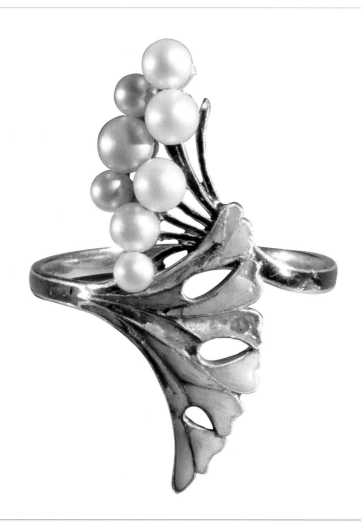

René Lalique
(1860–1945),
*Ring in the
Form of a
Flower in Gold,
Enamel and
Pearls,* Paris,
Musée des Arts
Décoratifs.

exquisite Louis XV *rocailles,* and Louis XVI ribbons and bows with lilies-of-the-valley and dragonflies that bring to mind the masterpieces of René Lalique. A love of nature, the inexhaustible fount of visual inspiration, bound Fabergé indissolubly to the art nouveau aesthetic, and to these he added technical brilliance, the use of high quality and highly expensive materials, and the same extraordinary interpretive realism with which the many works of Lalique were imbued. His workshop produced true trompe-l'oeil creations, translating precious and semi-precious stones into the most fragile of natural, vegetal materials, so turning the eternal into the ephemeral. One of his absolute masterpieces was the vase of lilies-of-the-valley given by the merchants of Novgorod to the Tzarina on the coronation of Nicholas II (1868–1918) in 1896. Gold was used for the stems of the flowers and the woven basket while pearls adorned with minuscule diamonds formed the corollas of the flowers that were represented in detail right down to their scalloped edges. Tapered leaves made from nephrite completed the work.

The brutal slaughter of Tzar Nicholas and his family at Ekaterinburg by the Bolsheviks also shrouded the history of the house of Fabergé with a macabre fascination. It was the end of the luxurious, welcoming and insulated world of the Winter Palace in St. Petersburg, where an entire room was dedicated to Fabergé's works.

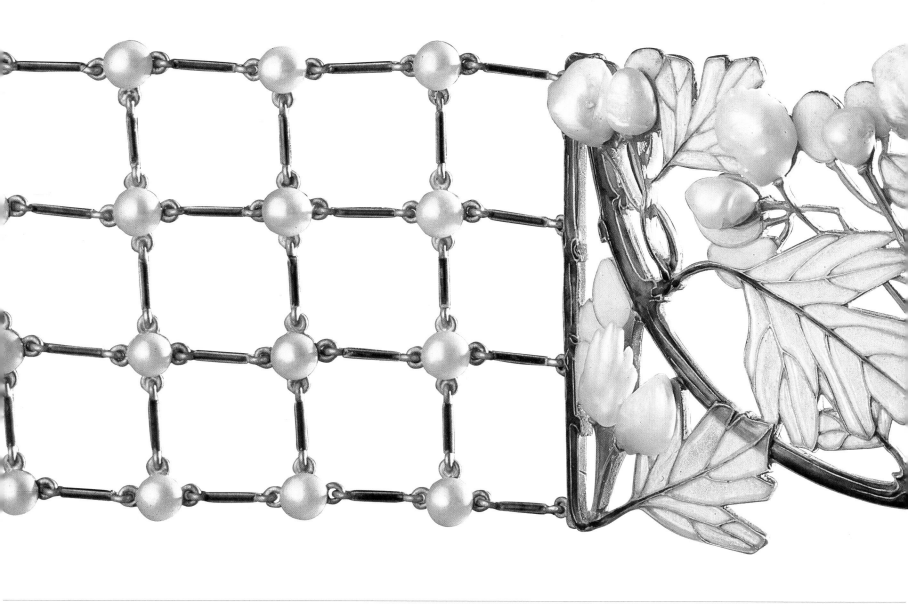

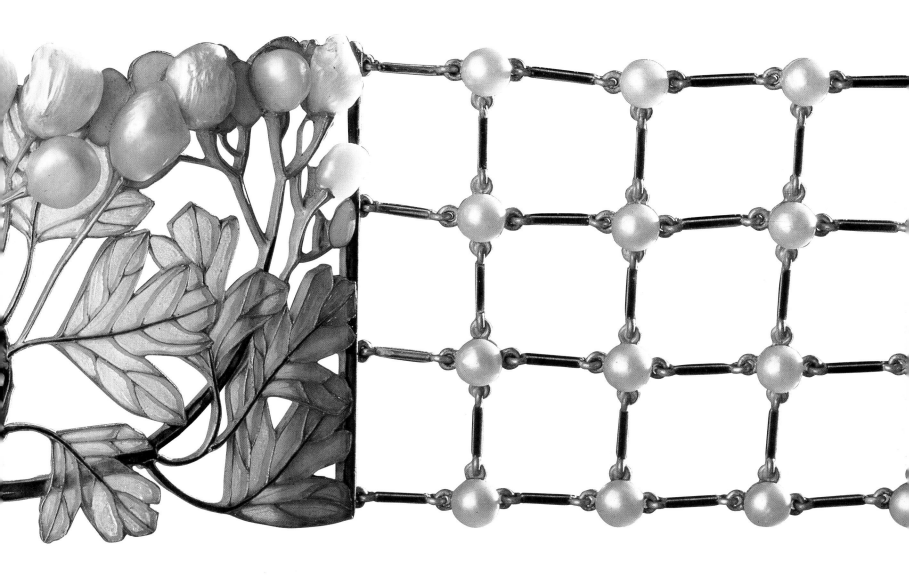

René Lalique
(1860–1945),
*Hawthorn Choker
in Gold, Enamel and
Pearls*, Paris, Musée
des Arts Décoratifs.

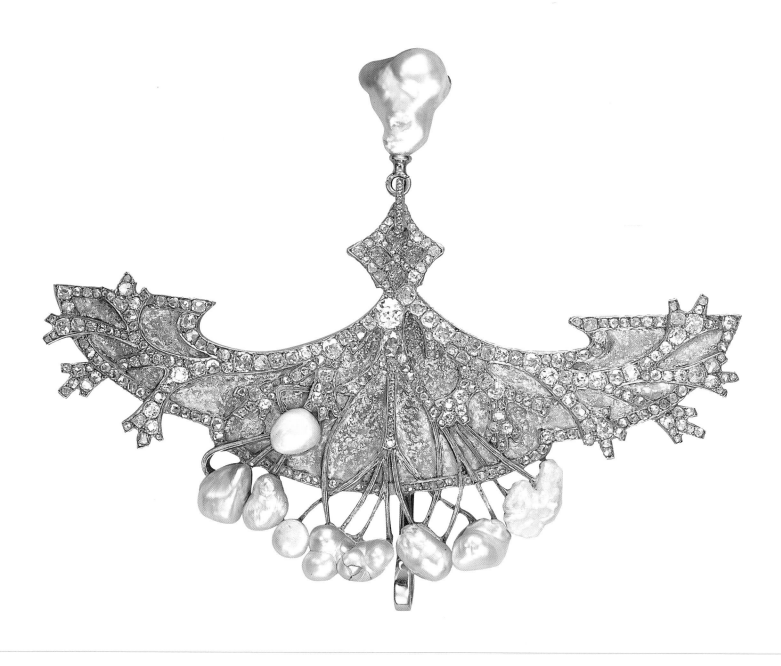

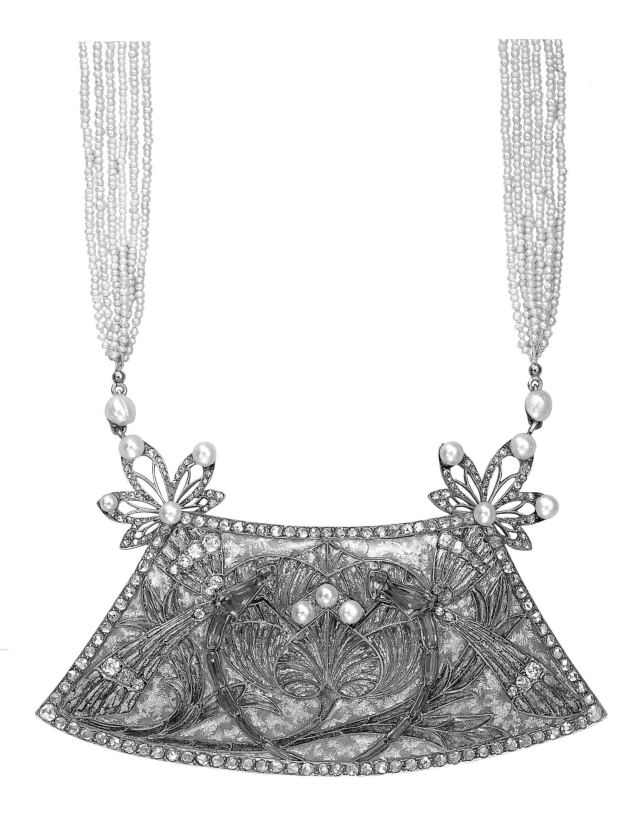

Georges
Fouquet,
*Plaque for a
Choker, in Gold,
Enamel and
Pearls*, Geneva,
Christie's.

Georges
Fouquet,
*Pendant in
Gold, Enamel
and Pearls*,
Geneva,
Christie's.

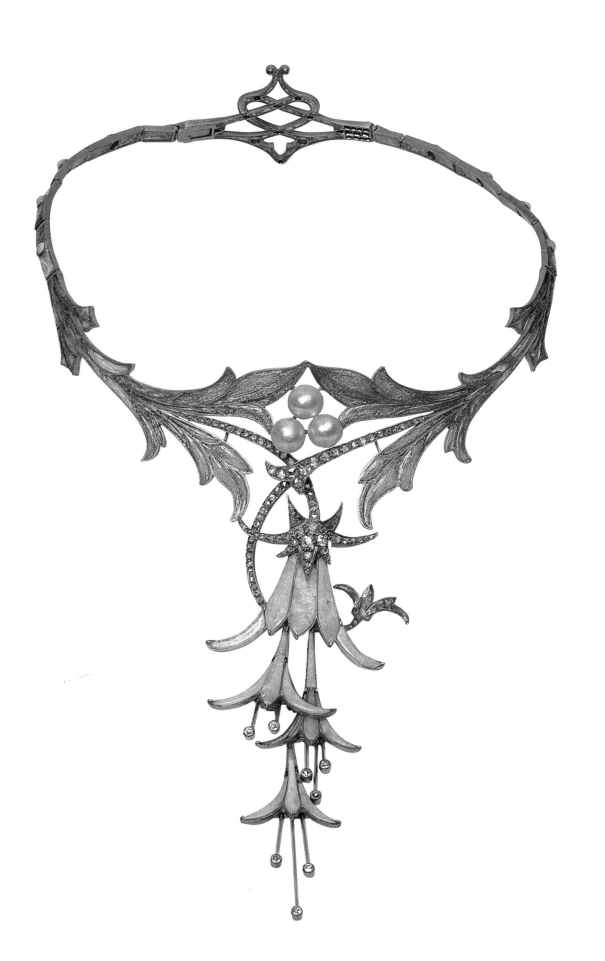

Georges
Fouquet,
*"Fuchsia" Collier
in Gold,
Enamel, Opals,
Diamonds and
Pearls,* Paris,
Musée du Petit
Palais.

Pearls and *Les Années Folles* of Art Deco In Paris, the fashion capital, the year 1909 was a turning point for art and style in general. It was the moment when the foundations were set for the revolutionary and modern deco style.

There were two principal events: one was the arrival in Paris of the Russian ballet of Serge Diaghilev (1872–1929), which was destined for tumultuous success on the stage of the Théatre des Champs Elysées; the other was the diffusion of the first Futurist manifesto by Tommaso Marinetti (1876–1944), which appeared in the newspaper *Le Figaro* the same year.

The Russian ballet brought with it a wave of exoticism; together with its energetic and emotionally powerful choreography, new lustrous colors lit with an intensity missing from the delicate art nouveau shades, triumphed on the Paris scene. Above all, the ballets satisfied the demands put upon an art in rapid evolution by a cultured and sophisticated public. Choreography, music, stage design and costumes were interwoven with the goal of producing a unique, multiform work of different materials that was able to involve the spectator in the energetic whirl of the dance against a background of unusual musical harmonies.

The emerging Futurist movement had similar intentions as it sang the praises of modernity and celebrated speed as the exhilarating result of recent technological discoveries. The celebration of modernity translated into new aesthetic aspirations, welcomed by numerous young Parisian painters, who applied them to the decorative arts at the turn of the decade with a new style: art deco. Fashion and jewelry were directly involved in this artistic process.

In the euphoric climate that followed the end of the first bloody world conflict, women entered the spotlight in their own right. New attention was paid to the social, intellectual and aesthetic life of the women of the 1920s. Widowed by the war, they unexpectedly found they were taking the place of men on building sites, in factories and in offices. Engaged in an active and working life, they received economic independence and greater freedom in exchange. Dress became an integral expression of this new notion of existence reflecting the dynamism of a working life, a liking for sport and dancing, and creating a tight link with women's needs that were no long simply aesthetic.

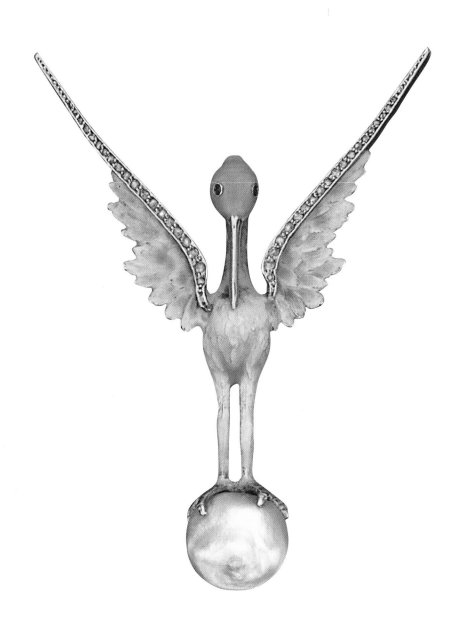

Art nouveau
manufacture,
Brooch in the
Form of a Stork,
in Gold, Enamel,
Precious Stones
and a Pearl,
Milan, Finarte.

The typical 1920s' woman had the figure of a slim boy; she wore knee-length dresses and bobbed hair. Her jewelry abandoned the flowery bourgeois style from the end of the previous century for drier, geometric forms. Every shape seemed to express geometry, verticality, slenderness and movement. Knots and bows became rigid in *broches* and pendants, and earrings grew in length to match the line of the neck revealed by the short hairstyles inspired by the sculpted heads of African art. The hanging designs of deco women's dresses made from light materials were accompanied by long *sautoirs* of pearls that were often completed by pearl tassels. Their very flexibility made strings of pearls well-suited to this new concept of elegance in which clothes and jewelry contributed to the dynamism of existence. Thus pearl tassels seemed to epitomize the essence of the new concept of ornamentation.

The colors of this jewelry were strident, and often the contrasts between the tones of the materials were aggressive, while the materials themselves were juxtaposed in experimental fashion, for instance, jade and onyx with diamonds, enamels and coral with fine stones, based on the precept that every material in nature could be used for purposes of jewelry. Pearls, however, did not fall from popularity. Around 1925, one of the products of the house of Cartier was brooches with pearl tassels; Louis Cartier (1875–1942), the house's jewelry designer of that era, preferred to use pearls that were small, round and, above all, natural, in a reaction to the huge influx of cultivated pearls. The technique of artificially stimulating the production of a pearl in an oyster was discovered at the beginning of the century, and by the 1920s cultivated pearls were inexorably conquering the market. They were produced en masse by the Japanese jeweler Kokichi Mikimoto (1875–1942) who, after many experiments, succeeded in obtaining magnificent spherical pearls shortly after 1900 by inserting tiny seed-pearls into the shells of pearl-bearing oysters. It

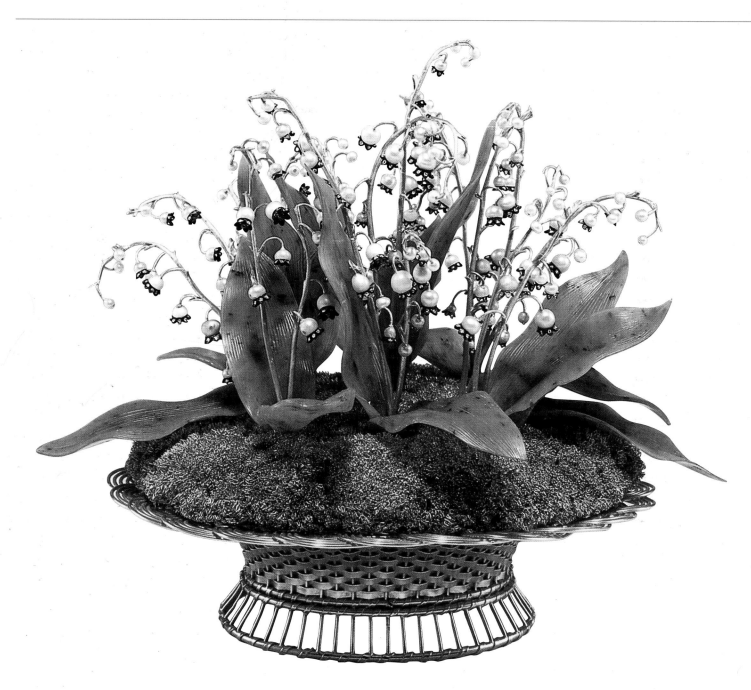

Carl Fabergé (1846–1920), *Basket of Lilies-of the-Valley, in Gold, Silver, Nephrite, Diamonds and Pearls,* New Orleans, Mathilda Geddings Grey Foundation.

took a few years for the product to reach the public but in the 1920s cultivated pearls had become established. Naturally there was a certain initial resistance to this strange material which, after all, could not be called totally artificial yet did not have the fascination of being a miracle of nature that gave true pearls their glamour.

During the period that cultivated pearls were conquering the markets, Louis Cartier was the victim of an unusually clever swindle. A few days after purchasing from Cartier a fifty-six grain pearl that had been found in the Persian Gulf, the customer returned expressing the wish to purchase a second, identical pearl. Louis replied that only God, not Cartier, was capable of finding such a pearl but the man insisted he was willing to pay any price. Orders were sent out to New York, Calcutta, London and Hong Kong in the hope that a miracle might transpire. An unknown private individual, having learned of the frantic search, offered to sell his own pearl of the same size, but at an exorbitant price: two and a half times what Cartier's customer had paid for the first pearl. Told by Cartier of the development, the original customer replied that he was happy to accept and that he was willing to pay the entire sum the next day. Satisfied with the arrangement, Carter closed the deal and paid the extravagant price to the unknown individual for the presumed second pearl. But the "original customer"—who was in fact also the "unknown individual"—did not return to the shop, having succeeded in selling the same pearl back to Cartier at two and a half times the original price. Deceived, Louis Cartier did not want to put the pearl up for sale again and he gave it to the Countess d'Almassy in 1925.

The story is emblematic: it was the miraculous uniqueness that characterizes natural pearls—which throughout history had made them the symbol of privilege and the élite—that in a certain sense dictated their end. Being so difficult to find, they were destined to lose ground in an era in which pearls had become common as a result of the affordable prices permitted by the advent of the cultivated pearl. And yet, although natural pearls were destined inexorably to lose market share because of their rarity, it was just this aspect that made their attraction eternal, just as anything rare and precious no longer obeys any law, including that of the market.

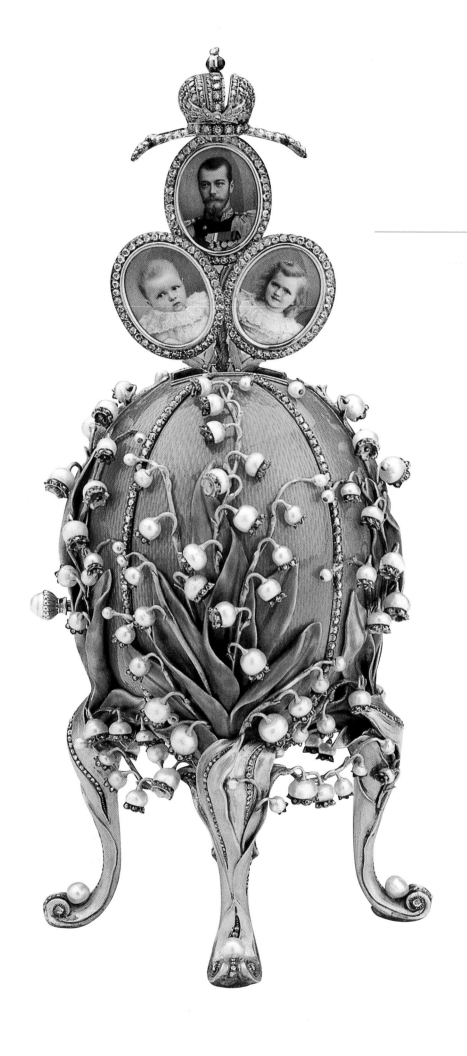

Carl Fabergé
(1846–1920),
*Lilies-of the-
Valley Egg, in
Gold, Silver,
Diamonds and
Pearls,* Moscow,
Armoury Museum
of the Kremlin.

Carl Fabergé
(1846–1920),
*Imperial Mosaic
Egg, in Gold,
Platinum,
Diamonds and
Pearls,* London,
Collection of H.
M. the Queen
Elizabeth of
Great Britain.

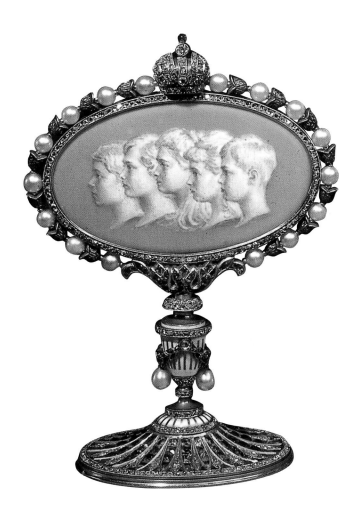

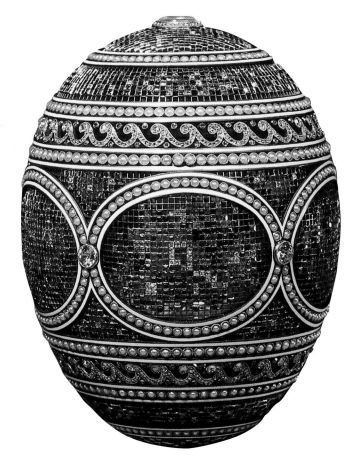

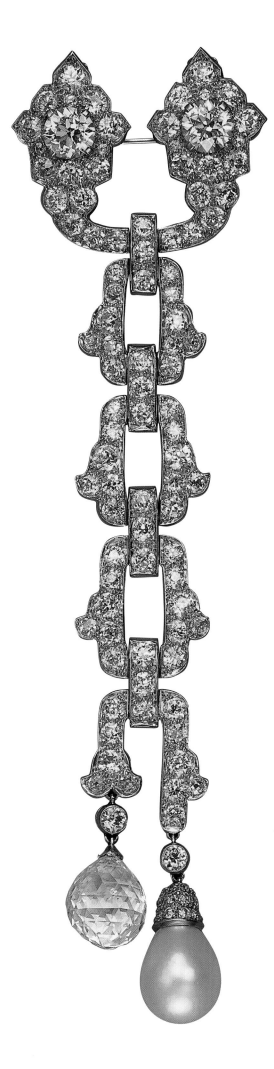

Maison Cartier New York, *Pendant in Platinum, Diamonds and Pearls*, London, Christie's.

Italian manufacture (1950 c.), *Tassel Pendant in Gold, Enamel, Diamonds, Ruby, Emeralds and Pearls*, Florence, private collection.

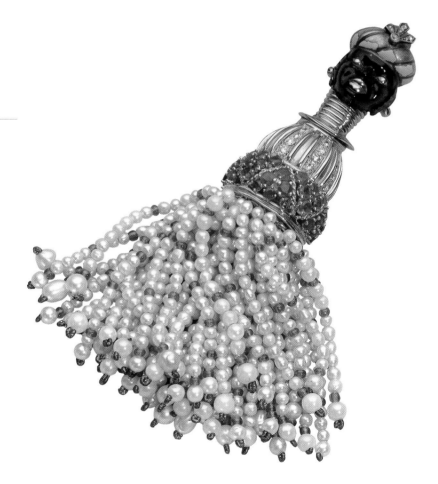

And this was the theme used by Paul Claudel (1868–1947) in his address *La mystique des pierres précieuse* (The mystery of precious stones) on the occasion of the presentation of the Légion d'Honneur to Pierre Cartier (1878–1964), in which he dedicated a long passage to the pearl. The pearl, in the words of Claudel, neither shines nor burns but it moves the admirer; it offers a cool and vivifying touch to the eye, the skin and the mind. Beyond any symbol that man has identified it with, for Claudel, the pearl had no other value than its intrinsic beauty and perfection, the fruits of its simplicity, purity and splendor; its only value lay in the desire it inspired. "Its appearance on the market downgraded every other desirable product and altered how they were handled; it unsettled banks which felt threatened by the fact that it introduced an element that could not be evaluated, by which I mean that spiritual yearning born of contemplation." The pearl is something gentle, mild, alluring and tender, it is the call of a divine and incorruptible flesh to our flesh. "It is more pervaded with continuity than eternity, it is a creation of time that has escaped the imposition of a set span. The humble mollusk is dead but what it has produced against its volition, this unprecedented being that it has given us, continues to live."

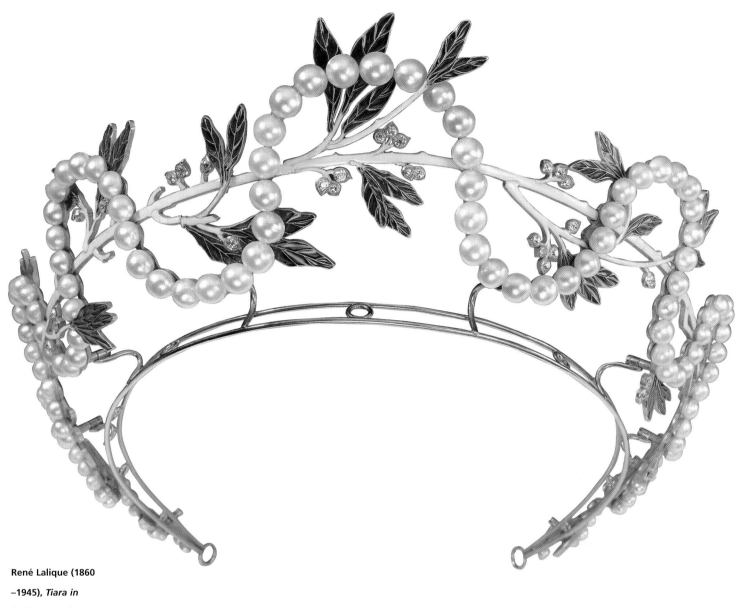

René Lalique (1860
–1945), *Tiara in
Gold, Enamel,
Diamonds and
Pearls,* Pforzheim,
Schmuckmuseum.

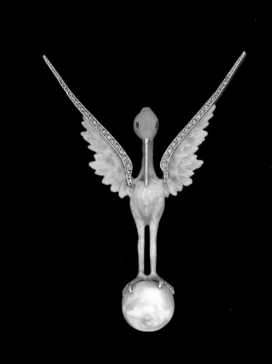

Notes

Foreword

[1] C. SIVARAMURTI, *L'Art en Inde*, Paris 1974, New York 1977, figs. 30, 60, 61, 94, 111, 152, 153.

[2] H. ROMMEL, see *Margarita*, in *Paulys Real-Encyclopadie des classischen Altertums Wissenschaft*, Stuttgart 1930, XXVIII, col. 1686.

[3] E. BABELON, see *Margarita*, in *Dictionnaire des Antiquités grecques et romaines*, ed. by C. DAREMBERG, E. SAGLIO, E. POTTIER, Paris 1904, III, pp. 1595–1596. G. BECATTI, *Oreficerie antiche*, Rome 1955, p. 118.

[4] AMM. 13, 6, 84.

[5] H. ROMMEL, *op. cit.*, coll. 1686-1687.

[6] Ibid., col. 1686.

[7] PLU. Ant. 74, 2. Also F. HAUCK, see *Margarites*, in *Grande Lessico del Nuovo Testamento*, Stuttgart 1942, Brescia 1970, VI, col. 1266.

[8] F. HAUCK, *op. cit.*, VI, coll. 1267–1270.

[9] THPHR. lap. 6, 36.

[10] ARR. Ind. 8, 9; H. ROMMEL, *op. cit.*, col. 1682–1683; J. BOLMAN, *The Mystery of the Pearl*, Leiden 1941, p. 1.

1. Writers, Poets and Philosophers: Pearls in Pagan Antiquity

[1] O. KELLER, *Die antike Tierwelt*, Leipzig 1909, II, pp. 557–559.

[2] ARR. ind. 8, 10.

[3] O. KELLER, *op. cit.*

[4] ARR. Ind. 8, 10.

[5] THPHR. lap. 6, 36.

[6] ATH. 3, 93, c.

[7] PLIN. nat. 9, 108.

[8] PLIN. nat. 9, 116.

[9] PLIN. nat. 9, 124.

[10] ATH. 3, 93, c.

[11] PLIN. nat. 9, 116.

[12] AEL. N. A. 10, 13.

[13] AMM. 13, 6, 85.

[14] PLIN. nat. 9, 107.

[15] SOL. 53, 23.

[16] PLIN. nat. 9, 107.

[17] SOL. 53, 24.

[18] AMM. 13, 6, 85.

[19] PLIN. nat. 9,108; SOL. 53, 25; AMM. 13, 6, 86.

[20] ATH. 3, 93, e-f.

[21] ATH. 3, 93, b.

[22] PLIN. nat. 9, 109; SOL. 53, 26.

[23] ARR. Ind. 8, 6–13.

[24] PLIN. nat. 9, 111.

[25] AEL. N. A. 15, 8.

[26] THPHR. lap. 6, 36.

[27] CIC. Verr. II, 4, 1, 1.

[28] CURT. 8, 9, 19.

[29] MELA, 3, 6, 49.

[30] SERV. Aen. 1, 655.

[31] PLIN. nat. 9, 112–113.

[32] PLIN. nat. 9, 112 & 123.

[33] ARR. Ind. 8, 6-13; ATH. 3, 93, c; THPHR. lap. 6, 36; STR. 11, 1, 67; CURT. 8, 5, 3; PETRON. 55, 10; PLIN. nat. 9, 106; AEL. N. A. 15, 8; SOL. 53, 28.

[34] MART. CAP. 6, 696.

[35] PLIN. nat. 9, 106. SOL. 53, 28. *The Periplus of the Erythraean Sea*, ed. by G. W. B. HUNTINGFORD, London 1980, p. 54. PHILOSTR. V. A. 3, 53.

[36] ARR. Ind. 38, 3. THPHR. lap. 6, 36. PLIN. nat. 9, 106. AEL. N. A. 10, 13.

[37] ATH. 3, 93, d–e. STR. 16, 3, 7. *The Periplus of ... op. cit.*, pp. 39–40.

[38] PLIN. nat. 9, 115.

[39] TAC. Agr. 12.

[40] PLIN. nat. 9, 106; SOL. 53, 30; AMM. 13, 6, 87.

[41] ATH. 3, 94, a–b.

[42] PLIN. nat. 9, 110.

[43] AEL. N. A. 10, 20.

[44] AEL. N. A. 15, 8.

[45] ATH. 3, 93, f-94, b.

[46] AEL. N. A. 10, 3.

[47] CURT. 8, 9, 24; 9, 1, 29.

[48] PHILOSTR. V. A. 2, 24.

[49] CURT. 9, 1, 2.

[50] CURT. 9, 1, 2.

[51] PLIN. nat. 37, 62.

[52] CURT. 8, 9, 19.

[53] ATH. 3, 93, b.

[54] ATH. 3, 93, d.

[55] ARR. Ind. 8, 13.

[56] PLIN. nat. 9, 111.

[57] ARR. Ind. 8, 8.

[58] THPHR. lap. 6, 36.

[59] VERG. Aen. 1, 655.

[60] SEN. benef. 7, 9, 4; IUV. sat. 6, 457–460; PLIN. nat. 9, 111 & 113.

[61] PLIN. nat. 9, 113.

[62] PLIN. nat. 37, 49.

[63] SEN. benef. 2, 12, 1.

[64] PLIN. nat. 37, 17.

[65] SVET. Aug. 6, 12, 4.

[66] SVET. Aug. 4, 37, 1.

[67] HOR. sat. 2, 3, 239-242; PLIN. nat. 9, 119; P. L. II, coll. 1048–1049.

[68] PLIN. nat. 9, 119; MACR. sat. 3, 17, 14–18.

[69] LAMPR. Alex. 18, 51.

70 PAUS. 8, 18, 6.

71 PLIN. nat. 37, 14–16.

72 SVET. Aug. 1, 47.

73 PLIN. nat. 9, 116; SOL. 53, 30.

74 PLIN. nat. 9, 117–118.

75 SOL. 53, 30.

76 PLIN. nat. 9, 118.

77 VARRO. Men. 283, 382; MAECEN. carm. frg. 5; MACR. sat. 2, 14, 12; PHAEDR. 3, 12.

78 SEN. benef. 7, 9, 4.

79 PERS. 2, 66.

80 VARRO. Men. 283.

81 JUV. sat. 6, 457–460.

82 SEN. benef. 7, 9, 4.

83 PLIN. nat. 9, 114.

84 QUINT. Inst. 11, 1, 3.

85 CIC. orat. 78–79.

2. Mystics and Alchemists: Pearls in the Sacred and Profane Worlds of the Middle Ages

1 P. L. IV, col. 464.

2 CLEM. paed., 2, 12.

3 TERT. cult. fem., 1, 6, 2.

4 CLEM. paed., 2, 12; TERT. cult. fem., 1, 6–9.

5 CLEM. paed., 2, 12.

6 P. G. XIII, coll. 847–858.

7 PHYSIOL. GR. 44.

8 P. L. CLXVII, coll. 80–82.

9 P. G. XXXIV, col. 659.

10 Alberti Magni Opera, Monasterii Westfaliorum 1987, XXI, pars I, pp. 415–417.

11 P. L. I, col. 1329.

12 P. G. XLVI, col. 317.

13 P. L. XXXIV, col. 1229.

14 P. L. LVII, col. 528.

15 Alberti Magni, op. cit., p. 247.

16 C. MEIER, Gemma Spiritalis, Munich 1987, pp. 70–72.

17 CLEM. paed. 2, 12.

18 P. L. V, coll. 343–344; P.L. XXIX, coll. 912–913; P.L. LXVIII, col. 927; P.L. CXII, col. 996.

19 P. L. CXVII, col. 1208.

20 P. L. CXLV, coll. 904–906.

21 P. L. XCIII, col. 203.

22 Acta Thomae, 108.

23 Ephrem Syri Opera, edit. cons. ed. by D. A. B. CAILLAU, Paris 1842, III, pp. 186–213.

24 Ibid., pp. 382–385.

25 Ibid., pp. 385–386.

26 Ibid., p. 389.

27 J. FONTAINE, Isidore de Séville et la mutation de l'encyclopedisme antique, La pensée encyclopedique au Moyen Âge, Montreux 1966, pp. 43–55.

28 J. FONTAINE, op. cit., p. 47.

29 P. L. LXXXII, col. 575.

30 P. STUDER, J. EVANS, op. cit., Paris 1924, pp. XV, XVI. Forty manuscripts have been found in England alone and over one hundred in continental Europe translated into French, Provençal, Italian, Irish, Danish, Hebrew and Spanish, often abridged with other texts.

31 P. L. CLXXI, col. 1766.

32 P. MICHAUD QUANTIN, Les petites encyclopedies du XIII siecle, La pensée encyclopedique au Moyen Âge, Montreux 1966, p. 105.

33 P. MICHAUD QUANTIN, op. cit., pp. 109–113.

34 Bartholomaei Anglici liber de proprietatibus rerum, Norimbergae 1519, p. 115 v.

35 Thomas Cantimpratensis liber de natura rerum, edit. cons. Berlin 1973, pp. 265–266.

36 Vincentii Bellovacensis Speculum majus sive quadruplex, Duaci 1624, Graz anastatic edit.,1964, I, coll. 534–538.

37 Alberti Magni op. cit., pp. 105–106.

38 Alfonso X lapidario (segun el manuscrito escurialense H. I. 15), ed. by R. M. Montalvo, Madrid 1981, pp. 26–27.

39 Ibid., p. 27.

40 A. BENEDICENTI, see Alchimia, in Enciclopedia Italiana, Rome 1929, edit. cons. Rome 1949, II, pp. 240–246.

41 L. THORNDIKE, The History of Magic and Experimental Science, New York 1929, II, p. 246.

42 Ibid., II, pp. 448–449.

43 Ibid., II, p. 252.

44 Ibid., II, p. 267.

45 Roggeri Baconi secretum secretorum cum glossis et notulis, ed. by R. STEELE, Oxford 1920, pp. 174–175.

46 Thomae Aquinatis de lapide philosophico, edit. cons. Rome 1951, pp. 43–44.

47 L. THORNDIKE, op. cit., III, p. 365.

48 Theophrast von Hohenheim Medizinische naturwissenschaftliche und philosophische Schriften, Cracow 1569, Munich and Berlin anastatic ed., 1930, III, p. 153.

49 L. THORNDIKE, op. cit., IV, pp. 27–28, 45–46, 54.

50 MS magliabechiano XIV, cod. 46, ff. 91–92.

51 Segreti diversi scritti a penna dal Sig. Agnolo della Casa, MS palatino 867, XIV, f. 32 r. e v.

52 Hieronymi Cardani Opera, Lugduni 1658, Stuttgart anastatic ed., 1966, II, pp. 562.

53 Andreae Baccii de gemmis et lapidibus pretiosis, Frankfurt 1603, p. 123.

54 F. REDI, Opere, Venice 1712, II, p. 80.

3. Occultists and Astrologers, Travelers and Scholars: Pearls in the Sixteenth and Seventeenth Centuries

[1] L. THORNDIKE, *op. cit.*, III, p. 353, note 19.

[2] *Ibid.*, II, pp. 892–893.

[3] *Ibid.*, II, pp. 854.

[4] *Ibid.*, II, p. 857

[5] *Regimen Sanitatis Salernitanum*, Ratisbonae 1711, p. 286.

[6] L. THORNDIKE, *op. cit.*, IV, p. 226.

[7] *Ibid.*, IV, p. 227.

[8] F. A. YATES, *Giordano Bruno and the Ermetic Tradition*, London 1964, edit. cons. Bari 1969, p. 13.

[9] *Ibid.*, pp. 25–26.

[10] *Ibid.*, pp. 79–81.

[11] *Ibid.*, p. 31.

[12] *Ibid.*, p. 81.

[13] L. THORNDIKE, *op. cit.*, IV, p. 565.

[14] F. A. YATES, *op. cit.*, pp. 78–79.

[15] *Marsilii Ficini Opera*, Basileae 1576, anastatic edit. Torino 1962, I, p. 563.

[16] F. A. YATES, *op. cit.*, pp. 151 & ss.

[17] *Henrici Cornelii Agrippae De occulta Philosophia*, S. L. 1533, anastatic edit. ed by K. A. NOWOTNY, Graz 1967, p. 13.

[18] *Ibid.*, pp. 29–30, pp. 32–33.

[19] *Ibid.*, pp. 23–24.

[20] *Ibid.*, pp. 15–16.

[21] *Ibid.*, pp. 24–25.

[22] *Ibid.*, pp. 25–26.

[23] *Ibid.*, pp. 26–30, pp. 41–47.

[24] *Ibid.*, pp. 32–33.

[25] *Ibid.*, pp. 34–35.

[26] *Henrici Cornelii Agrippae, op. cit.*, pp. 43–44.

[27] *Ibid.*, pp. 40–41.

[28] *Andreae Baccii, op. cit.*, pp. 124–125.

[29] *Anselmii Boetii De Boot Gemmarum et lapidum historia*, Lugduni 1636, p. 172.

[30] *Ibid.*, p. 168.

[31] *Regimen Sanitatis Salernitanum*, Ratisbonae 1711, p. 286.

[32] *Andreae Baccii, op. cit.*, pp. 124–125. *Anselmi Boetii De Boot, op. cit.*, pp. 172; 174.

[33] G. B. PORTA, *De i miracoli et meravigliosi effetti dalla natura prodotti*, Venezia 1560, p. 157.

[34] *Andreae Baccii, op. cit.*, p. 125.

[35] *Andreae Baccii, op. cit.*, p. 118.

[36] *Camilli Leonardi Speculum Lapidum*, Venetiis 1516, pp. XXXVI v.–XXXVII r.

[37] *Camilli Leonardi op. cit.*, pp. XXXVI v–XXXVII r.

[38] *Anselmi Boetii De Boot op. cit.*, pp. 166 & ss.

[39] *Ibid.*, pp. 175–180.

[40] *Encyclopédie ou Dictionnaire raisonné des Sciences, des Arts et des Métiers*, ed. by M. DIDEROT and M. D'ALAMBERT, Lausanne and Berne 1780, see *perle*, XXV, pp. 364–370.

[41] *Scopritori e viaggiatori del Cinquecento e del Seicento, il Cinquecento*, ed. by I. LUZZANA CARACI and M. POZZI, *La Letteratura italiana Storia e Testi*, 40, I, Milan Naples 1992, p. 77.

[42] *Ibid.*, pp. 161–162.

[43] *Ibid.*, p. 236.

[44] *Ibid.*, p. 262–263.

[45] *Scopritori e viaggiatori* (...), p. 437.

[46] *Ibid.*, pp. 823–826.

[47] *Viaggiatori del Seicento*, ed. by M. Guglielminetti, Turin 1967, p. 699.

[48] *Ibid.*, p. 226.

[49] *Ibid.*, p. 237.

[50] *Ibid.*, p. 238–239.

[51] *Scopritori e viaggiatori* (...), p. 440.

[52] *Ibid.*, p. 504.

[53] *Viaggiatori del Seicento* (...), p. 698.

[54] *Scopritori e viaggiatori.* (...), p. 438.

[55] *Ibid.*, p. 480.

[56] *Ibid.*, p. 699.

[57] *Viaggiatori del Seicento* (...), pp. 699–700.

[58] F. PICINELLI, *Mundus Symbolicus*, Coloniae Agrippinae 1687, anastatic edit. Hildesheim New York 1979, pp. 705–710.

Glossary

Aigrette = A gold or silver hat ornament or hair ornament to support a feather, or made in the form of a jeweled feather.

Bandeau = A type of head ornament in the form of a narrow band encircling the forehead.

Berthe = A large collar-shaped necklace composed of a network of gemstones, sometimes embellished with suspended pearls or drop-shaped gemstones.

Broche = A brooch or ornamental clasp with a pin to attach it to a garment, hat or sleeve as a fastener or as a decorative piece.

Cabochon = A gem cut in a convex curve and polished but not given facets.

Champlevé = The enameling technique in which the design is made by cutting lines or cells in a metal base, filling them with powdered enamel of various colors and then firing the whole to fuse the enamels.

Chatelaine = An ornamental clasp worn during the day at a woman's waist and attached either to a belt or girdle by a hook-plate from which several short chains were hung; the chains terminated with rings to which various small objects for daily household use were attached.

Cloisonné = The technique of decoration by enameling in which bent wire or metal strips of rectangular-section wire are attached edgewise to a metal base to form a design and the spaces between filled with colored enamels that are then fused.

Collier de chien = Literally dog collar. A wide ornamented jeweled necklace worn tightly around a woman's throat.

Cotière = Elaborate long chain with pendant worn by ladies of the French court during the late Renaissance.

Corbeille de mariage = A bride's jewelry box.

Devant le corsage = A bodice ornament.

Équipage = A collection of small articles for personal use, such as a chatelaine with its suspended scissors, nail trimmer, tweezers, thimble, pencil and the small container for such articles.

Ferronière = A type of ornament in the form of a band worn around a woman's forehead and decorated with a jewel in the center.

À girandole = A type of earring composed of a bow-shaped ornament, or more usually a large circular gemstone at or near the top of the setting, and having three pear-shaped faceted diamonds or sometimes three pearls suspended at the bottom.

Objet de vertu = A small object of artistic quality and of value, made of precious metal and often embellished with gemstones.

Opus interrasile = A style of openwork decoration on metal made by piercing the metal with a chisel or other tool to form a pattern.

Pendeloque = A diamond or other gemstone that is somewhat pear-shaped.

Pendentif = French name for a pendant.

À potence = A style of setting a pearl with small gold projections on two sides.

Rivière = A type of necklace that is strung with graduated gemstones of the same variety, usually individually set and without other ornamentation.

Enamel "en ronde bosse" = Literally enamel on an object in the round: enamel applied thickly on a raised or modeled metal surface to form a relief decoration, or applied over metal figures in the round.

Sautoir = A woman's long neck chain, loosely worn and usually hanging below the waist.

En suite = Set

En tremblant = A brooch, pendant, aigrette or hair ornament decorated with flowers or another motif that has stiff projecting wires at the top that tremble when the piece is subjected to any movement.

References

Abbreviated sources

AEL. N. A. = Eliano, *De natura animalium.*
AMM. = Ammiano Marcellino, *Rerum gestarum libri XXXI.*
ARR. Ind. = Arriano, *Indica.*
ATH. = Ateneo, *Deipnosophistae.*
CIC. Verr. = Cicero, *Orationes in Verrem.*
CIC. Orat. = Cicero, *Orator.*
CLEM. paed. = Clemente Alessandrino, *Paedagogus.*
CURT. = Quinto Curzio Rufo, *Historiae Alexandri Magni.*
HOR. Sat. = Horace, *Saturae.*
ISID.Orig. = *Isidori Hispaliensis Episcopi etymologiarum libri XVI.*
IUV. sat. = Juvenal, *Saturae.*
LAMPR. = *Scriptores Historiae augusteae.*
MACR. Sat. = Macrobio, *Saturnalia*
MAECEN. carm. frg. = Mecenate, *Fragmenta.*
MART. CAP. = Marziano Capella, *De nuptiis Philologiae et Mercurii.*
MELA = Pomponio Mela, *De chorographia libri tres.*
PAUS. = Pausanias, *Greciae descriptio.*
PERS. = Persius, *Saturae.*
PETRON. = Petronius, *Satyricon.*
P.G. = *Patrologia Cursus Completus (series graeca),* edited by J.P. Migne, I edition 1856–1861, consulted edition Paris 1857–1866.
PHAEDR. = Phaedrus, *Phabulae novae.*
PHILOSTR. V. A. = Flavius Philostratus, *Vita Apollonii.*
PHYSIOL. GR.= *Physiologus graecus*
P.L. = *Patrologiae Cursus Completus (series latina),* edited by J.P. Migne, I edition Paris 1844–1855, consulted edition Paris 1878 & ss.
PLIN. nat. = Pliny the Elder, *Naturalis historia.*
PLU. = Plutarch, *Vitae parallelae.*
QUINT. Inst. = Quintilian, *Institutionis oratoriae.*
SEN. benef. = Seneca, *De beneficiis*
SERV. Aen. = Servius, *In Vergilii carmina commentarius.*
SOL. = Solino, *Collectanea rerum memorabilium.*
STR. = Strabone, *Geographica.*
SVET. Aug. = Svetonius, *De vita Caesarum, liber secundus, Divus Augustus.*
TAC. Agr. = Tacitus, *De vita Iulii Agricolae.*
TERT. cult. fem. = Tertullian, *De cultu foeminarum.*
THPHR. lap. = Theophrastus, *De lapidibus*
VARRO. Men. = Varro, *Saturarum menippearum fragmenta.*
VERG. Aen. = Virgil, *Aeneidos.*

Complete sources

Alberti Magni Opera, Monasterii Westfaliorum 1987.
Alfonso X lapidario (segun el manuscrito escurialense H. I. 15), edited by R. M. Montalvo, Madrid 1981, pages 26-27.
Andreae Baccii de gemmis et lapidibus pretiosis, Frankfurt 1603.
Anselmii Boetii De Boot Gemmarum et lapidum historia, Lugduni 1636.
Bartholomaei Anglici liber de proprietatibus rerum, Nuremberg 1519.
Camilli Leonardi Speculum Lapidum, Venetiis 1516.

Ephrem Syri Opera, consulted edition edited by D. A. B. Caillau, Paris 1842.
Henrici Cornelii Agrippae De occulta Philosophia, S. L. 1533, anastatic edition edited by K. A. Nowotny, Graz 1967.
Hieronymi Cardani Opera, Lugduni 1658, anastatic edition Stuttgart 1966.
Marsilii Ficini Opera, Basileae 1576, anastatic edition Turin 1962, I, page 563.
The Periplus of Erythrean Sea, edited by G.W. Huntingford, London 1980.
F. Picinelli, *Mundus Symbolicus,* Coloniae Agrippinae 1687, anastatic edition Hildesheim New York 1979, pages 705-710.
G. B. Porta, *De i miracoli e meravigliosi effetti dalla natura prodotti,* Venice 1560.
F. Redi, *Opere,* Venice 1712.
Regimen Sanitatis Salernitanum, Ratisbonae 1711, page 286.
Roggeri Baconi Secretum secretorum cum glossis et notulis, edited by R. Steele, Oxford 1920.
Scopritori e viaggiatori del Cinquecento e del Seicento, Il Cinquecento, edited by I. Luzzana Caraci and M. Pozzi, *La Letteratura italiana. Storia e Testi,* 40, I, Milan and Naples 1992, page 77.
Theophrast von Hohenheim Medizinische naturwissenschaftliche und philosophische Schriften, Cracow 1569, anastatic edition Munich and Berlin 1930.
Thomae Aquinatis de lapide philosophico, consulted edition Rome 1951.
Thomas Cantimpratensis liber de natura rerum, consulted edition Berlin 1973.
Viaggiatori del Seicento, edited by M. Guglielminetti, Turin 1967, page 699.
Vincentii Bellovacensis Speculum majus sive quadriplex, Duaci 1624, anastatic edition Graz 1964.

Manuscripts

MS magliabechiano XIV, cod. 46, ff. 91-92.
Segreti diversi scritti a penna dal Sig. Agnolo della Casa, MS palatino 867, XIV, f. 32 r. and v.

General texts

E. Babelon, headword *Margarita,* in *Dictionnaire des antiquités grecques et romaines,* edited by C. H. Daremberg, E. Saglio, E. Pottier, Paris 1904, III, pages 1595–1596.
L. Baisier, *The Lapidaire Chrétien,* Washington 1936.
V. Baldasseroni, headword *Perle,* in *Enciclopedia Italiana,* Rome 1935, consulted edition Rome 1949, XXVI, pages 771–776.
G. Becatti, *Oreficerie antiche,* Rome 1955.
A. Benedicenti, headword *Alchimia,* in *Enciclopedia Italiana,* Rome 1929, consulted edition Rome 1949, II, pages 240–246.
J. Bidez, F. Cumont, *Les Mages hellénisés,* Paris 1936, consulted edition Paris 1973.
J. Bolman, *The Mistery of the Pearl,* Leiden 1941.
G. G. Boson, *Les métaux et les pierres dans les incriptions assyro-babyloniennes,* Munich 1914.
O. Ceretti Borsini, *Bellezza e magia delle gemme,* Milan 1971, pages 179–181
A. Bouché-Leclerq, *L'astrologie grecque,* Paris 1899.
Encyclopédie ou Dictionnaire raisonné des sciences, des arts et des mètiers, edited by M. Diderot and M. D'Alembert, Lausanne and Berne 1780, headword *Perle,* XXV, pages 364–370.
U. Engelen, *Die Edelsteine in der deutschen Dichtung des 12. und 13. Jahrhunderts* (Münstersche Mittelalter-schriften, 27), Munich 1978, pages 350–356.
J. Evans, *Magical Jewels of the Middle Ages and the Renaissance,* Oxford 1922, consulted edition New York 1976.
A. J. Festugière, *La Révélation d'Hermès Trismégiste,* Paris 1950.
J. Fontaine, *Isidore de Sèville et la mutation de l'encyclopédisme antique,* in *La pensée encyclopédique au Moyen Âge,* Montreux 1966, pages 43-62.
R. Halloux, *Les Alchimistes grecs,* Paris 1981.
F. Hauck, headword *Margarites,* in *Grande Lessico del Nuovo Testamento,* Stuttgart 1942, consulted edition Brescia 1970, VI, columns 1266–1270.
O. Keller, *Die antike Tierwelt,* Leipzig 1909, II, pages 552–560.
C. W. King, *The Natural History of Precious Stones and the Precious Metals,* London 1870, pages 258–275.
G. F. Kunz, *The Curious Lore of Precious Stones,* Philadelphia 1930, consulted edition New York 1971.
G. F. Kunz, C. H. Stevenson, *The Book of the Pearl,* London 1908.
Les Lapidaires Grecs, edited by R. Halloux and J. Schamp, Paris 1983.
F. Lauchert, *Geschichte des Physiologus,* Strassburg 1889.
C. Meier, *Gemma Spiritalis,* Munich 1987.
P. Michaud-Quantin, *Les petites encyclopédies du XIIIe siècle,* in *La pensée encyclopédique au Moyen Âge,* Montreaux 1966, pages 105–120.
H. Rommel, headword *Margarita,* in *Paulys Real-Enzyklopädie des classischen Altertums Wissenschaft,* Stuttgart 1930, XXVIII, columns 1682–1687.
L. Rosenthal, *Au royaume de la perle,* Paris 1920.
C. Sivaramurti, *L'Art en Inde,* Paris 1974, consulted edition New York 1977.
P. Studer, J. Evans, *Anglo-Norman Lapidaries,* Paris 1924.
Thesaurus linguae latinae, Leipzig 1966, headword *Margarita,* VIII, columns 391–393.
L. Thorndike, *The History of Magic and Experimental Science,* New York 1929.
B. Widmer, *Eine Geschichte des Physiologus auf einem Madonnenbild der Brera, "Zeitschrift für Religions und Geistesgeschichte",* XV, 1963, pages 313 and following.
F. A. Yates, *Giordano Bruno and the Hermetic Tradition,* London 1964, consulted edition Bari 1969.

Pearl Jewels

J. Anderson Black, *Storia dei gioielli,* Novara 1973, consulted edition Novara 1984.

E. Armstrong, *Lorenzo de' Medici and Florence in the Fifteenth Century*, New York-London 1896.

L'Art de Cartier, catalogue of the exhibition edited by T. Burollet, Paris 1989.

L'Art en France sous le Second Empire, catalogue of the exhibition, Paris 1979.

C. Aschengreen Piacenti, *Il Museo degli Argenti a Firenze*, Milan 1967.

R. Assunto, *La critica d'arte nel pensiero medievale*, Milan 1961.

G. Bapst, *Histoire des Joyaux de la Couronne*, Paris 1889.

C. Barini, *Ornatus muliebris, i gioielli e le antiche romane*, Turin 1958.

G. Becatti, *Oreficerie antiche*, Rome 1955.

V. Becker, *Art Nouveau Jewelry*, London 1985, consulted edition Milan 1985.

I. Belli Barsali, *Oreficeria medievale*, Milan 1966.

E. de Bruyne, *Etudes d'Esthetique du Moyen Âge*, Louvain 1947.

S. Bury, *Jewellery 1789–1910*, 2 volumes, Woodbridge 1991.

R. Cameron, "Perles", *L'Oeil*, 72, 1960, pages 66–79.

G. Cantelli, *Storie dell'oreficeria e dell'arte tessile in Toscana, dal Medioevo all'età moderna*, Florence 1996.

P. Claudel, *La mystique des pierres précieuses*, Paris 1938.

F. Coarelli, I. Belli Barsali, E. Steingräber, *Tesori di oreficeria, venticinque secoli di gioielli*, Milan 1966, consulted edition 1973.

Collezione Castellani, Le Oreficerie, catalogue of the Museo Nazionale Etrusco of Villa Giulia edited by I. Caruso, Rome 1988.

M. Cristofani, M. Martelli, *L'oro degli Etruschi*, Novara 1983.

D. Davanzo Poli, "L'abbigliamento femminile veneto nel primo Cinquecento", in *Amor Sacro e Amor Profano*, Rome 1995, pages 154–160

V. De Michele, G. Manzini, *Munera Imperialia, analisi delle gemme del Duomo di Monza*, Milan 1993.

Dictionnaire d'orfèvrerie, de gravure et de ciselure chrétiennes, edited by Abbot J. Textier, Paris 1857.

R. Distelberger, "La corona dell'Imperatore Rodolfo II in seguito corona del Sacro Romano Impero", in *Tesoro Sacro e Profano* catalogue of the Kunsthistorisches Museum, Vienna 1992.

F. Dumont, "Froment Meurice, le Victor Hugo de l'orfèvrerie", in *Connaissance des Arts*, 1956, n. 57, pages 42–45

U. Engelen, *Die Edelsteine in der deutschen Dichtung des 12. und 13. Jarhunderts* (Münstersche Mittelalter-schriften, 27), Munich 1978, pages 350–356.

J. Evans, *Magical Jewels of The Middle Ages and the Renaissance*, Oxford 1922, consulted edition New York 1976.

J. Evans, *A History of Jewellery 1100-1870*, London 1953.

L. Field, *The Jewels of Queen Elizabeth II, Her Personal Collection*, New York 1992.

E. Fontenay, *Les Bijoux anciens et modernes*, Paris 1881.

Gioielli, catalogue of the Museo Poldi Pezzoli edited by M.T. Balboni Brizza and A. Zanni, Turin 1996.

I gioielli dell'Elettrice Palatina al Museo degli Argenti, catalogue of the collection edited by Y. Hackenbroch and M. Sframeli, Florence 1988.

Grafica per orafi modelli del Cinque e Seicento, catalogue of the exhibition edited by A. Omodeo, Florence 1975.

G. Gregorietti, *I gioielli*, Verona 1977.

A. Griseri, *Oreficeria barocca*, Milan 1985.

A. Griseri, *Oreficeria del Rinascimento*, Milan 1986.

G. von Habsburg, *Fabergé*, Munich 1986.

Y. Hackenbroch, *Renaissance Jewellery*, London 1979, consulted edition Munich 1979.

J. Herald, *Renaissance Dress in Italy 1400–1500*, London 1981.

R. A. Higgins, *Greek and Roman Jewellery*, London 1961.

Jewellery through 7000 years, catalogue of the British Museum edited by H. Tait, London 1976.

K. Joyce, S. Addison, *Pearls, Ornament and Obsession*, London 1992, consulted edition New York 1992.

J. Lanllier, M. A. Pini, *Cinq siècles de joaillerie en Occident*, Fribourg 1972, consulted edition Milan 1972.

R. Levi Pisetzky, *Storia del costume in Italia*, 5 volumes, Milan 1964.

A. Lipinsky, *Oro, argento, gemme e smalti*, Florence 1975.

A. Lugli, *Naturalia et mirabilia*, Milan 1983.

F. Malaguzzi Valeri, *La Corte di Ludovico il Moro*, 4 volumes, Milan 1913–23

D. Mascetti, *Gioielli dell'Ottocento*, Milan 1984.

D. Mascetti, *Oreficeria del Settecento*, Milan 1985.

D. Mascetti, A. Triossi, *Earrings from Antiquity to the Present*, London 1990, consulted edition Milan 1991.

The Masters Jewellers, edited by K. Snowman, London 1990, consulted edition Milan 1991.

A. Merati, *Il Duomo di Monza e il suo Tesoro*, Monza 1982.

G. C. Munn, *Castellani and Giuliano, Revivalist Jewellers of the 19th Century*, Fribourg 1983.

H. Newman, *An Illustrated Dictionary of Jewelry*, London 1987, consulted edition 1990, pages 229–231.

J. Ogden, *Ancient Jewellery*, London 1992.

L'Oreficeria nella Firenze del Quattrocento, catalogue of the exhibition edited by M.G. Ciardi Duprè dal Poggetto, Florence 1977.

L'Orfèvrerie gothique (XIIIe 1–debut XVe siècle) au Musée de Cluny, Paris 1989.

C. Phillips, *Jewelry, from Antiquity to the Present*, London 1996.

L. Pirizio Biroli Stefanelli, *L'Oro dei Romani, gioielli di età imperiale*, Rome 1992.

E. Polidori Calamandrei, *Le vesti delle donne fiorentine nel Quattrocento*, Florence 1924, consulted anastatic edition Rome 1973.

Prag um 1600, Kunst und Kultur am Hofe Rudolf II, catalogue of the exhibition in Essen and in Vienna 1988–89.

René Lalique, catalogue of the exhibition edited by A. Riboud and M.C. Lalique, Paris 1991.

M. Righetti, *Storia liturgica*, Milan 1964.

M. Robbiani, *Gli orecchini, mito e seduzione*, Vicenza 1991.

A. Santangelo, P. Sticotti, G. Corso, headword *Diadema*, in *Enciclopedia Italiana*, Rome 1931, consulted edition Rome 1948, XII, pages 721–723.

L.A. Scatozza Höricht, *I monili di Ercolano*, Rome 1989.

J. Schlosser, *Die Kunst- und Wunderkammern der Spätrenaissance*, Leipzig 1908, consulted edition Florence 1974.

Splendori di pietre dure, catalogue of the exhibition edited by A. M. Giusti, Florence 1989.

E. Steingräber, *Alter Schmuck*, Munich 1956, consulted edition Florence 1965.

P. Stone, "Baroque Pearls", *Apollo*, 68, 1958, pages 194–199; 69, 1959, pages 33–37, pages 107–112.

C.H.V. Sutherland, *Gold, its beauty, power and allure*, London 1961, consulted edition Milan 1961.

Il Tesoro del Duomo di Monza, catalogue edited by L. Vitali, Milan 1966.

H. Vever, *La bijouterie française au XIXe siècle*, 3 volumes, Paris 1906.